Contents

W9-BRY-433

Chapter 4:
Other Features To Consider 63

Chapter 5:
Having Fun With A Camera & Other Tips 77

Part 2: Scanners 97 - 220

Chapter 6:
The Second Frame: Introducing Scanners 99

Chapter 7:
Selecting A Scanner .. 113

Chapter 8:
Tips On Using A Scanner .. 145

Chapter 9:
Don't Know What To Scan? Try These Ideas 189

Part 3: Image Editors........................ 219-288

Chapter 10:
Image Editors Are The Digital Darkrooms 223

Chapter 11:
Working With Filters And Plug-ins249

Chapter 12:
Working With Text And Effects271

Part 4: More Information 289-326

Introduction

You may not realize it but you're probably a big user of digital technology already. For example, every time you listen to your favorite CD, whether is Beethoven or Sheryl Crow, you're using digital technology. Digital technology is becoming more important in the computer world, too. Desktop publishing and the World Wide Web demand colorful graphics and images to break up text and add interest.

You've likely snapped photos of special occasions like vacations, proms, reunions and countless other situations. You'd take the film to the photo center and wait a few hours or days for them to develop the film. Then after a while, the excitement wore off and you moved the photos to a box in the closet.

You're probably just as "snap happy" today. However, now you can use your photos in a completely different way than you could before.

The basic technology of photography has not changed much in the last 150 years. Today's digital cameras use the same basic technology as your 35-mm film camera. There is, however, one important difference: Digital cameras create images instantly. You can then manipulate ("tweak"), print and even e-mail the images. Don't panic... the price of many consumer level digital cameras is less than $300 now.

Even if you're not interested in digital cameras or are unimpressed with their low resolution, you can still use your PC to explore the world of digital technology. For example, use a color scanner to transfer your conventional prints onto your computer.

Then after your images are saved on your hard drive, it's very easy to turn your PC into a digital darkroom. Even a beginner's beginner can use image editors like Paint Shop Pro, MGI PhotoSuite II, Photo Line or others to remove red eye, change backgrounds, adjust colors and contrasts, add special effects and otherwise "tweak" images (see Chapters 10-14).

Then when you're finished tweaking the image, put it into a report, letter, newsletter or even the Internet. You can start a family newsletter and keep grandparents up-to-date on your kids. Put a picture of your missing pet in a flyer so would-be rescuers have more information. Many image editors also let you put your pictures on calendars, mugs, magnets or screen savers. Then you can print out the image using inexpensive, photo-quality inkjet printers.

Don't have a scanner or digital camera. You can still be part of the new digital darkroom. You can also have your 35-mm film processed onto a floppy disk or Photo CD. Seattle FilmWorks, a mail-order film processor, will place digitized film onto a floppy diskette. You can even download your photos from their Web site. PictureVision offers a similar service at their PhotoNet site.

Inside Easy Digital Photography

We've divided this book into four parts. The first part talks about digital cameras and their technology. This includes tips on selecting a digital camera, how they work and using a digital camera once you bought one. The second part deals with scanners. We'll talk about tips on selecting, installing and using scanners and other uses for scanners, such as scanning 3-D objects, etc. The third part talks about image editors. These are software programs that let you tweak an image. We've even included two on the companion CD-ROM that you can use. The fourth part talks about the Internet, image managers and the companion CD-ROM.

We're interested in knowing what you think of digital cameras and today's digital technology. Let us know how you use your digital camera, scanner and image editor. Send your ideas and comments to **ezdigitalphoto@yahoo.com**.

Part 1

Digital Cameras

Chapter 1:
The First Frame:
Introducing Digital
Cameras

Chapter 1

The First Frame: Introducing Digital Cameras

"Development" Of Digital Cameras

The reasons for the fast growth of digital cameras

Who Uses Digital Cameras?

Advantages And Disadvantages

Disadvantages of using a digital camera
Advantages of digital cameras

Perhaps A Digital And Film Solution

For the last 150 years photography involved silver-nitrate-based film, the corner drug store and waiting hours or even days for the film to be developed. The basic technology of photography has not changed much during that time. The fast speed, assorted lenses and other capabilities of today's 35-mm camera would impress the famous Civil War photographer Matthew Brady. Nevertheless, he would still understand how the camera works.

An "unretouched" photo snapped with the Chinon ES3000 digital camera

It would be a different story, however, if Brady were to get his hands on one of today's color digital cameras. It's doubtful he would even recognize it as a camera because it's unlikely he ever considered using a camera that did not use film. Color digital cameras, also called filmless cameras, create instant images that can be manipulated, printed and electronically mailed.

"Development" Of Digital Cameras

An inventor at Stanford University named D. Gregg created a crude forerunner to digital photography in 1963. Although Gregg's videodisk camera could snap images, it could only store those images for a short time (usually a few minutes). Nevertheless, it suggested that a new exciting technology was about to appear.

The idea for digital cameras literally came from outer space. The digital imaging technology grew from research involving satellites for military and scientific research applications.

Although digital cameras sound like a new technology, practical electronic photography began back in 1982 with the Sony Mavica. Sony shook the photographic world when it introduced Mavica. The Mavica, short for magnetic video camera, was revolutionary for one main reason: it didn't use film. Mavica may have shaken the photographic world but it shocked manufacturers. They realized they had two choices: start research on their own electronic photography products or face declining sales.

Although it was a still camera, the Mavica was more like a Sony television camera. The pictures it produced were technically television pictures. However, Mavica produced single frames of video instead of 25 (in Europe) or 30 (in Japan and the US) frames per second. In other words, the Mavica produced video pictures. These pictures, taken as individual frames, were "still" pictures. Instead of film, Mavica recorded still video images on two-inch floppy disks (resembling today's miniature computer disks).

However, the Mavica used analog recordings instead of digital recordings. Therefore, before the signals could be used in a computer, they had to be converted from analog to digital. This was done using a digitizing card.

Mavica cameras were available only in the US and Japan. Sony never produced a still video camera for the European market. Instead, Canon introduced the Ion RC-251 still video camera through specialty stores. Using a digitizing card in the Mac, users were able to get digital images from the Ion RC-251 camera.

6

Today's digital cameras started with the legendary QuickTake camera from Apple Computer (co-developed with Kodak). The first QuickTake camera cost around $700 and was the size of a small pair of binoculars. This fixed-lens camera included an internal 1-Meg flash memory. This was enough to store 8 to 32 images, depending on the resolution (maximum 640 x 480). Users connected the QuickTake to the Mac or PC through the serial port.

Many companies have since released digital cameras. These companies include well-known camera makers such as Minolta and Kodak as well as companies from the computer world such as Ricoh, Chinon and Casio. Most of these cameras were improvements over the QuickTake. For example, they exceeded the image capacity and internal storage limitations of the QuickTake. They also added higher resolution color CCD imagers, JPEG for fast compression, more flash memory and faster serial communications.

The reasons for the fast growth of digital cameras

There is no single reason for the explosive growth of digital cameras and digital imaging. We can list at least five reasons related to the sudden increase in popularity of digital cameras:

Faster and more powerful PCs

A fast processor, such as the Pentium-class processor, is virtually required when working with the images captured by a digital camera. Working with these images is very math intensive. Processors before the Pentium, even the 486, weren't fast enough to handle the necessary calculations. These earlier processors simply required too much time to handle these images.

Larger capacity hard drives

Digital images can also require large amounts of hard-drive space. Just one image that you'll snap with a digital camera can be larger than 1 Meg. Storing several of these shots obviously requires a relatively large hard drive and these weren't available until recently. Now that large capacity hard drives are available (several gigabytes), we have plenty of room to store dozens of images.

Image editors

Perhaps the most important breakthrough wasn't the arrival of more powerful hardware, but more powerful software. Software, especially image editors, are required to manipulate or edit photographic images. This was realized in 1991 — the year recognized by graphic artists as the start of the "image revolution." That year Adobe Systems released the first version of Photoshop. Although countless image editors have come and gone and dozens of image editors are now available, Photoshop remains the industry standard.

*Although Photoshop started the "image revolution"
in 1991, more recent and less expensive image editors such
as Paint Shop Pro have made a huge impact for digital imaging at home.*

Although Photoshop remains the industry standard, its price (about $300) puts it out of range for most home enthusiasts. Fortunately, affordable image editors are available. These image editors, such as MGI PhotoSuite II and Paint Shop Pro 5, include many of the features found in Photoshop. However, their retail price (less than $100) makes them much more price-friendly.

Lower prices, more competition

Although megapixel resolution cameras are still more expensive than 35-mm cameras, the cost of a digital camera continues to fall as competition from different manufacturers increases. The suggested retail price for most home digital cameras range from $300 to $1,000 and the "street price" is even lower.

Although even the street price is steep for many PC users, it's much less than what comparable cameras cost a very short time ago. The least expensive digital camera then was the Kodak QuickTake 150 (about $750). Furthermore, the prices are likely to continue dropping as competition increases and more companies release new models.

Of course, you can always go "top end" with studio digital cameras that currently cost several thousand dollars.

The Kodak 410 is an example of a professional digital camera (suggested retail price is about $7000).

Hey, they're fun to use

Using a digital camera can be just plain fun. These cameras are great for viewing full-color, full-screen pictures on your monitor. They make enhancing your home page on the Internet a breeze. Perhaps their most interesting feature currently is their new technology; it's fun to have something new.

Who Uses Digital Cameras?

You don't have to look very far to see digital cameras being used. You'll find digital cameras used for desktop publishing, web pages, catalogs, entertainment venues and environmental issues.

The following is part of a growing list of examples of how and where digital cameras are used today:

Internet publishing

Visual graphics have become a necessity for eye-catching web pages. So, digital cameras have become invaluable for designers providing artwork and page layout for businesses wanting an Internet home page.

When you're in a hurry to update your page, use a digital camera. Then you won't need to race to the local photofinisher to develop and print the photos. Instead, simply transfer the images directly from your camera to your PC (requiring a few seconds per image). You then can edit and post the new images within minutes.

Resolution is perfect for Web pages

Most digital cameras can produce resolutions of at least 640 x 480 pixels. This is more than you'll likely need for Web pages. You may even need to crop or resample pictures down to smaller sizes.

Graphic arts service providers

Graphic arts service providers have discovered that digital cameras created new business opportunities. Because many of their customers are looking for a "one-stop service" outlet, these shops use digital cameras as a competitive advantage.

This allows the service provider to control the entire graphic arts process, from photography to image processing to prepress.

Electronic publishing

Many publishers use digital cameras to add images into their books and magazines quickly. This eliminates the need to use photographs and slides because the media is electronic.

Souvenirs

Digital cameras are great for taking photographs with your favorite "cartoon" characters. Then you can quickly incorporate them into T-shirts and mugs for memorable personalized souvenirs.

Real estate and insurance agents

Real estate and insurance agents were among the first to see the potential of digital cameras. They use digital cameras to include pictures in reports and publications. Real estate agents can "show" a property almost immediately by posting photographs of properties for sale or rent to hundreds of potential customers on the Internet. They can also send the information to associates in a remote office. Insurance agents can use a digital camera and the Internet to transmit images of property damage to speed claims processing.

The United States Navy

The U.S. Navy is faced with the increasingly serious and difficult problem of disposing photochemical waste. So it decided to do most of its photography digitally. Digital photography doesn't need chemicals to develop images. Other branches of the military are also changing over to digital cameras.

Lower advertising costs

Stores can lower advertising costs by switching to digital cameras. Because the images are sent directly to the printer, the retailer doesn't pay for developing, scanning and other costs.

Government agencies

Law enforcement agencies, photo ID centers and photojournalists use digital photography more frequently today. For example, New York's Department of Motor Vehicles uses a digital photography system for every driver's favorite photograph: their driver's license picture.

Digital photography classes

Schools and colleges offer digital photography classes along with traditional photography classes. This lets students create a digital portfolio of their work over the semester or term that can be stored on CD-ROM or other media. This portfolio may be used as an evaluation tool for college entry or employment.

Local newspaper

Your local newspaper, like many major newspapers around the country, probably uses digitized photographs. Photojournalists can send digital images along with their stories by electronic mail. Photojournalists no longer have to wait for the lab to develop the film or run to get the processed film to the editor.

Publicity

Major photography magazines, such as *Shutterbug*, *Photographic* and *Popular Photography*, have more articles on digital photography.

Personal use

Perhaps you've wanted to add photos to your newsletters, flyers or even in a database. Your previous options were to buy prescanned photographic images on a CD-ROM or to buy a scanner and scan images into your PC. The images then had to be edited and saved on a hard drive before they could be placed in the document. Either option was time-consuming and expensive.

Today, you'll find a digital camera to be a valuable tool. Images taken with a digital camera can be almost immediately inserted into sales presentations or printed in brochures, newsletters and catalogs. The advantage with a digital camera is that you're knocking out at least one, and in many cases, two steps.

Great way to learn photography

Camera buffs have complained forever about wasting dollars to process poor shots that they took. Now, digital cameras eliminate that potential costly problem. A digital camera is great for learning and experimenting with photography. For example, digital cameras can store dozens of images and because you can overwrite the images, you can shoot all the pictures you want. Then you can delete the less-interesting photos and transfer the "keepers" to your PC.

Security

Businesses can easily and quickly increase their security systems by using digital photographs when issuing personal ID badges. These photo IDs can be quickly checked against an image database in a PC.

Advantages And Disadvantages

We've talked about how great digital cameras are, who uses them and why, but like all new technologies, digital cameras have certain advantages and disadvantages. This section talks about both. We'll start with the disadvantages.

Disadvantages of using a digital camera

Before you gather your family, friends, pets or models for a photo shoot, it's important for you to understand what digital cameras are not. Most important, they are not replacements for film cameras.

You don't absolutely need a digital camera to enjoy digital imaging. For example, you can use a 35-mm camera and scan selected slides or negatives.

Consideration	Digital cameras	
Image quality	Consumer digital cameras are still a long way from challenging regular cameras in image quality and features for the price. Most digital cameras have resolutions under 100 dpi. This makes digital cameras good for screen- oriented applications such as e-mail attachments, websites, etc.	
Storage	A digital camera 's storage is reusable once you download a batch of images. Also, you can snap anywhere from one image to the maximum number of images before downloading to your PC.	
Camera prices	Quality digital cameras are still more expensive than film cameras. However, prices are still falling to a fraction of what they were a few years ago.	
Learning photography	A digital camera is great for learning and experimenting with photography. Digital cameras eliminate costly low quality shots. Delete the less-interesting photos and transfer the "keepers" to your PC.	
Computer knowledge not necessary	Digital cameras do not require computer knowledge. Ease of use is an important part of the package.	
Environmental considerations	No film processing involved so no worry about using and disposing toxic chemicals.	
Time	Images are available immediately. Digital cameras outperform all other image-capture options for fun, convenience and especially immediacy. A digital camera lets you capture what you see.	
Resolution	Resolution or image quality is low when compared to film. Even most megapixel cameras can only produce 4x6-inch images (but a few can produce 8x10-inch images).	
Storage	Digital images must be stored on magnetic or optical media. This adds to the cost of shooting photographs.	
Longevity	Storage media may not be readable in the future as formats and devices change (although files can be converted as technology/file formats change).	
Cost	Digital photography completely eliminates film and processing costs. However, digital cameras can be power hungry devices so you may need to consider battery costs as you use the camera.	
Creative controls	Only higher-end digital cameras include the controls you'll find on the least expensive SLR cameras. Also, digital cameras feature a limited choice of lenses.	

You can also use connect a scanner to your PC (see Chapters 6-9). The following table lists advantages and disadvantages to using a digital camera or a scanner.

	Using a scanner
	Pictures from film cameras have resolutions of many thousands of dots per inch; If your application requires the highest possible image quality, your best bet is to use a film camera and then scan the processed photo.
	You have to buy a new roll of film. You cannot snap and develop only a few pictures on the roll without wasting film and money.
	The price of a decent 35-mm film camera is less than a digital camera yet it includes several features, options and controls not found on the digital camera.
	It can become expensive and time-onsuming to experiment with film and a scanner. Also, it's easy to forget settings and other information when experimenting with film.
	Scanners are by definition a computer peripheral. Therefore, computer knowledge is needed to install cards, software, cables and more.
	Film manufacturing and film processing are chemically intensive and pollute the environment.
	Images are available only after the roll is finished, processed and the image(s) scanned. Scanners require that you already have an existing image to scan. Even film-to-disk services are not truly "immediate" because you have to wait hours or days before you can use an image on your computer.
	Scanners are capable of producing excellent quality. You can make 16x20-inch prints from 35-mm film.
	Photographs can be kept as either positives, negatives or both, and are self-storing. Slides are also self-storing, but should be protected in sheet holders for protection.
	You don't need special equipment to look at photographs -- even slides and negatives can be held up to a light for previewing. Also, slides and negatives can last for many years (even decades) with proper care.
	You must buy film and then pay for it to be processed.
	Even the cheapest 35-mm SLR includes professional level controls. A large choice of lenses is also available for most models.

Downtime

Digital cameras can take as long as 1.5 seconds from the time you press the shutter until they capture the picture. Therefore, your subjects will have to remain motionless a little longer than usual. This is called the *cycle time*.

Also, another four to nine seconds is required for the camera to save the image to its memory. This recycle time depends on how new the batteries are and whether you're using a flash. So, since you cannot take your next image until the previous one is saved, you cannot take sequential action shots, such as those in a sports event.

Printout quality

When you print the image you snapped with your digital camera, you might notice the images typically look coarse and washed-out. The printout may appear this way even on high-end color laser and thermal printers. The printout quality of an image taken with a digital camera is simply no match for the richly saturated, continuous-tone prints that even a $10 disposable 35-mm camera can produce.

Digital cameras are still more expensive than traditional 35-mm cameras

Although this remains true, the gap is narrowing rapidly. The cameras we talk about in Chapter Three are well under $1,000 (and street prices are likely to be well under the manufacturers suggested retail price). Some high-end models are available for over $2,000. Although that's not cheap, it's about half the price comparable cameras were selling for only a short time ago. As the field of companies selling digital cameras grows and competition increases, the prices will continue to drop.

The reason digital cameras are more expensive than traditional cameras is that they're really little computers that can take pictures. They include computer memory, microchips, microprocessors and a CCD image sensor chip often larger and more expensive than those used in a video camcorder. Fortunately, each new product introduction is decreasing in price and helping to drive down the cost of digital camera prices.

Although improving, the image quality cannot match that of photos taken with a film camera

Until the megapixel digital cameras were released, a $10 disposable camera produced better image quality than a digital camera that cost $1,000. Digital cameras simply could not match the resolution or color accuracy of film.

However, that has changed with megapixel cameras and two megapixel cameras. Now most users and experts cannot tell the difference between images snapped with digital camera and pictures originally taken with a 35-mm film camera and scanned with a quality scanner.

It's very likely we won't be mentioning this "disadvantage" in the next printing of *Easy Digital Photography*.

These cameras typically give you very few lens and aperture options

Digital cameras have few lens options or shutter controls. In other words, few entry-level digital cameras allow you to manually set f-stops or shutter speeds to adjust for changing light conditions.

Furthermore, because many digital cameras have fixed focal length lenses, interchangeable lenses aren't available for these cameras. Also, most cameras don't allow for close-up images. Therefore, hardcore photographers may feel limited in what they can do with a digital camera.

You'll need a color output device to get the images from your PC to paper

Unless you're using your images for Web development or transferring them over the Internet or e-mail, the images remain in your hard drive until you print them. Since you won't want to use a monochrome printer, you'll need to buy a color printer. Unfortunately, quality color printers aren't cheap. They range from low-end color inkjet printers for about $300 to dye-sublimation, thermal-wax-transfer and color laser printers for several thousands of dollars.

Viewfinder system

Many digital cameras feature simple optical viewfinders that have no automatic parallax correction. Automatic parallax correction allows you to make adjustments for accurately framing close-up and macro shots. Without this ability, what you see in the viewfinder may not necessarily be what you are capturing in the camera. This is especially true at close range.

If you run out of digital "film," you can be out of luck

Keep in mind that although you don't need film in a digital camera, you cannot snap an unlimited number of pictures. You can receive "memory full" errors after you snap only a few pictures. For example, the Epson Photo PC stores just 16 high-resolution images in its standard configuration. Once you've taken those 16 pictures, you must transfer the images to your PC to clear the memory for more pictures. Sixteen pictures may get you through an afternoon party but it's probably not enough for a two-week vacation.

The number of pictures you can take with a digital camera depends on the amount of memory in the camera and the resolution you use for your pictures. Most cameras give you the option of adding extra memory-at extra cost, of course.

You have to be near a computer with a serial cable to transfer the photos

This is a disadvantage related to the one above. If your digital camera runs out of memory, you must transfer or delete those images before snapping more. So, you must take time to go to your PC and transfer the images.

Advantages of digital cameras

So why use, let alone buy, a digital camera with those disadvantages? Let's talk about the advantages of using digital cameras. Most of these advantages overcome these disadvantages.

No film or processing costs, so you can cut photo costs dramatically

The only real cost associated with digital technology is the initial cost of the camera itself. You don't need to worry about film costs, processing costs, etc. (However, digital cameras do use batteries and this can add to the cost of using a digital camera.)

Speed—all the pictures can be "developed" in seconds or minutes

A digital camera provides a fast way to capture images directly to your PC. Instead of waiting hours or days to have your film processed and printed, simply snap a picture and immediately transfer the image to your laptop or desktop PC. The image can then be quickly and easily sent to your Web home page or to friends through the Internet. Professional photographers, real estate agents, students, insurance agents, graphic artists, teachers and home PC users are using digital cameras to capture images that can be seen immediately on their computers.

Reshoot any image several times for the best shot

You can reshoot almost immediately if you don't like the appearance of an image. Therefore, you can shoot several images of the same subject, select the best and toss the rest.

Use image editing software for endless retouching options (delete, rotate, crop and enhance digital images quickly and easily)

By using a digital camera, you can store and manipulate the image immediately on your computer. This is what gives digital cameras their power. Once the image is in your computer, you have total control over image content and quality.

You can save images in several file formats and insert them into documents creating impressive presentations, reports and art. Inexpensive image editing software lets you cut and paste elements from different photos and manipulate almost every aspect of an image. Remember drawing horns and a beard on your elementary principal's portrait? By using image editing software, the horns and beard can look like they grew naturally from his head as if he was photographed with them already present.

19

Use a modem to send pictures around the globe in minutes

By using a digital camera and a modem, you can send your images anywhere in the world in a matter of minutes. This is an important advantage for photojournalists.

Digital images can last a lifetime

Many of the color or black and white photos you have from the 1940s, 1950s and 1960s may be fading. As long as you have a computer, digital images can last forever and cannot "fade."

Security

A digital camera is perfect when you need to create a photographic database of personnel, parts or property.

Digital cameras are "green"

The environmental benefit is not always clearly associated with digital photography. But film manufacturing and film processing are chemically intensive and still pollute the environment. However, because you don't have to worry about film processing, the environment benefits from reduced use (and disposal) of toxic chemicals.

Manufacturers are agreeing upon some standards

Many of the newer cameras use the same type of removable flash-memory PC card for storing images. This makes it easier and less expensive to add memory (and therefore picture capacity) to your camera.

Fun

Furthermore, a digital camera can be just plain fun if you want to experiment with photography.

Image quality

Beyond the image manipulation power, digital cameras also maintain image quality. In other words, most photographs undergo at least two steps from original to printing: film processing and scanning. However, a digital camera eliminates these two steps. That is at least two generations closer to the original image.

Furthermore, you'll eventually need to scan your film anyway so why not save a step (and a generation) and money?

As the cameras themselves improve, digital cameras will be able to capture a greater tonal range than film.

Computer knowledge not necessary

You don't have to know a lot about computers to use a digital camera. Because the point-and-shoot digital cameras are geared for the average user, ease of use is an important part of the package. The professional digital cameras are aimed at an experienced group of people who already have solid photographic and computer skills and want features that take advantage of the advanced equipment.

Perhaps A Digital And Film Solution

Imagek has been working on what might be called a compromise between film and digital. Although it was still in development at presstime, its potential is impressive. The Imagek cartridge will let you convert your familiar 35-mm SLR and all your lenses to a digital format.

As you can see in the following photo, it fits into a 35-mm camera in place of the film:

21

Use it to shoot and store 30 pictures at a time and at 1.3 megapixel resolution (1280 x 1024 pixels at 24-bit color depth). It's also reusable thousands of times. Use it with your current lenses and attachments. As with any digital camera, you can connect it to your PC to instantly view, store, and edit the images. However, unlike a digital camera, you can rapidly switch between conventional film and digital photography in the same camera because you're using a 35-mm camera.

To load the EFS-1, take it out of the carrier and place it into the camera body like traditional film. The imager extends over the film plane and is self seating. Then close the camera back and you're ready to shoot.

Imagek plans to price the Electronic Film System below $800. Imagek expects initial systems to be available in the June 1999. For more information, check their website (http://www.imagek.com/).

Chapter 2:
Inside A
Digital Camera

Chapter 2

Inside A Digital Camera

How Do These Things Work

CCD (charge-coupled device)
Transferring images from your camera to your PC

CMOS Cameras

D igital cameras have three items in common with traditional cameras. Both have a lens, shutter and diaphragm. However, that's where the similarities end. As you've guessed, digital cameras use a completely different technology to develop pictures. In this chapter we'll take a look at how digital cameras work.

How Do These Things Work

A s their name suggests, digital cameras do not use film but instead use built-in memory chips to store the pictures you snap. Traditional cameras focus their images on film that is coated with light-sensitive silver halide crystals. After you take the film to the lab, it's dipped in chemicals to develop and the image appears on the paper.

However, you do not take the pictures stored in a digital camera to the corner drugstore for processing. Instead, you download (or transfer) the pictures from the camera to your PC.

The Kodak DC240 Zoom Digital camera (www.kodak.com).

CCD (charge-coupled device)

As novel as digital cameras may seem, they use a familiar bit of magic to capture images. Instead of film, digital cameras focus their images on small photosensitive semiconductor chips called *charge-coupled devices*, or simply, CCD. (Scanners, fax machines and camcorders also use CCDs.) The CCD acts as the "film" in a digital camera by turning the image it captures into pixels (picture elements). To "develop" these pictures, you transfer them to your PC. Then you can use image editing software to manipulate (or tweak) the image.

CCDs contain hundreds of thousands (sometimes millions, depending on the camera) of resistors that act as sampling points. The resolution, and therefore image quality, improves as the number of CCD cells increases. In other words, the more CCD cells that a digital camera has, the higher the resolution and, therefore, higher image quality.

When you press the shutter button on a digital camera, light is reflected from your subject to the CCDs. This in turn creates electrical impulses that are translated immediately into the zeros and ones of digital information that your PC understands. The information is then saved to memory. Available light is more important to a digital camera than to a film camera. This is because more electricity is generated as more light hits the CCD cells. When low light or no light is present, very little current is generated (or maybe no current at all). The result is dark or muddy pictures.

A digital camera requires a great deal of light. Otherwise, the pictures can appear dark or muddy if low light or no light is present.

Color is produced as the image passes through red, green and blue filters. The light then falls on the CCD's pixels. These pixels are sensitive to red, blue or green color. Then an analog-to-digital converter (ADC) chip converts the intensity of electrical charges into zeroes and ones. Digital cameras use built-in ADC circuitry to instantly convert the charges when the image is captured. The digital data is then compressed and saved to the camera's memory. The amount of time required for all this depends on the camera, but is typically about five seconds. Some color digital cameras require a much longer time to produce a picture. Additional time is required for the camera to recharge its built-in flash (if it has one). Then you're ready to shoot the next picture.

When your film camera runs out of film, you simply insert a new roll of film and continue shooting. Many digital cameras save the images you take to built-in memory. So, you're much more limited in how many pictures you can take with a digital camera. The maximum varies with the manufacturer. The Chinon camera, for example, can record only five images in high quality mode while the Casio can store 96 images. One option is to use 1 Meg to 16 Meg PC memory cards to increase the number of images. However, this is an expensive option.

Digital Camera Terms To Understand

Megapixel resolution

A megapixel camera can produce an image consisting of at least 1 million pixels (one pixel is a little square that makes up the image).

CMOS digital camera

Some manufacturers are developing the new CMOS (Complementary Metal-oxide Semiconductor) active pixel sensor array for digital cameras.

CMOS cameras require less power are cheaper to manufacture than CCD digital cameras.

Digital film

Digital film is a type of removable memory cards such as the PC Card (PCMCIA) or one of the miniature cards recently released (CompactFlash, MiniatureCard and SmartMedia). By using a camera with removable storage, you can remove one storage device and insert another. The number of images you take is limited only by the number of storage devices you have.

Viewfinder

The viewfinder is what you'll use to preview your image before taking the picture. Digital cameras use two types of viewfinders (some cameras will use both). An *optical viewfinder* requires you to put the camera up to your eye to see what you are shooting. An *LCD panel* displays images on small flat screens usually located on the back of the camera.

Compression

Digital cameras use software (algorithms) to eliminate redundant information and reduce file sizes. Although this shortens the time required to store, transmit and download images, it may affect the quality of the image. The Joint Photographic Experts Group (JPEG) developed the most popular and reliable compression method.

Fixed focus

A lens that has been focused in a fixed position by the manufacturer so you do not have to adjust the focus of this lens. Fixed-focus cameras offer a simple solution for focusing but do not offer the flexibility required in more challenging photographic situations.

Aperture

The aperture of the camera controls how much light is passed on to the film or digital array while the shutter is open. The less the number, the more light. The aperture also controls other optical factors, such as depth of field and sharpness. All these cameras have preprogrammed exposure modes, so direct control of aperture isn't possible.

Digital camera

A camera that directly captures an image without using film. Instead of film, digital cameras use a CCD that converts light into electrical signals. These signals are then converted into binary data. Images are stored temporarily in random access memory (RAM), in-camera storage media or saved directly to a computer.

LCD (Liquid Crystal Display) panel

Many cameras use a small color LCD (liquid-crystal display) panel instead of an optical viewfinder (some cameras have both). The important advantage for cameras with a preview feature is that they're great for close-up photography or other work requiring precise framing. Another important advantage of a preview screen is that it can display captured images, allowing you to scroll through all the shots stored in the camera. The ability to preview your photos gives you a chance to reshoot a picture if necessary.

CCD (Charge-coupled device)

Instead of film, digital cameras focus their images on small photosensitive semiconductor chips called *charge-coupled devices*, or simply, CCD. The CCD acts as the "film" in a digital camera by turning the image it captures into pixels (picture elements). CCDs contain hundreds of thousands (sometimes millions, depending on the camera) of resistors that act as sampling points. The resolution, and therefore image quality, improves as the number of CCD cells increases. In other words, the more CCD cells, the higher the resolution and, therefore, image quality.

Transferring images from your camera to your PC

When you've reached the maximum number of images (or whenever you're ready to view the images), you must transfer the images to your PC. This is also called *offloading* or *downloading*.

Digital images are transferred from the camera to your PC through a serial cable and special software provided by the manufacturer. The time required to transfer images depends on your camera, the transfer rate of your PC through the serial port (bps) and the file format that is used. Sending a 24-bit color image through a serial connection can be slow (typically between 10 and 90 seconds per image).

An example of transferring (also called downloading and offloading) images from a digital camera to a PC.

Once in your computer, use the image editors from Chapter 10 to retouch, crop, edit and store the images. Many digital camera manufacturers include image editing applications called *applets*. These applets let you do some minor editing or enhancing to the images (for example, cropping, rotating and tweaking).

CMOS Cameras

Although CCD is a proven and reliable technology, it also requires a great deal of power. That's not a problem if you're connected directly to a DC power source (such as CCD-based scanners that are connected to a wall outlet). However, your digital camera is not likely to be connected to a wall outlet.

Therefore, a few manufacturers are developing a new system called the Complementary Metal-oxide Semiconductor (CMOS) active pixel sensor array for digital cameras. This is the same CMOS technology used by your PC.

*Vivitar Corp.'s ViviCam 3000 is an early
example of a digital camera based on the CMOS technology.*

The advantages of using image sensors based on CMOS chips is that they draw less power than CCDs and they're cheaper to manufacture. Also, CMOS chips can be assigned tasks other than image sampling. It's possible, for instance, for CMOS chips to handle white balancing and analog-to-digital conversion—chores CCD-equipped cameras relegate to other circuits and memory buffers.

CMOS technology promises not only to cut the cost of buying digital cameras but also in using digital cameras. The extra savings comes from saving on battery replacements.

The disadvantage of CMOS-based cameras is that they do not produce better quality images compared to CCD-equipped cameras. Some are inferior in quality and others suffer from the same image problems CCD cameras do (including poor color balancing and the poor performance in low-light conditions).

Don't worry right now whether a camera uses CMOS or CCD technology. However, it is a promising technology and a trend worth watching.

Chapter 3:
Selecting A
Digital Camera

Chapter 3

Selecting A Digital Camera

Viewfinder

LCD (liquid-crystal display) panel
Optical viewfinder

Flash

Built-in flash
Red-eye reduction

Resolution

Megapixel resolution

Image Capacity

Digital film

Lens/exposure Options

Focal length
Zoom lenses
Macro mode
Aperture and f/stop
Other lens characteristics

The growing interest in and popularity of digital cameras is easy to understand. If you're considering becoming a digital photographer, however, you should consider many things. First is selecting the right camera. Although selecting the right digital camera is very easy, you'll still need to make important decisions before you buy. Price is certainly an important consideration, but it alone should not determine which camera you select.

One item that digital cameras and film cameras share is the same terminology. This is good because before you can make an intelligent decision about selecting, buying and especially using a digital camera, you should understand the parts of the camera.

ISO Equivalent

A traditional 35-mm camera follows the International Standards Organization (ISO) to determine film speed. So, the higher the ISO number, the less light needed for the picture. Because digital cameras obviously don't use film, the industry uses an equivalency rating. This rating specifies the digital camera's sensitivity to lighting. For example, ISO 100 could be used for sunny outside shots and ISO 800 could take candlelight stills with no flash

If you're familiar with using a 35-mm camera, you'll understand the terminology used in the "digital world." Although a few terms such as bit-depth, resolution and compression are specific to digital cameras, other terms like f/stop, aperture and macro lens, are used in both camera worlds. However, since some of these terms may be new, we'll explain them here.

Check The FEATURES_CAMERAS.PDF File

For a summary of features from several digital cameras, see the FEATURES_CAMERAS.PDF file on the companion CD-ROM. See Chapter 15 for more information on using the companion CD-ROM and other files.

Features require two chapters

Since a digital camera has so many features we've devoted two chapters to features you should look for in a digital camera. This chapter focuses on the main features or the most important. Chapter 4 talks about other features that are nice to consider but may not be critical "make or break" features.

Viewfinder

The viewfinder is what you'll use to preview your image before taking the picture. We'll talk about the two types of viewfinders used by digital cameras in this section. An *optical viewfinder* requires you to put the camera up to your eye to see what you are shooting. If you're familiar with the viewfinder on a conventional film camera, you'll be comfortable with its digital counterpart. The second type of viewfinder is called an *LCD panel*. These viewfinders display images on small flat screens usually located on the back of the camera. LCD panels can also display important information such as camera functions, commands, battery life and more.

Viewfinders	
Options	Comments
LCD panel (Liquid Control Display)	Great for closeup photography or other photographs requiring precise framing. Also LCD, panels provide a great way to review images. However, LCD panels drain battery power very quickly.
Optical	Makes framing pictures easier-especially when following "fast" action. Also optical viewfinders do not require battery power. Ideally, the viewfinder should be coupled with a zoom lens (if the camera includes a zoom lens).

The type of viewfinder and lens to look for on a digital camera can depend on whether you're:

1. Planning to shoot stills such as buildings or landscapes

or

2. Action shots such as your children's sporting events

We'll talk about viewfinders in this section and lenses starting on page 54.

LCD (liquid-crystal display) panel

Many cameras use a small color LCD (liquid-crystal display) panel instead of an optical viewfinder (and some cameras have both). Although Casio was the first manufacturer to include an LCD panel, other manufacturers now also feature LCD panels. These manufacturers include Agfa, Olympus, Ricoh, Epson and others.

The size of the preview screen is measured diagonally and specified in inches. Typical sizes are from 1.8-inches (such as Agfa e780 and Kodak DC210 Plus) to 2-inches (such as the Agfa e1680 and Kodak D260). However, a few cameras such as the Casio QV-7000SX use a larger LCD panel at 2.5-inches.

Quick Tips For Selecting A Digital Camera

Advanced features

Decide whether you want good picture quality or advanced features like a zoom lens before buying - some digital cameras will not provide both. Don't be swayed by features that you may never use.

Resolution

Where and how you'll use the images you snap will determine what resolution you'll need in a digital camera. Resolution for a digital camera refers to the number of pixels that make up an image that it captures. Resolution is directly related to image quality so the more pixels in a captured image, the higher the quality of the captured image.

Storage (image capacity)

Find out how many images the camera stores. Most digital cameras use some form of removable storage (the others rely only on built-in memory).

Removable storage includes PC Cards or a miniature card (CompactFlash, MiniatureCard or SmartMedia). A few cameras store images on small hard disks or even standard 3.5-inch floppy diskettes.

By using a camera with removable storage, you can remove one storage device and insert another. The number of images you take is limited only by the number of storage devices you have.

Flash

The camera you're selecting should have a built-in flash. This is especially important if you're snapping most of your photos indoors. The location of the flash can be important and might depend on what type of images you plan to snap. Some cameras feature a raised flash that is aimed in alignment with the lens. Other cameras may have the flash mounted to the side of the lens. This can result in off-center lighting (or shadows), especially when shooting close-ups.

Other points

Make certain the camera has a reliable and user-friendly connection to your computer and that its software is easy to install and use.

Determine how many shots the camera can take before you'll need to replace or recharge the batteries.

Hold the camera before you buy it and make certain it feels comfortable.

Also, many but not all cameras can use rechargeable batteries.

Viewfinder: LCD panel or optical viewfinder

The viewfinder is what you'll use to preview your images before taking the picture. Many cameras use a small color LCD (liquid-crystal display) panel instead of an optical viewfinder (and some cameras have both).

LCD panels are great for close-up photography or other work requiring precise framing. They can also display captured images so you can scroll through all the shots stored in the camera.

However, an LCD panel drains battery life quickly. Therefore, we recommend considering a camera that also includes an optical viewfinder.

Lens

Digital cameras can include and use many types of lenses (depending on the camera). A fixed-focus lens is the most common type of lens.

A zoom lens provides the most versatility; use it to take photos ranging from wide-angle pans to telephoto shots. Some digital cameras can use an autofocus lens that let you snap pictures from about 20 inches to 20 yards from the subject.

An autofocus lens normally delivers better shots than a fixed-focus lens. A macro lens is usually an add-on lens that lets you get close-up shots—as within a few inches up to two feet.

*Casio digital cameras use a small active matrix LCD
panel instead of an optical viewfinder (www.casio.com).*

The important advantage for cameras with a preview feature is that they're great for close-up photography or other work requiring precise framing. Another important advantage of a preview screen is that it can display captured images, allowing you to scroll through all the shots stored in the camera. The ability to preview your photos gives you a chance to reshoot a picture if necessary. You can delete shots you don't need and make room for new pictures. Without a display screen you must transfer all the images to your PC to see the images.

Optical viewfinder

Although an LCD panel has several advantages, it does have a few disadvantages. Its main disadvantage is that it drains battery life quickly. Another disadvantage is that although the LCD panel provides precise framing, the LCD image is slightly slower (about two-thirds of a second) than the "action." This makes shots of rapidly moving subjects very difficult. So, don't plan on taking too many pictures of your daughter's record setting 100-meter dash. Another problem is that the live previewing is usually at a very low resolution.

Therefore, we recommend considering a camera that also includes an optical viewfinder. An optical viewfinder doesn't use battery power so you can preserve the batteries for the flash or when you need to use the LCD panel. An optical viewfinder makes it easier for you to frame images – especially when following fast action. Many digital cameras feature both an LCD panel and optical viewfinder. These include cameras from Agfa, Kodak, Fujifilm, Nikon, Olympus and others.

The Agfa e780 (www.agfahome.com) is an example
of a camera with both an LCD panel and optical viewfinder.

If you select a camera with an LCD panel, keep the LCD turned off and use the optical viewfinder for taking pictures when possible. Use the LCD only when you're certain you won't run out of battery power. Also, some users may not like using the LCD panel because they have to usually hold these cameras at "arms length" when shooting. (For best results, keep your elbows tight against your body to reduce camera movement.)

You also have to be careful because LCD displays can "disappear" in direct sunlight. (Although you can control the brightness of the LCD screen on most digital cameras.)

Real-image viewfinder and diopter adjustment

One type of optical viewfinder, called a *real-image viewfinder*, is connected to the zoom lens. It shows the full area covered by the image sensor. Also, the optical viewfinders on some cameras use a *diopter adjustment* to bring the image into clear focus. You may want to consider this feature if you wear glasses because these cameras can adjust this setting so you won't need to wear glasses while snapping the image.

Our recommendation is to try the different viewfinders and see what works best for you. Again, we recommend going with a camera that features both an optical viewfinder and an LCD panel.

Flash

Another item to consider when selecting a digital camera is whether you'll be shooting most of your photos indoors. If so, you'll need to make certain the camera has a flash and then consider the quality of the flash.

Flash	
Options	Comments
Fixed on-camera	Has a tendency to give hard lighting and red eye.
Rotatable on-camera	Allows you to bounce light off walls, ceilings or other surfaces for softer lighting effects.
Sync cord connection	Allows you to remove the flash from the camera and move it to different locations for different lighting effects.
Hot shoe	Mounts a flash on the camera and makes electrical connections to metering system.
Red eye reduction	A preflash forces the iris to close slightly before the main flash is fired and the exposure taken.
Off mode	Let's you turn the flash off so it won't fire when you don't want it to (saves battery power).

Built-in flash

You'll soon discover that digital cameras without flash usually deliver dark, muddy pictures indoors. This is why most digital cameras include a built-in flash for extra light. The built-in flash lets you snap photos in low light conditions such as when available light is dim or nonexistent. A built-in flash also lets you fill in dark shadows on sunny days. A good flash should be about as bright as daylight.

The flash unit on the Casio
QV-7000SX digital camera (www.casio.com).

However, the flash on digital cameras is not designed to produce or replace quality lighting. We mentioned in Chapter 1 that digital cameras depend on good lighting more than a 35-mm camera does. In addition, the built-in flash on many digital cameras doesn't have much range and isn't adjustable. Therefore, you probably won't be able to bounce flash to soften shadows or position the flash away from the camera to eliminate red-eye (see below).

Many studio photographs are taken by flash, but usually with one flash unit connected to the camera triggering multiple slave flash heads. Although this is a complex technique, it will work with the digital cameras we talk about in this book.

The power of a flash is usually specified by a guide number (sometimes indicated by "GN"). A higher guide number indicates a greater useful range for the flash. It's easy to determine the maximum range. Simply divide the guide number by the maximum aperture of the camera (we'll talk more about aperture below).

Our recommendation is to make certain that the digital camera you're interested in buying has a built-in flash. If it doesn't have a built-in flash, either spend the extra money for an optional flash or search for a camera with a flash.

Flash location is important

The location of the flash can be important and might depend on what type of images you plan to snap. For example, the Olympus D-500L features a raised flash that's aimed in alignment with the lens. Other cameras may have the flash flush-mounted to the side of the lens. This can result in off-center lighting (or shadows), especially when shooting close-ups.

The location of the flash is different even on cameras
from the same manufacturer (Kodak in this example, www.kodak.com).

Red-eye reduction

An often-overlooked feature is red-eye reduction. (Red-eye is caused when light enters the eye and bounces back to the camera from the blood vessels in the retina.) Many digital cameras have built-in red-eye reduction that eliminates, or at least reduces, the glowing red pupils from the people in your pictures. These cameras use a preflash that forces the iris to close slightly before the main flash is fired and the exposure taken.

To reduce the effect of red eye, move in for a close-up picture, use a wide-angle lens setting or have the subject look away from the camera. You may need to use an image editor (see Chapters 10-14) to reduce the effect of red eye.

Resolution

Where and how you'll use the images you snap will determine what resolution you'll need in a digital camera. For example, will you print the photos or use them in documents. You might want to e-mail the images to family members thousands of miles away.

What is resolution

Digital cameras have several resolutions and you'll need to understand what the numbers mean. Resolution for a digital camera refers to the number of pixels that make up an image that it captures. Resolution is directly related to image quality so the more pixels in an captured image, the higher the quality of the captured image.

Resolution Options	Comments
Megapixel (XPA)	Captures more detail and a fuller tonal range than other consumer digital cameras. These cameras capture at least 1,000,000 pixels or at least 2,000,000 for 2 megapixel cameras.
SVGA	Captures images at a resolution of 800x600 pixels (total 480,000 pixels)
VGA	Captures images at a resolution of 640x480 pixels (total 307,200 pixels)

Megapixel resolution

You'll see *megapixel resolution* mentioned often with digital cameras. A megapixel (XGA) camera captures more detail and a fuller tonal range than any digital camera not only in the more typical 640x480 (VGA) camera but also any 800x600 (SVGA) camera. A megapixel camera can produce an image consisting of at least 1 million pixels (one pixel is a little square that makes up the image). Many digital cameras, such as the Olympus D-600L, can capture images at a resolution of 1280x1024 pixels. This is slightly over 1,300,000 pixels (to find out the total pixels, multiply width by height).

Note On The Meaning Of "Mega"

Contrary to what you might think, the word "mega" does not mean "million." It's taken from the Greek word meaning "great" but has come to mean "one million."

However, be careful with this term when selecting a digital camera because it has at least two definitions. The more technical and accurate definition of megapixel is one million pixels (or picture elements) per image. The industry has also defined megapixel as any image you can snap that has one dimension (height or width) having at least 1,000 pixels. So, according to this definition, a camera that snaps an image at a resolution of 1,024x768 pixels (totaling only 786,432 pixels) can still be considered a megapixel camera.

Other resolutions that most digital cameras can typically capture is 640 x 480 or even lower (320 x 240). A lower resolution normally lets you increase the number of shots a camera can hold in the same amount of memory, but at a lower image quality.

Difference in resolutions of 640 x 480 (top) and a megapixel camera (bottom).

We mentioned that how you plan to use a digital camera can determine the resolution you should look for in the camera. For example, cameras with lower resolutions such as 640 x 480 are perfect for images you plan to put on the Internet or use as e-mail attachments. If this is how you're planning to use a digital camera, then higher resolutions only increase the file size of the image without significantly improving its quality.

If you're printing or publishing the images or need photorealistic enlargements larger than 5x7-inches then look for a camera with higher resolutions, especially the megapixel cameras.

47

Another reason to go with a camera featuring higher resolution is that although you can store more lower resolution images, "tweaking" these images using an image editor requires more work. It's much easier to work with a high-resolution image in an image editor (see Chapters 10-14). Then you can zoom in to work on fine details of the image without losing visual details in a multitude of pixels.

Use the image editor, if necessary, to resample a large image down to a smaller size for smaller storage or to use on the web. Keep in mind, however, that going the other way is difficult — when not impossible.

The DC265 from Kodak is an example of a megapixel camera (www.kodak.com).

Although you'll still find many cameras available that have a maximum resolution of 640x480, we recommend that you seriously consider a camera with a higher resolution. You'll find the improved quality of the images to be worth the extra cost (and even that may not be much).

Best resolutions of popular digital cameras			
Camera/Model	Resolution	Camera/Model	Resolution
Agfa ePhoto 780	640x480	Leica digilux	1280x1024
Agfa ePhoto 1680	1600x1200	Nikon Coolpix 900s	1280x960
Casio QV-7000SX	1280x960	Olympus D-400 Zoom	1280x960
Kodak DC210 Plus	1152x964	Olympus D-620L	1280x1024
Kodak DC260	1536x1024	Ricoh RDC-4200	1280x960
Epson PhotoPC	1280x960	Sanyo VPC-X300	1024x768
Fujifilm MX-500	1280x1024	Sony MVC-FD71	640x480
HP PhotoSmart C30	1152x872	Sony MVC-FD81	1024x768
Konica Q-M100V	1152x872	Toshiba PDR-M1	1280x1024

Image Capacity

As with a hard drive, having more memory available for a digital camera means you have more room to store images. The number of images that you can store in a camera depends on many factors. The reason image capacity is so important is that when you've reached the maximum number of images the camera can handle, you must make room for new ones. You only have two ways to do this: either stop snapping pictures or delete some of the ones you've already taken. Some inexpensive cameras or early digital cameras, such as the Kodak DC20, used a set amount of memory for storing images (for example, 96 total images). Most digital cameras today let you use a removable storage card (called *digital film*) and increase the image capacity of your camera.

Digital film types	
Options	Comments
Type(s)	1. CompactFlash is the most popular.
	2. Miniature card (also called the Intel mini-card)
	3. SmartMedia (also called SSFDC or Solid State Floppy Disk Card)
Capacity	Memory cards have many advantages but price can be steep for many users. A typical 2MB card can hold up to 36 pictures.

You'll see one phrase in this book often: *how you plan to use the camera greatly determines the features you should look for.* This is true for storing images. Look for a camera that can handle the number of images you expect to snap between transfers to your PC. If you won't be far from your PC when you've snapped the last picture, a camera that can store at least 16 pictures in high-quality mode will do the job nicely. If distance, time, location, etc., will cause delays in transferring the images to your PC, consider a camera with lots of storage space or that uses digital film.

Perhaps use your experiences as a guide. For example, if you shoot three or four rolls of 24-exposure film when you're on vacation, your digital camera should store a similar number of images.

Digital film

One way digital cameras have become more user-friendly is by using digital film (or what we used to call removable storage). Most digital cameras use some form of digital film (the others rely only on built-in memory).

Digital film is a type of removable memory card such as the standard PC Card (PCMCIA) format that is widely used with notebook computers or one of the miniature cards recently released (CompactFlash, MiniatureCard and SmartMedia – see below). Some cameras store images on little hard disks or, as with the Sony Mavica, save their images to standard 3.5-inch floppy diskettes. By using a camera with digital film, you can remove one card and insert another. The number of images you take is limited only by the number of cards you have.

The number of images that can be stored on digital cameras with built-in fixed storage cannot be increased. These are typically older or very inexpensive cameras. This obviously reduces the number of photos you can take before you must delete them to make room for new ones.

Digital film is a great improvement over earlier digital cameras where you had to attach the camera physically to the serial port of your PC and download photos. This was not only slow and cumbersome, but you always had to pray the camera was recognized by the software (which didn't always happen).

A memory card can be considered similar to a roll of film; when it's full, simply take it out of the camera and replace it with another card. They are different from film of course because you can reuse them. Furthermore, swapping the cards is faster than rewinding and reloading a roll of film in a film camera. A typical 2MB memory card holds 36 medium-quality images. The miniature cards slip into adapters that you can insert into any PC Card (PCMCIA) slot.

Although memory cards have many advantages, their price is a disadvantage for many users. Fortunately, their price (currently about $25 to $50 per megabyte) has fallen significantly recently and are likely to continue falling.

Another disadvantage is that it's irrelevant which card you like. If your camera uses a removable storage card, it will take only one format. Therefore, make certain extra cards are easily available and you're comfortable with its price. On the upside, prices are likely to decline sharply because most digital cameras will be using digital film within a year.

Internal PC Card Drive

If your digital studio includes a desktop PC and your camera uses a PC card, consider an internal PC Card drive. These drives, such as the SwapBox Classic from SCM Microsystems (www.scmmicro.com), install into an available 3.5-inch bay. Also, external PC Card readers are available, for example the Camera Connect from Actiontec (www.actiontec.com), that connect to the parallel port.

CompactFlash, MiniatureCard And SmartMedia

CompactFlash

CompactFlash was developed by SanDisk Corporation. It uses the ATA architecture that emulates a hard drive. The cards measure 1.433-inches wide by 1.685-inches (42.8 mm) long. The format is supported by several companies who have formed the Compact Flash Association. CompactFlash is the most widely used form of in-camera storage. Cameras from Casio, Kodak Nikon, Epson and others use the CompactFlash format.

MiniatureCard

The miniature cards slip into adapters that you can insert into any PC Card (PCMCIA) slot. This can be an ideal for sending images to a laptop.

SmartMedia

SmartMedia is shaped like a floppy disk but much smaller (about half the size of a credit card). It's also based on an ATA architecture. Simplicity is the big advantage that SmartMedia enjoys. To help keep manufacturing costs down, the SmartMedia has no controllers or supporting circuitry.

However, it does have one disadvantage. Since the SmartMedia has no controllers or supporting ciruitry, these functions must be in the camera. Although this isn't a technical problem, it can present compatibility problems with newer or older versions of the cards. For example, many of the first cameras using SmartMedia had to be returned to the manufacturers for upgrades when the next generation of higher-capacity cards was released. The SmartMedia format is supported by several companies who have formed the Solid State Floppy Disk Card Forum. Cameras from Agfa, Fujifilm, Leica, Ricoh, Sanyo and Olympus use SmartMedia.

52

Connecting to your PC

To get the pictures into your computer, you simply transfer the images from the camera to your PC. This process is called *downloading* or *transferring*.

Several methods of downloading images are possible. Most digital cameras include two cables (one for a PC and one for a Mac) to move the images to your computer. These cables are either serial (slower) or parallel (faster). The cameras also include the software for controlling the downloading process. Once the cable is connected, transferring the images to your PC is as easy as clicking on a button. This command automatically sends and saves the images to your hard drive.

The fastest cable method is to use an USB or firewire (IEEE 1394) cable between the computer and the camera. Fortunately, you may not have to use the slow serial port. For example, the Kodak DC260 uses a much easier and faster USB connection instead of the slow serial port. Although at presstime, few cameras used this type of connection, most cameras are likely to be offering USB ports very soon.

Despite the advances in the removable media, you may still need to connect (or tether) the camera to your PC. Examples include when you're updating the camera's ROM, shooting by remote control from a stationary position or changing some of the camera's parameters.

Soon after you've snapped a picture with your digital camera, you can use the image in any paint, word processor, desktop publishing or image editor program (see Chapter 10 for more information). The images you download from a digital camera are stored on your hard drive like any other graphics file.

53

Image capacity of popular digital cameras (Standard/Best)			
Camera/model	Capacity	Camera/model	Capacity
Agfa ePhoto 780	96/12	Leica digilux	44/11
Agfa ePhoto 1680	48/6	Nikon Coolpix 900s	24/6
Casio QV-7000SX	55/14	Olympus D-400 Zoom	120/18
Kodak DC210 Plus	120/26	Olympus D-620L	100/8
Kodak DC260	90/16	Ricoh RDC-4200	70/6
Epson PhotoPC	50/7	Ricoh RDC-4300	70/6
Fujifilm MX-500	22/5	Sanyo VPC-X300	60/12
Fujifilm MX-700	44/11	Sony MVC-FD71	40/17
HP PhotoSmart C30	40/8	Sony MVC-FD81	40/6
Konica Q-M100V	50/10	Toshiba PDR-M1	22/5

Lens/exposure Options

The job of the camera lens is to focus the scene sharply onto the surface of the image sensor. The better the lens can do this, the better the picture will be. Therefore, the lens on a digital camera, like the lens on a 35-mm camera, is an important consideration when buying a camera. The focal length and type of lens (for example, zoom or macro) will depend on whether you're shooting wide angle scenes such as landscapes or close-ups such as stamps and coins.

Glass Or Plastic Lens

Make certain to find out whether the camera uses a glass or plastic lens. Glass lenses are generally sharper and more damage resistant than plastic lenses. However, not all glass lenses are created equally. If possible, stay away from a lens that is made by an unfamiliar manufacturer. Lenses made by familiar companies such as Nikon and Canon are considered the best.

Digital cameras can include and use many types of lenses (depending on the camera). A fixed-focus lens is the most common type of lens. To stay in focus with this type of lens, you must be between two to four feet from the subject. A zoom lens provides the most versatility; use it to take photos ranging from wide-angle pans to telephoto shots. Some digital cameras can use an autofocus lens that let you snap pictures from about 20 inches to 20 yards from the subject. An autofocus lens normally delivers better shots than a fixed-focus lens. A macro lens is usually an add-on lens that lets you get close-up shots-really close-up shots, as within a few inches up to two feet.

We'll talk more about these lenses in this section.

Lenses	
Options	Comments
Focal length	Determines the angle of view. Focal length is usually listed in three ways: wide angle, normal and telephoto)
Maximum aperture	The aperature is the small round hole in front of the camera lens. It controls the amount of light entering the camera. Larger apertures (for example, f/1.8) are better in low light or when capturing fast action. Smaller aperatures (for example, f/3.2) are used in conditions where more light is available.
Zoom and range	Optical zooms are usually recommended over digital zooms.
Interchangeable	Interchangeable lens let you change focal lengths.

Focal length

An important characteristic of any lens is its angle of view (called *focal length*). Here again, your choice of lens depends in part on what you plan to do with the camera.

Focal length is usually listed in one of three ways:

Wide angle (35-mm or less)

These lenses are best for photographing buildings, landscapes, and interiors. Shorter focal lengths create images with a greater angle of view and are called "short" or wide-angle.

Normal (about 50-mm)

Normal lenses are a compromise between wide angle and telephoto. The lens is considered "normal" when its focal length is close to the diagonal measurement of the film format. It's close to the magnification of the human eye.

Telephoto (90-mm and more)

Telephoto lenses are best for portraits. Longer focal lengths have greater magnification and are often called "long" or telephoto (although telephoto actually refers to a specific optical design).

Equivalent 35-mm lens

While shopping for a digital camera, you'll often see references (including in this book) to lens focal lengths such as:

```
7-mm equivalent to a 50-mm lens
```

Manufacturers, reviewers and resellers use "equivalent to a 50-mm lens" because we're more familiar with 35-mm cameras – digital cameras are still new to us. In this example, the 7-mm number refers to the focal length of the lens in the digital camera. It's so short because most image sensors are small (about 1/3 of an inch). The 50-mm lens refers to a telephoto on a sensor that small.

Zoom lenses

If you want the most flexibility in subject matter and the best quality across a variety of shooting conditions, consider a zoom lens (if the camera can handle it). The advantage of using a zoom lens is that you can change the focal length of the lens any time.

The focal length of a zoom lens is usually specified as degrees of magnification. You'll see numbers such as 2x or 3x for a focal length. A 3x zoom lens enlarges (or reduces) the subject in an image by three times depending on which way it's zoomed over its full range. You'll also see the equivalent range of the zoom lens when it's used on a 35-mm camera (for example, 38-mm ~ 114-mm).

Most digital cameras will have an electronic zoom so the camera's operating system magnifies a portion of the image. However, fewer cameras include true optical zooms like those found on traditional cameras. You'll get better results and images using a camera with an optical zoom instead of an electronic zoom. Let's look at the two types of zoom lenses available for digital cameras.

57

Optical and digital zoom

Optical zoom on a digital camera is similar to what you'll find on a typical 35-mm camera. The digital camera has a button that you push to zoom in or out. In this case, physical lens elements move inside the camera.

Digital zoom, on the other hand, has no moving parts. Instead it uses the "intelligence" within the camera itself. In this case, the camera looks at the scene and digitally zooms in (usually two or three times closer).

A digital zoom lens takes a part of the normal image falling on the sensor and then either saves this part unchanged or enlarges it. However, the quality of your image suffers when you do this. Because the image doesn't have as many unique pixels as one taken with an optical zoom, your images will tend to be more *pixilated* than the same image taken with an optical zoom camera.

Our recommendation is to avoid cameras with only digital zoom. It sounds fancy but you probably won't need this feature anyway. You can get the same effect by using an image editor to crop a normal image.

Is A Zoom Lens Necessary

A zoom lens isn't absolutely a necessity but is a nice feature. If your camera doesn't have zoom capabilities, try taking a few steps back or moving in closer to your subject.

Macro mode

If you plan to take close-ups (about one foot or closer) of a subject or other item, consider a camera with a macro lens. These lenses work like a normal lens until you want to take an extreme close up of your subject. Then you simply switch to macro mode. Although macro mode lets you get close enough to take close-up images of small objects, you will lose depth of field.

Aperture and f/stop

The aperture is the small round hole in front of the camera lens. Its primary function is to control the amount of light that enters the camera. Most film cameras and many digital cameras use an aperture that is variable. The degree of variation is expressed by the *f/stop* (F).

Although f/stop sounds complicated, it's a simple fraction because the f-stop is inversely related to the size of the lens opening. Therefore, the larger the f-stop, the smaller the opening.

❖ The "f" represents "focal" length of the lens

❖ The "/" means divided by

❖ The number represents the stop currently used

For example, if you were using a camera with a 50-mm lens set at f/1.4, the diameter of the lens would be 35.7-mm. In this example, "50" represents the focal length of the lens, divided by 1.4 (the stop) to get the answer of 35.7 for the diameter of the aperture.

Again, a lower f/stop indicates a larger aperture. Larger apertures (such as f/1.8) let more light enter the camera compared to smaller apertures (such as f/3.2). Therefore, use a larger aperture when you want to snap images in less light or freeze faster actions.

Digital cameras will normally have either fixed apertures that do not allow you to make adjustments or aperture ranges that allow you to make adjustments.

Other lens characteristics

Besides those already discussed, others features can affect the quality of the images you snap

Focus

Digital cameras have two types of focusing called *fixed focus* and *autofocus*. Since fixed focus lenses are set by the manufacturer, you cannot make any adjustments. These are normally found on less expensive cameras. However, some digital cameras use multiple fixed focus settings that you may select. More expensive cameras let you set the focus manually or use autofocus to actually make all the adjustments necessary to produce the sharpest image for you. By using one of these cameras, all you need to do is point and let the camera do the work.

Interchangeable lenses and lens accessories

Fixed focal length lenses give you only one angle-of-view. The most expensive cameras allow you to use interchangeable lenses, but most don't. However, some cameras have threads to attach telephoto or wide-angle adapters. A wide-angle attachment can shorten the focal length by 30 to 40 percent. The resulting wider view is especially important if you cannot move back from the subject. The threads also accept close-up lenses. However, you'll find it's very difficult to frame and focus a close-up picture using a digital camera unless it has a live preview feature.

You can also attach filters and other lens accessories. Although it seems odd, some cameras make it difficult to attach these add-ons.

Detachable and rotatable lens

Unlike the lens on a traditional 35-mm camera, the lens on a digital camera doesn't have to be in a fixed location. Two examples of this type of lens are detachable and rotatable.

Detachable lenses

As its name suggests, you can remove (detach) these lenses from the camera. A cable or cord connects the lens to the camera. This lets you position the lens in places where the entire camera cannot fit or go. For example, you can position the lens above a crowd, around corners or through a peephole in a wall. An example of a camera with a detachable lens is the Dimage V from Minolta. You can remove the lens from its mount and use a 40-inch cord to attach the lens to the camera.

One note concerning detachable lenses. Check the location of the built-in flash if this type of lens and camera interests you. The flash on the Dimage V, for example, is not part of the lens but built into the body of the camera. This is fine under normal use but can create a potential lighting problem when you detach the lens.

Rotatable lenses (sometimes called swivel)

These lenses connect the lens to the camera body with a rotating joint so you can hold the camera at any angle while still seeing the preview screen. When rotated a full 180-degrees, you can take a self portrait while composing the image on the preview screen.

Both designs allow you to position the camera so you can read the LCD screen in bright light while still pointing the lens where you want it. One useful application of this would be holding the camera or lens over the heads of a crowd while still previewing the image on LCD display.

Chapter 4:
Other Features
To Consider

Chapter 4

Other Features
To Consider

Delays after snapping the picture
Burst-mode settings
24-bit color and image quality
Output directly to a printer
Compatibility
Deleting images: the "oops" factor
Warranty and support
Ergonomics
Video and audio capabilities
Power source and batteries
Bundled software
Compression
Shutter speeds
Operating system
Self-timer, tripod socket and separate flash
Automatic exposure
Focus and exposure lock
A few last suggestions

W e've talked about the most important features you should look for in a digital camera (viewfinder, flash, resolution and others) in Chapter 3. In this chapter we'll mention other features that you may want to consider in a digital camera.

Delays after snapping the picture

Although digital and film cameras share many characteristics, shooting with a digital camera isn't always like shooting with a film camera. For example, most digital cameras have two small but noticeable delays that can affect how you snap pictures – especially fast action pictures. One is called the *refresh rate* and refers to the time between pressing the shutter and when the camera captures the image.

The refresh rate is typically up to two seconds long (depending on the camera—some cameras such as from Casio and Ricoh have very little delay). It takes many new digital camera enthusiasts time to adjust to this problem — especially those coming from the film world. It also makes some digital cameras incapable of taking action shots or working with uncooperative pets or children.

The reason for a refresh rate on most digital cameras are the steps involved in capturing the image. The camera first clears the CCD after you press the shutter release. It then sets the correct color and the exposure. Then, if you're using autofocus, it must focus the image. Finally it must determine if a flash is required and fires the flash if necessary. Then the image is captured. Keep the refresh rate in mind when snapping your pictures, especially if you're snapping several consecutive shots. This is particularly true if you're experienced with fast 35-mm film cameras.

Also, most digital cameras require time (called the *recycle time*) for postcapture processing. During the recycle time, the camera must convert the data from analog to digital, sharpen and compress the image and then save the image as a file. This recycle time can last as long as thirty seconds (especially longer on lower cost cameras or when battery power is low). You cannot take another picture during the recycle time of the camera.

Burst-mode settings

The refresh rate and recycle time not only affect how quickly you can snap a photo but they also affect how quickly you can snap a series of photos. This is called the *frame rate* and if it's too long, you may lose the chance to snap a picture. As with the refresh rate and recycle time, many new digital photo enthusiasts have a hard time adjusting to the frame rate delay. Furthermore, makes some slower cameras a poor choice for quick-action shots and candid shots.

To overcome this problem, some cameras (such as those from Kodak and Nikon) feature a *burst-mode* setting that lets you snap one photo after another until you release the shutter button. However, to increase the frame rate, they often reduce the resolution used to capture the images.

A few cameras divide the surface of the image sensor into sections and store images in each section before processing them all at once. A better method of reducing the recycle time is to temporarily store a series of images in the camera's RAM until they can be processed.

24-bit color and image quality

The number of colors the camera can capture is important. Do not consider any digital camera that captures less than 24-bit color (also called "true color" or "16.7 million colors"). The term 24-bit color refers to the number of bits per pixel of information. The digital cameras that we talk about are all 24-bit cameras-don't consider anything less.

Output directly to a printer

Many digital cameras now let you output images directly to your printer and avoid using your PC completely. Although this feature, called *direct-to-printer*, can be useful and save time, the problem is that each camera currently must use a dedicated printer from its own manufacturer. In other words, Olympus cameras work only with Olympus printers and Casio cameras work only with Casio printers. Unfortunately, this is likely to remain true for a while or at least until interface standards are established. Therefore, if you're interested in a camera with a direct-to-printer feature, make certain the camera and printer are compatible.

Compatibility

Compatibility probably should not be a concern. All the cameras support (or should support) both Windows and Mac systems. Some manufacturers ship separate versions of their cameras — in other words, a version that works only with a PC and a version that works only with a Mac. Make certain you get the version that works with your computer. Fortunately, most manufacturers include both Mac and Windows support in the same camera.

Another compatibility problem faced by early digital camera users was the file format used by the camera. Many early digital cameras saved images in proprietary formats. This meant the image files had to be converted to a format that other programs such as image editors could understand. Fortunately, that has changed. Many digital cameras are now capable of saving images in standard JPEG format that any image editor can open.

An important part of the software bundled with the camera is its file export capabilities. Make certain it can save your images in the file format you need. If you plan to capture images for multimedia presentations, for example, your requirements may be different from those for printed materials or Web display.

Deleting images: the "oops" factor

To delete an image stored in a digital camera, you simply press a button. This will give you additional room for more images. A digital camera should also let you delete the most recent capture so you don't waste valuable memory on a botched shot. Most cameras also let you delete several nonsequential shots, but a few cameras force you to delete all the images that are stored.

Our recommendation is to get a camera that lets you delete images (especially nonsequential shots).

Warranty and support

A digital camera should have at least a one-year warranty. Toll-free support should also be included. Other pluses to look for include faxback services and online forums to answer your questions.

Ergonomics

Although digital cameras do resemble their film counterparts, we recommend that you make certain the camera feels comfortable in your hands before you make your final decision. Hold the camera long enough to determine if it's comfortable in your hands and the controls are easy to reach and operate.

Digital cameras come in different shapes and sizes so ergonomics can be an important consideration when buying a camera.

Video and audio capabilities

Cameras from Fujix, Ricoh and Casio can output the image in standard NTSC video format for viewing on a TV screen. Therefore, these cameras are like self-contained picture playback devices, even without a computer. Cameras from Epson and Polaroid allow you to preview images when you connect the camera to your PC. However, you're limited in both delay and resolution. Furthermore, the Polaroid's preview is in black/white.

A few cameras include a video-clip capability. You won't be able to record full-length home movie-type videos, but you can save a few seconds of motion video instead of still images. This may be just the right length for your web site or e-mail.

Many cameras also feature audio annotation. This great feature lets you identify or add information about an image by recording a small sound bite of several seconds. It's very useful for identifying and labeling your shots as you take them.

Power source and batteries

Batteries power digital cameras and so battery drain is always a concern with all digital camera users. LCD display panels and the camera's flash consume a great deal of battery power.

We recommend that you look for a camera that can operate using nickel cadmium (NiCd), nickel-metal hydride (NiMH) or lithium-ion (Li-ion) batteries. Get rechargeable nickel cadmium or nickel hydride batteries if possible. It's also a good idea to buy a spare set to keep charged. The best battery life usually comes from lithium ion batteries like those used in camcorders. The Sony Mavica cameras use this type of battery.

Make certain to look for a camera that can go into "sleep mode." This saves battery power if the camera is unused for even a few seconds. An AC adapter is another option. It allows you to plug the camera into the wall when the batteries no longer work. Although this limits the area you can shoot, you can at least continue snapping pictures. If your camera uses an LCD panel, make certain to turn it off when you don't need to use it.

Most cameras can operate with alkaline batteries. However, they won't last long — 20 to 30 minutes of shooting time (especially if you're using a LCD panel or flash). Alkaline batteries are virtually useless for a digital camera on very cold days. Use a heavy duty battery such as Duracell Ultra if you must use alkaline batteries.

Some digital cameras are bundled with rechargeable batteries but the lower-priced models usually include only alkalines in the box to get you started. If so, we recommend adding a set of rechargeables (about $25, including charger).

Finally, make certain to select the right type of batteries when it comes time to replace them. The user's manual will tell you which type you need and how to remove and replace the old battery. This is very important because some cameras, for example the Olympus D-600L, cannot support lithium batteries. See the chart on page 84 for other tips on saving battery power.

> **Note On Recharging Batteries**
>
> Some NiCD batteries may require that you fully drain them before you recharge them. Otherwise, due to crystal growth inside the battery, they won't hold as much power after you recharge them.

Bundled software

All digital cameras include software to control how images are transferred from the camera to your PC. This typically involves only transferring the image and providing some simple functions, like deleting images from the camera. The primary task of the software that is included with most digital cameras is to transfer the images from the camera and cards or to let you control the camera from the software.

You'll probably find that a camera will be more useful to you if it includes additional software. The basic image editor included with most cameras (sometimes called an image-editing applet) is important but should not be a determining factor in selecting a camera. It usually provides basic functions (crop, rotate and tweak images). A few image-editing applets even eliminate the "red eye" effect.

Another important software feature is the ability to view thumbnail images before downloading the full-size files. This will save you a lot of time by allowing you to extract the best shots from a group.

Finally, one note concerning bundled software. Although this may sound obvious, many people unknowingly buy a camera that won't work with their computer. So, make certain the camera and its bundled software will work with your PC and operating system.

Compression

We said in Chapter 1 that a disadvantage of digital cameras is they have only a specific amount of RAM. So, a camera can store fewer high-resolution images than lower resolution images. To store these higher resolution images, a digital camera uses compression schemes to pack high-quality images into

71

less space. Why is compression necessary? A 24-bit image snapped with a 640x480 resolution requires nearly 1 Meg of memory. In other words, a digital camera uses a compression scheme to reduce the size of the images so more images can fit in its fixed memory.

Problems using compression schemes

Compression schemes, however, lead to certain problems. The compression techniques used by some digital cameras may, as a side effect, degrade the quality of the images. In this case, the compression is called *lossy*, meaning that the expansion process cannot restore the full original image. So, remember, you'll get the best image quality by using the least amount of compression.

Several digital cameras allow you to choose the level of compression. Unless you must conserve memory for image storage or are intentionally shooting in a low resolution mode, snap pictures at the highest quality setting. You can always use an image editor later to compress images. So consider cameras that let you decide when and how much to compress the pictures as they're snapped.

The total number of images stored depends on the camera. It ranges from about 10 up to 28 for high-resolution pictures, or from 40 to over 100 for low resolution images.

Shutter speeds

The shutter on a digital camera opens and closes to let light to hit the image sensor of the camera. The shutter speed is the amount of time, measured in fractions of a second, the shutter stays open. For example, setting the shutter speed at 500 means that the light passing through the aperture remains on the film (or CCD) for exactly 1/500th of a second.

If you can control the shutter speed of the camera, you can decide if a moving object will appear sharp or blurred in the image. In other words, selecting a camera that features a faster shutter speed means you can freeze faster actions. You can also intentionally blur action, or capture scenes in low light levels, by selecting a camera with a slower shutter speed.

A Note On f/stops And Shutter Speeds

If you've used a 35-mm camera, you know the importance of f-stops and shutter speed ranges. They tell how a camera will perform in low-light and fast-action situations. However, the CCD sensors used in digital cameras vary so much between cameras that the ranges of f-stops and shutter speeds provide few clues to the overall image quality that you can expect.

Being able to control aperture lets you control depth of field. This let's you either throw the background out of focus or keep both it and the foreground sharp. With adjustable focus, you can pick the part of the scene that will be in sharpest focus while using the aperture setting to determine what is sharp and what is soft in the foreground and background.

Operating system

Yes, even digital cameras have their own operating systems. A digital camera needs an operating system to control image compression, store images, display images and more.

As in the computer world, there are several such operating systems that a digital camera can use. Unfortunately, this makes most of them incompatible with other cameras. This is why you simply cannot snap pictures with a camera and then download them into any computer. The computer must have software or drivers that can "talk" to your specific camera model. (However, once your images are downloaded, they are in a standard, universal format that any computer can read.)

Kodak is the first manufacturer to feature a digital camera operating system (OS) when they released their DC260 digital camera. The operating system that runs on the camera's internal computer is called Digita and was created by FlashPoint Technology, Inc.

The basic idea behind Digita is that the camera should work independently of the computer but easily link with it when needed. A camera using Digita lets you not only capture the image but also view, edit, catalog and store the images. You can also add voice or text messages and finally share photos directly from your camera. It uses a graphic interface that appears on the camera's LCD display to show menus and icons that you use to make choices.

One of the most interesting features about Digita is that you can use small programs called scripts to make the camera perform different tasks. The possible uses for scripts are virtually endless. For example, create a script so the camera snaps a picture every five minutes so you can create a time-lapse sequence of a sunrise.

Scripts are also great idea if you feel you're not an accomplished photographer. All you need to do is create a series of instructions of what and how to shoot. For example, if you're snapping your friend's picture, you can develop a script with frame-by-frame guidelines that would remind you to shoot the friend from a distance of five feet, a sideview from ten feet and a backview from five feet.

Self-timer, tripod socket and separate flash

If you really want everyone in the picture – including the photographer – consider a digital camera with a self-timer. A self-timer gives you enough time to set the timer (most average about ten seconds), and get in the picture.

Other features, such as tripod socket and the ability to use a separate flash are good features to complete your selection. The capability of using another flash may be especially important when you consider that most of the built-in flashes don't travel more than a few feet.

Automatic exposure

Most consumer level digital cameras use automatic exposure. The exposure setting used in a digital camera is critical. Its CCD sensors have less exposure latitude than color film. (The CCD sensitivity typically corresponds to an ASA film speed in the 80 to 125 range.) However, many digital cameras feature no exposure adjustments. A few examples of cameras with exposure steps include cameras from Kodak (five exposure steps) and Fujix (ten exposure steps).

Note On Exposure Settings
Once you've become experienced with your digital camera, you can hold its exposure settings by pressing down slightly on the shutter button. This will, with practice, help you gain some exposure control. Unfortunately, no digital camera currently indicates its exposure setting.

Focus and exposure lock

Because most digital cameras use autofocus, the camera focuses on the part of the image in the center of the viewfinder. Although this usually will get you sharp pictures, it might give you problems when the main subject isn't in the center of the image.

To avoid this situation some cameras can "lock" the focus and exposure. In other words, you point at one part of the scene and press about halfway down on the shutter. The settings are locked in as you hold down the shutter button. Then point the camera anywhere to recompose the picture.

A few last suggestions

Make certain to test a digital camera before you buy it. Shoot test images in the store and, if possible, outdoors. Try to shoot under different lighting conditions and make certain to take at least a few pictures using the flash.

Then, save the images onto a floppy disk or ZIP disk and take the disk home. Load and work with the images at home on the same output device you plan on using. Check the quality of the images.

Also, before leaving the store with your new camera, make certain the package is complete...all cables, installation diskettes, manual(s), etc.

Finally, don't get discouraged in a few months (maybe weeks) when you discover the camera you bought has been replaced with a new model with better resolution, more features and lower cost.

Chapter 5:
Having Fun With A Camera & Other Tips

Chapter 5

Having Fun With A Camera & Other Tips

One of the things that make a vacation worthwhile is bragging about it to your friends and coworkers. You will, of course, need pictures to back up some of your wilder stories. However, you'll need to know how to take the best possible pictures using your digital camera; otherwise, the images may not be what you expect.

There's really no secret to using a digital camera successfully. Most of the basic tips you'll find about how to use a 35-mm camera also apply to using a digital camera. In this chapter we'll give you specific suggestions on how to use your digital camera. Keep in mind that we could fill an entire book with photography tips and tricks. If you want more basic tips, check with your local library or bookstore for a book on basic photography.

Select the right tools

Start by choosing the appropriate combination of tools for the job. You may be able to rent a digital camera from a computer retailer or a photography shop if you're not sure where to start or if a digital camera is even the right tool. If the rental price is affordable, maybe rent more than one type of digital camera. Then you can experiment with different cameras and quickly gain valuable experience, not only for the particular equipment that interests you, but also for digital imaging in general.

Understand your camera

An important step in becoming a good digital photographer is learning to work within the limitations of your digital camera. If you cannot learn to do that, then many of your images may not turn out good and you may lose that one perfect picture for which you've been waiting.

Make certain you understand its features and you know the locations of important parts (control buttons, viewfinder, levels, flash, power, etc.). It's also important to understand terms that you'll be using such as resolution, downloading, image capacity and others.

When to shoot

You may not realize it but there are better times during the day to snap pictures. Lighting is not equal at all times of the day (remember, digital cameras depend a lot on light). Too much sunlight, such as at noon or early afternoon, will produce glare and dark shadows on your images.

The best times to take outdoor pictures are usually early in the morning (two or three hours after sunrise) or late in the day (two or three hours before sunset). The light is softer, warmer and more favorable for both people and landscapes at those times.

The light is more favorable early in the morning or late in the day.

Check the batteries

Always check battery level before using a camera. We said in Chapter 2 that the power for digital cameras comes from batteries and so battery drain is always a concern. Batteries are generally good for between 400-700 recharge cycles (about 1-2 years). Check the batteries in your digital camera at least once every 6 months and probably more often if you're frequently using the LCD panel or the flash. Check the user's manual for more specific information. You don't want to miss that once-in-a-lifetime picture because of low battery power.

Make certain to select the right type of batteries when it comes time to replace them. The user's manual will tell you which type your camera uses and how to remove and replace the old battery.

Flying

When flying, be sure your batteries are charged. You may be asked to turn the camera on at a security check point.

Recycling

You may not think that the small batteries used in a digital camera are a big concern for the environment. However, the Environmental Protection Agency (EPA) estimates that over 2 billion used batteries are sent into solid waste facilities every year in the United States. These batteries are responsible for the majority of the mercury (up to 88%) and cadmium (54%) found in landfills. Many types of batteries — including those used in digital cameras — can be recycled instead of thrown away. Many stores collect and send used batteries to a recycling factory to be recycled. So consider recycling the next time you need to replace batteries in your camera.

Quick Tips For Taking Great Digital Photographs

Take a variety of pictures

Don't simply take all nature pictures or all people pictures. Add some variety to your digital photo album.

Try a different perspective

Combine close-up shots with panoramic views. In other words, change the distance and angle between you and the subject.

Understand your camera

It's important to work within the limitations of your digital camera. Make certain you understand its features and you know the locations of important parts (control buttons, viewfinder, levels, flash, power, etc.).

Check the batteries

Check the batteries in your digital camera at least once every 6 months and probably more often if you're frequently using the LCD panel or the flash.

When to shoot

The best times to take outdoor pictures are usually early in the morning (two or three hours after sunrise) or late in the day (two or three hours before sunset). The light is softer, warmer and more favorable for both people and landscapes at those times.

Experiment with different lighting

Digital cameras depend more on lighting than traditional 35-mm cameras. However, never point your digital camera directly into the light.

Taking fast series of pictures

Before trying to take a fast series of images, such as sports action, make certain your camera can store and save images quickly (e.g., in one second or less).

Get closer

If you can get more visual information in your viewfinder, you'll have more information to work with later on your PC. Therefore, avoid long distances to your subject.

Try a new angle or vantage point

Consider a different angle or viewpoint when shooting a subject; the first angle or viewpoint from which you're shooting may not be the best.

Setup the shot carefully

Digital photography shares many of the same photography techniques that you're familiar with from traditional photography. Don't assume that an image editor — even a high quality editor — can fix a poor quality image.

Hold the camera steady

An easy way to eliminate blurry pictures is to keep a firm grip on the camera. Hold the camera firmly with your right hand. When you're ready to snap the picture, use your right forefinger to press the shutter release button. Steady the camera further by using your left hand to grip the lower-left corner of the camera.

Preserving Battery Power

There is nothing more frustrating for a photographer than to run out of battery power right when the perfect photo opportunity presents itself. This is why you should always have extra batteries or at least an AC adapter available.

You can also prolong the power of your batteries by following these suggestions:

1. All batteries from car batteries to camera batteries lose power simply sitting on the shelf - this even includes new batteries on the store shelf. Therefore, when you buy new batteries, charge and recharge them a few times. Then you're certain the batteries are fully charged.

2. An LCD panel is very power hungry. So, if your camera uses an LCD panel (and most cameras do today) turn it off when you're not using it. If you need to use the LCD panel, try turning down its brightness or if use the black & white mode (if available) to save battery power. Use the optical viewfinder whenever possible.

3. Fully drain the battery charge and then re-charge them periodically. The easiest way to do this is with a conditioning charger that drains the battery before recharging it, or a pulse charger that uses a negative pulse to remove the gas bubbles.

4. Use a cotton swab and a bit of rubbing alcohol (isopropyl alcohol) to clean the battery contacts in the camera and charger.

5. Always remove the battery if you're not using the camera for awhile (just don't forget to put it back in when you want to snap some more pictures). Keep the battery in a cool, dry place. It's also a good idea to remove the flash memory cards from the camera when not in use.

6. Check your user's manual for other battery saving tips or suggestions.

Use a fast PC

We've mentioned many times how big the files can be in digital imaging. A large-capacity hard drive is only part of your hardware considerations. You'll also need a fast PC to process the images. The bare minimum is a PC with a 486 processor, but we recommend at least a Pentium-class processor.

Get close

Get as close as possible to your subject; this is especially true for frame portraits. Disable the flash (if lighting permits) to avoid paleface. Try to shoot in daylight, especially in late afternoon, but avoid direct sunlight. If you're working with artificial light, keep the background slightly darker than the subject's face. However, don't keep it so dark that the automatic exposure setting in the camera compensates for it. Otherwise, your subject's face will wash out. Keep in mind that while you can use an image editor later to adjust lighting and color, it's better to start with the best shot you can get.

Get as close as possible to your subject when using a digital camera. (Photo taken using an Agfa Ephoto 1680 / Photo courtesy of Agfa -www.agfahome.com).

What you see in the viewfinder is likely to be what's in the picture. Check around the border area of the viewfinder. Get closer (use the zoom lens if your camera has one) if your subject doesn't fill the frame. Sometimes the camera may be too far from you. If so, you cannot see the borders of the viewfinder; move the camera closer to your eye.

Hold the camera steady

An easy way to eliminate blurry pictures is to keep a firm grip on the camera. Also, your digital camera won't immediately click the shutter when you push the button. Digital cameras require a lag time, called the cycle time, to calculate lighting and focus requirements. So hold the camera very steady as you snap a picture. We recommend using a tripod if one is available. The small digital camera may look a little funny sitting on top of a tripod, but it's an effective technique. Also, if you're taking pictures of people, tell your subjects to hold their poses and remain still until the flash goes off or the camera is ready for the next shot.

Hold the camera firmly with your right hand. When you're ready to snap the picture, use your right forefinger to press the shutter release button. Steady the camera further by using your left hand to grip the lower-left corner of the camera.

Predict and be prepared

If you're looking for candid, action or other "unexpected" shots, make certain you can anticipate the action. The best photographers can guess or even predict what action will occur next.

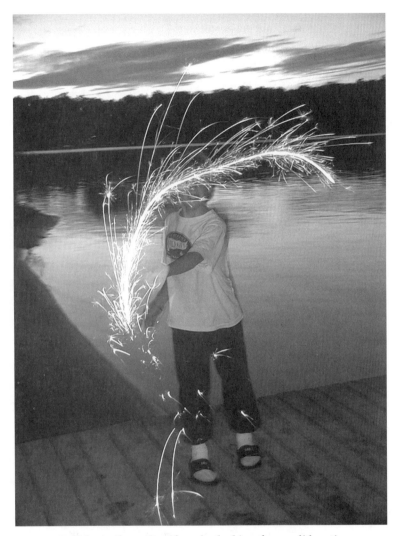

*Anticipate the action if you're looking for candid, action
or other "unexpected" shots. (Photo taken using an
Agfa Ephoto 1680 / Photo courtesy of Agfa - www.agfahome.com).*

Also, you'll find out that you may have only one chance to capture the ideal picture. Be ready; click the shutter as soon as you see something happen. Then get ready as fast as you can because you never know when another good picture will present itself.

87

Go crazy

Although we mentioned that basic 35-mm photography tips also apply to digital cameras, don't consider your digital camera as another 35-mm camera. For example, put your digital camera out on the table the next time you have a party. (Make certain you trust everyone at the party — you don't want someone walking off with your camera.) Tell your partying guests to take all the pictures they want, candid or otherwise. You'll probably be surprised at the different types of pictures when you transfer the images to your PC.

Have fun using your digital camera... experiment with the camera, subjects and the images you've snapped. (Photo taken using an Agfa Ephoto 1680 / Photo courtesy of Agfa - www.agfahome.com).

Don't just try to have fun-do have fun! If you're having fun while using your digital camera, the quality of your pictures will show it. Don't be afraid to experiment with the camera or the images you've snapped. Use image editors creatively, too (see Chapters 10-14 for information on image editors). Learn the tricks and quirks of taking images snapped with your digital camera and tweaking them with an image editor.

If possible, use one of the image editors we talk about in Chapters 10-14. You'll be able to combine parts of different images, change colors and draw in objects or text. You'll probably discover the only limitation will be your imagination.

Flash hints

Too many users believe that nighttime or indoors are the only time to use the flash on a camera. However, using a flash during daylight can help eliminate some of the problems caused by backlighting and dark shadows. Always remember that proper lighting is important when snapping pictures with a digital camera.

It's also very important to remember that the built-in flash has no "carrying power." In other words, the flash is only designed for close-in illumination of the subject and is not generally effective past 9 or 10 feet. This is true for all cameras, both film and digital. For example, you've probably seen flashbulbs popping off from all over the stadium at the Super Bowl or other events. However, trying to use a flash unit to light a football field from dozens of feet away is simply wasting a flash and maybe losing the picture. Using a flash from that distance will not affect the picture because the flash has no carrying power beyond a few feet.

Check your user's manual for more information on the carrying power of the flash unit. The owner's manual may also include suggestions on when to use the flash unit.

Remember, there's no film developing

You don't have to worry about film developing costs with digital cameras so why are you hesitating to snap pictures? We recommend that you go wild and snap pictures as if your life were in the balance. As you take more pictures, you'll become more familiar with your camera and will become a better photographer.

Also, by snapping more pictures, you'll increase your chances of getting better pictures. Human emotions can be elusive to capture with a camera so keep taking pictures of your children, coworkers and friends. You'll discover the best way to capture one of these types of pictures is to shoot quickly and often. Perhaps many images won't turn out too well, but maybe you'll get that one picture you'll always treasure.

Try a new angle or vantage point

Consider a different angle or viewpoint when shooting a subject; the first angle or viewpoint from which you're shooting may not be the best. A picture may look a lot better if you simply snap it from a different angle a few feet away. Walk around the subject or, if possible, look up or down at the subject. In other words, experiment with many visual possibilities. Find a stronger foreground or a less cluttered background, different colors and lines, better light on the subject or an unusual angle.

Always consider a different angle or viewpoint when shooting. (Photo taken using an Agfa Ephoto 1680 / Photo courtesy of Agfa - www.agfahome.com).

Take a variety of pictures

Don't simply take all nature pictures or all people pictures. Add variety to your digital photo album. Then others will be more interested in looking through the album. If you're taking some posed pictures, mix in a few candid shots as well. This technique is especially effective at birthday parties, reunions, etc. Turn the camera vertical instead of the usual horizontal and snap some pictures. Combine close-up shots with panoramic views. You'll discover the best way to capture moments is to include several views.

Add some variety to your digital photo album. (Photo taken using an Agfa Ephoto 1680 / Photo courtesy of Agfa - www.agfahome.com).

Manual is important

Today's digital cameras tend to be complicated to use — especially if you've never used a camera (film or digital camera) before. For example, you'll need to determine what the different icons mean on the LCD panel and which command sequences you need to follow to start different features or options.

These icons and commands are not the same between digital cameras. So, read the user's manual carefully so you can understand the capabilities of your cameras.

Cleaning your camera and lens

The lens should only be cleaned when necessary. The best way to clean the lens is to keep it clean: Keep the lens covered when you're not using the camera. A little dust on the lens won't affect the image but a scratch from cleaning might affect the image. The one exception are fingerprints — they should be removed quickly because they harm the lens coating.

Begin cleaning your camera by using a soft lint-free cloth to wipe off the outside of the camera. Use a cotton swab a bit of rubbing alcohol (isopropyl alcohol) on a Q-tip can to clean the metal parts of the camera. Open the "flaps" to the memory and battery compartments occasionally and use a soft brush or blower to remove dust.

Clean the camera lens by first using a very soft brush (such as a sable artist's brush) or blower (an ear syringe is good) to remove abrasive dust particles.

Then use a bit of photographic lens cleaning tissue or lens cleaning cloth. Put a small drop of lens cleaning fluid on the end of the tissue. If you don't have cleaning fluid, your condensed breath on the lens also works well. UNDER NO CIRCUMSTANCES PUT LENS CLEANING FLUID DIRECTLY ON THE LENS. It might "leak" inside the lens and into the camera. Move the tissue in a circular motion to clean the lens surface. Don't press hard when cleaning, otherwise you may damage the delicate lens coating that covers the front element of the lens. Then use a new cloth and dry the lens, moving in a circular motion. Always discard the cleaning tissues when you are done.

Protecting your camera

Protect stored cameras from dust, heat, and humidity. A camera bag or case makes an excellent storage container. Remove batteries before storing.

Heat

Never expose your digital camera to excessive temperature extremes. For example, don't leave the camera in your car on a hot day – especially if the car is sitting directly in the sun.

We all enjoy taking pictures at the beach so it's not always possible to avoid keeping the camera out in high temperatures. If so, keep the camera covered with a clean white towel or reflective material such as tinfoil. Do not store the camera near heat sources inside your house such as radiators, kitchens or even fireplaces.

Never aim the camera directly at the sun. This isn't so much to protect the camera but to prevent damage to your eyes. Make certain to carry the camera when walking. Don't wear the camera strap around your neck— especially over rough terrain. The camera strap could get tangled and strangle you if you fall.

Cold

One note about digital cameras and cold weather...batteries weaken quicker in colder weather. So, always carry extra batteries. When you're not snapping pictures, keep the camera inside your coat to keep it warm.

Condensation can be a problem when you're bringing the camera indoors from colder outdoor temperatures. One way to prevent condensation is to wrap the camera in a plastic bag or newspaper until it warms up to room temperature. Condensation may be unavoidable so if it does occur, don't take the camera back out in the cold again. Wait until the condensation disappears.

Elements

Always protect equipment from water, especially salt water, and from dust, dirt, and sand. A camera case helps but at the beach a plastic bag is even better. When shooting in the mist, fog, or rain, cover the camera with a plastic bag into which you've cut a hole for the lens to stick out. Use a rubber band to seal the bag around the lens. You can reach through the normal opening in the bag to operate the controls.

Screwing a skylight filter over the lens allows you to wipe off spray and condensation without damaging the delicate lens surface.

Traveling

Use lens caps or covers to protect lenses when you're not using your camera. Regardless of the type of traveling — plane, train, car, etc. — store all small items and other accessories in cases. Then pack everything carefully so they don't bump into each other if they move around during traveling.

Also, when traveling through airports keep in mind that carry-on metal detectors are less damaging than those used to examine checked baggage. So, if you're concerned about X-ray induced damage, carry your digital camera and accessories with you on board the aircraft.

Replacing the slow serial connection

One of the chief virtues of digital imaging is that it lets you store your snapshots in a standard PC and print them out later whenever you need them. The question is, how do you get the photos out of the camera in the first place? You can select from several products to replace the slow, cumbersome serial connection that your camera uses.

ActionTec CameraConnect Pro

One example is the ActionTec CameraConnect Pro ($90 street). This handy reader has three slots—for CompactFlash, SmartMedia, and a PC Card. Not only does it connect easily to your parallel port and printer but it also appears as a logical drive in Windows Explorer. (Sunnyvale, CA; 800-797-7001; www.actiontec.com)

SCM SwapBox

If your camera uses CompactFlash or SmartMedia memory, you probably have (or can buy) an adapter to read those disks in a PC Card drive. Although that's fine for laptop users, it's not always so great for desktop PC users. If this is your situation, consider the SCM SwapBox line of PC Card readers ($99 list for an internal IDE or external parallel port). These readers are assigned drive letters in Windows Explorer so you can access the media as you would any other removable drive. (Los Gatos, CA; 408-370-4888; www.scmmicro.com)

SmartDisk FlashPath floppy disk adapter

Another solution if you're using a camera with SmartMedia memory is the SmartDisk FlashPath floppy disk adapter from SmartDisk.

As you can see from the photo on the right, it's the same size as a 3.5-inch floppy diskette. Therefore, it works in a standard floppy disk drive. Simply insert your SmartMedia card into the FlashPath and slip the adapter in your floppy disk drive for access to your images. For more information visit their website (www .smartdisk.com).

Iomega Clik! drive

If you're a serious digital shutterbug who frequently runs out of storage when taking pictures, one useful tool to consider is the the Clik! drive from Iomega (the same company responsbile for the popular Zip drives).

The Iomega Clik! drive ($200 street) is a battery-operated drive- (and rechargeable in its special connector) that plugs into your PC. Although it's not cheap ($249) the Clik! Drive for Digital Cameras makes it easy to store images safely when you're away from your PC (or as the professinonals refer to it: out in the field). Just insert your CompactFlash or SmartMedia card into

the appropriate slot on the pocket-size drive, press a button and the handheld unit transfers everything on the memory card to a 40 MB Clik! disk. Erase the pictures from the memory and you can start snapping pictures again. (Roy, UT; 800-697-7833; www.iomega.com

Each Clik! disk holds 40MB and costs around $10 (when purchased in multiple packs).

Sending digital photos directly from your camera to a printer

You have at least two options available if you want to simply send digital photos directly from your camera to a printer. One example is the Lexmark Photo Jetprinter 5770 (www.lexmark.com).

The Jetprinter 5770 (shown on the right) resembles a typical ink jet except that it has two slots for CompactFlash cards and for SmartMedia on the chassis. Simply insert the appropriate card and follow the prompts on the LCD when you're ready to print.

Another option is the Syntran CamPrint (www.syntran.com). Note, however, the CamPrint only works with certain cameras and certain printers. Check with Syntran or your dealer before buying.

To Use CamPrint, simply hook one end of this box-and-cable system to the serial-out port of your digital camera and the other end to the rear plug of your printer. CamPrint then runs your images directly from the camera.

Part 2

Scanners

Chapter 6:
The Second Frame:
Introducing
Scanners

Chapter 6

The Second Frame: Introducing Scanners

Scanner Types

Flatbed scanner
Sheet-fed scanners
Scanning without a computer

How Scanners Scan

Optics inside a scanner

Is CIS The New Scanner Technology

CIS or CCD?

Maybe you've had one or more of the following happen to you or someone you know:

❖ Your children spent time creating a special drawing or other artwork only to have it accidentally lost, damaged or misplaced.

❖ You realized that your vacation pictures were interesting for a while but are now stored, forgotten, in boxes in the closet.

❖ You've discovered that important legal papers and other documents were misplaced or lost.

❖ Insurance agents are asking for proof of ownership for a valuable collection that was lost in a fire or through theft.

Maybe you've wondered if it were possible to have copies of these mementos and important documents in case the originals were lost or destroyed. It is possible — if you have a scanner. What can you do with a scanner? Use a scanner to turn artwork, important documents, photographs and countless other items into digital files. Then you can store the files safely on your hard drive, ZIP disks or other storage device until you need them.

Scanners are no longer marketed only for professionals. They're now a popular and affordable way for every user to import or load images into their PC. Furthermore, the power of today's PCs can easily run complex image editors that let everyone manipulate, print and archive images. For example,

you can still proudly show off your children's drawings on the refrigerator door as you've always done. However, by using a scanner, you can also show off the same artwork on the Internet. Instead of simply putting vacation pictures in forgotten boxes, showcase your vacation photos in electronic greeting cards, homemade calendars or create a magazine cover. Use a scanner to scan your birth certificate, mortgage, insurance papers, etc. Then you won't have to search frantically for the important documents. Instead, call up the scanned image on your PC.

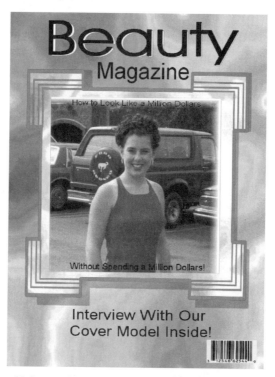

Using an image editor like MGI PhotoSuite II
lets you turn your scanned images into magazine covers.

Don't panic...buying a scanner isn't likely to put a crimp in your budget. Several flatbed color scanners are available for under $200. In other words, you can find a good color flatbed scanner package (including image editor, OCR software and more) for less than a typical personal laser printer.

*Microtek (www.microtekusa.com/) has been a leading
manufacturer of scanners for many years. This is their ScanMaker scanner.*

Scanner prices, like PC prices, continue to tumble while features continue to become more powerful. Prices for color flatbed scanners fell dramatically in 1998 (to below $100 in some cases). In short, thanks to inexpensive PCs, friendly image editors and the popularity of color photos in documents and web sites, a scanner is the next must-have peripheral for mainstream PC users.

Scanner Types

Several types and styles of scanners are available from which you can select. Some scanners have very specialized functions or are used in service bureaus and professional applications. These include slide scanners and drum scanners. As the name suggests, slide scanners are used to scan 35-mm slides. A drum scanner is used for very high resolution and professional printing. These scanners are usually too large and too expensive for home or even small business use.

The types of scanners for home users have evolved into two main types called *flatbed* scanners and *sheet-fed* scanners.

Hand-held Scanners And Photo Scanners

We should also mention two types of scanners that were popular until recently: photo scanners and hand-held scanners (or sometimes simply handhelds).

The best way to describe the appearance of a hand-held scanner is to compare it to an oversized computer mouse. Hand-held scanners were inexpensive alternatives when the price of flatbed and sheet-fed scanners were well over a thousand dollars. However, now that flatbed and sheet-fed scanners have come down in price, the appeal of hand-held scanners has disappeared.

A photo scanner is a small, relatively inexpensive motorized scanner that scans photographs, business cards and other similar sized images. Their specialty, as the name suggests, is to capture snapshot-sized photographs. However, this also limits the size of the image they can scan. They are, nevertheless, easy to use and certainly don't need as much desk space as a flatbed scanner.

The following pages talks about flatbed and sheet-fed scanners in detail.

Flatbed scanner

The most popular desktop scanners today are flatbed scanners. Flatbed scanners, as the name suggests, have a flat glass surface (called the *bed* or sometimes the *platen*) on which you place the object you want to scan. The bed also doubles as the scanning area.

A flatbed scanner resembles a photocopier in both how it looks and operates. In other words, you place the object you want to scan on the bed and close the cover. The scanning head or light bar moves below the object and scans it (we'll talk more about how it scans in the next section).

*The SnapScan 1212 from Agfa
(www.agfahome.com) is an example of a flatbed scanner.*

Flatbed scanners are more versatile than sheet-fed scanners and therefore can scan a far wider range of objects. For example, flatbed scanners can scan flat originals of different sizes, such as photographs, text and other items. A flatbed scanner is also perfect if you want to scan pages from a book without removing or damaging the pages. In other words, use a flatbed scanner to scan anything from paper to full color artwork to 3-D objects such as coins and keys. (Chapter 9 even talks about how to scan small three-dimensional objects like coins, keys, food, clothing, etc.). Furthermore, they're usually bundled with "value-added" software and image editors.

You can even use an optional automatic document feeder to scan several pages at once. Also, most flatbed scanners can use a transparency adapter so you can scan slides, x-rays and other transparent originals. However, these are very special add-ons and cost about as much as the scanner itself.

As with digital cameras, fierce competition is forcing the retail prices of flatbed scanners to fall. The magic price for entry-level scanners is from $200 to $400 (see the following Chapter 8 for information on selecting a scanner).

Sheet-fed scanners

Sheet-fed scanners, also called personal sheet-fed scanners, are increasing in popularity. They're somewhat similar to a fax machine because the page being scanned is moved past the scanhead. (A flatbed scanner is similar to a photocopier; the scanhead is moved below the object to be scanned.) Sheet-fed scanners require less room than a flatbed. They can either be a thin device that fits between your keyboard and computer or a larger unit that resembles a printer.

The disadvantage of using a sheet-fed scanner is that you can scan only a single sheet of paper. (Some sheet-fed scanners can use automatic document feeders to avoid this problem.) This is why sheet fed scanners are usually used for small amounts of scanning. This also presents a problem if you want to scan a page from a book or magazine. To scan a page from a book or magazine with a sheet-fed scanner you must tear out the page. Keep in mind that anything you want to scan must fit through a narrow opening that is either in the front or in the rear of the scanner.

Although the resolution capabilities of sheet-fed scanners is similar to flatbed scanners, the quality of the scans produced by sheet-fed scanners usually cannot match those produced by flatbed scanners. Distortions can be a problem. This is because a sheet-fed scanner moves the paper as it's being scanned.

Nevertheless, a sheet-fed scanner will save space on a crowded desktop. Also, some models feature detachable scanning heads that can be pulled across bound pages by hand. If you're on a tighter budget and primarily scan text documents for OCR or archiving, a sheet-fed scanner may fill your requirements.

Scanning without a computer

One way to avoid compatibility problems is to consider the Microtek ImageDeck. Microtek refers to the ImageDeck as the "Stand-Alone Scanning Appliance" because you don't need to connect it to a PC. All you need to do is plug it into a wall outlet and you're ready to scan.

The Microtek ImageDeck is the "Stand-Alone Scanning Appliance"
because you simply plug it into a wall outlet and you're ready to scan
(www.microtekusa.com).

It's basically a Microtek ScanMaker X6 with a built in 3.5-inch floppy drive, a 100-MB Iomega Zip drive and a control panel. Place the image you want to scan on the scanbed, like you do with any other scanner. Then use the control buttons — similar to an office photocopier — to scan directly to either disk drive.

The ImageDeck is a 36-bit, 600 x 600 dpi scanner. You can attach a printer to the standard parallel port, which turns the ImageDeck into a copier. The ImageDeck can format floppy disks but not ZIP disks so make certain to use a preformatted ZIP disk.

Check out the Microtek website (www.microtekusa.com) for more information.

How Scanners Scan

Before we talk more about scanners, we need to talk about how a scanner works. Although many types of scanners are available, we're usually talking about flatbed scanners in this section. Flatbed scanners are the most versatile and probably most widely used type of scanner. See the "Scanner Types" section above for information on the specific types of scanners.

We don't want to become involved with the "mechanics" of how a scanner works. Instead, we'll give some general information. You're probably more interested in knowing that a scanner will work than in how it does work. Therefore, a simple way to describe how a scanner works is to say it converts light into digits (1s and 0s) that your PC understands. This simple description applies to all types of scanners. A scanner really isn't much different from a photocopier. However, instead of printing a copy to a sheet of paper, the scanner stores the "copy" of the image you scanned. You can then save the image as a file on your hard drive.

To scan an object, scanners use several thousand CCDs (charge coupled devices) as their "eyes." These tiny components convert the amount of light received into electrical impulses. The strength of those impulses depends on the intensity of light that strikes them. They send that information to your PC. Since your PC can only understand whole numbers (integers), the impulses are translated from analog to digital. The pictures are then stored as groups of integers.

To capture a whole image, the scanner divides the image into a grid and uses a row of eyes (called the *scanhead*) to record how much light is reflected in each location. When the computer has the necessary data, it creates a file that represents the image in digital form.

Each of the cells in the grid is called a *pixel* (an abbreviation for picture element). Each pixel contains either one color or one shade of gray. The entire picture is completed only when the pixels are all combined. Scanners differ primarily in two ways:

1. How many pixels they can measure (called *resolution*).

2. How the actual scanning process occurs.

The color (and its intensity) in each pixel is determined in one or more bits of data. The number of bits refers to the number of colors each pixel can contain. The most common are one-bit, 8-bit and 24-bit. A 1-bit scanner is the most basic type of scanner because it only records black and white. Each bit is able to express two values (either "on" or "off").

Most color scanners today are at least 24-bit because they collect 8 bits of information about each of the three primary scanning colors (red, blue and green). See "Bit-depth" in Chapter 7 for more information.

Scanners, like digital cameras, depend on a quality light source

As we mentioned, scanners capture image data by reading light that's been reflected off, or passed through, the item being scanned. Therefore, the quality of the light source can determine the quality of the resulting scan. The first desktop scanners used fluorescent bulbs as light sources. These lights emitted consistent white light for only a short time and released enough heat to affect other parts of the scanner. Most quality scanners now use a *cold-cathode* bulb. These bulbs produce whiter and more consistent light but produce less heat compared to the fluorescent bulbs.

Optics inside a scanner

A scanner uses prisms, lenses and other optical parts to direct light from the bulb to the CCDs. These optical parts can vary in quality. A high-quality scanner uses high-quality glass optics that are color-corrected and coated for minimum diffusion. However, some lower priced scanners use plastic components to keep costs down.

Flatbed scanners use several methods of reading light values with CCDs. The first generation of scanners used a three-pass method. In this method, one CCD read each of the primary scanning colors (red, blue and green) separately. Most of today's flatbed scanners, however, use a single pass method with either a beam splitter or coated CCDs.

When a beam splitter is used, light passes through a prism and separates into the three primary scanning colors. A different CCD reads each color. This is generally considered the best way to process reflected light. However, to hold down costs, many manufacturers use three CCDs.

Because a film coats each of these CCDs, it reads only one of the primary scanning colors from an unsplit beam. This second method, although technically inaccurate, normally produces results that are very similar to those of a scanner with a beam splitter.

Color scanning usually requires three separate scanning passes: one each for red, green, and blue. Rather than exposing the entire image at once, the diodes sweep across the source image (like the light sensors on a photocopying machine).

The number of distinct readings, taken vertically and horizontally, determines the resolution of the scanned image. The possible number of values that could be represented is the *dynamic range* of the image.

The image is converted to a specific file format after it's been scanned. Many formats are available that you can use, but a few formats are better than others. Once your image is saved on your hard drive, you can load it into an image editor or any application that can load a graphics file.

Is CIS The New Scanner Technology

To call the level that the price of scanners has fallen since early 1998 astonishing is an understatement. Certainly user demand is fueling the price drop but technology also is playing a part. Manufacturers can of course sell their scanners for any price they want, but they won't remain in business long selling a scanner for less than it costs to manufacture.

The heart of most color flatbed scanners (and digital cameras) is a small photosensitive chip called a CCD. As we mention in this chapter, a scanner with CCD technology uses a complex system of mirrors and a lens to focus the image on the CCD. Not only is this somewhat costly, but the delicate optics can become misaligned, adversely affecting scan quality.

So to reduce costs, some manufacturers have replaced the traditional CCD technology in their scanners with a new technology called Contact Image Sensor (CIS). A CIS scanner uses fewer moving parts than CCD scanners (this helps keep down costs) but the main difference for a CIS scanner is how it scans an original. The familiar CCD scanner uses a series of mirrors and a lens to focus the image onto a photosensitive chip. However, CIS scanners use a row of either 300 or 600 photosensitive sensors that extend the full width of the scanner. These sensors are located about a millimeter below the item being scanned. (This is also why CIS resolution is currently limited to either 300 or 600 pixels per inch — although this is acceptable if you plan to display your scanned images only on the Internet.)

A series of closely packed red, blue, and green LEDs (light emitting diodes) provide the white light source. By removing the CCD light source, mirrors and the fluorescent or cold cathode tube, manufacturers have made CIS scanners thinner, lighter and more energy-efficient. (Although a CIS scanner uses less power, you won't become wealthy on the savings...you'll pay about $1.00 a year in electricity charges to use a 20 watt CCD scanner for an hour each day.)

The smaller size of a CIS scanner is perfect for crowded desktops and for portability. The low power required by a CIS scanner means that it can run off battery power or a powered USB port. However, keeping an external power supply available is also a good idea.

Although you may not be familiar with the term CIS, it's not a new technology. CIS was used in sheetfed scanners from Storm Technologies and Visioneer in late 1997. The Artec A6SE from Ultima International was one an early CIS-based flatbed. Now other leading manufacturers such as Microtek, Canon Computer Systems, Mustek USA and others are using CIS technology in their scanners.

CIS or CCD?

Although a promising technology, early tests and reviews of CIS scanners suggest that image quality does not match the quality of a comparable CCD scanner. Many reviewers and retailers considered the detail and the colors of the first CIS scanners generally were not as fine as that of even an inexpensive CCD scanner. In addition, 3-D objects generally haven't scanned as well on a CIS scanner. So, if you scan pages from books or other 3-D objects that won't lie flat on the glass, consider a CCD scanner before a CIS scanner — at least for now.

CCD technology is still currently the most reliable for producing the best-quality scans between a comparable CCD scanner and a CIS scanner. The exception to this might be if you're planning only to scan text and other documents (OCR, fax and other documents). Then a new CIS scanner may work as well as a CCD scanner.

Keep in mind too that image quality certainly will improve as the CIS technology matures. For now, look closely at CCD scanners in the same price range before you buy.

Chapter 7:
Selecting A Scanner

Chapter 7

Selecting A Scanner

Before Selecting A Scanner

Resolution And Its Importance

Bit-depth

Bundled Software

Conclusion On Selecting A Scanner

Perhaps you've been thinking about buying a scanner. Maybe a friend just bought one and is telling you how great it is. Or maybe you're tired of using the scanner in the office and think it's now time to buy your own scanner.

However, you should not simply run out and buy the first scanner you see. You need to make a few important decisions first. Chapter 6 introduced you to scanners. This chapter will tell you what to look for when selecting a scanner.

Important Note

We're talking about specific scanners and manufacturers in this chapter. However, we're not necessarily recommending only these scanners or only these manufacturers. Models, prices and software bundles may change without notice so check the manufacturers' web sites or your favorite dealers for the most current information. Refer to the table near the end of the chapter for a quick comparison of all the scanners we mention.

Before Selecting A Scanner

Before you go shopping for a scanner, you should consider the information that we'll talk about in this chapter. By understanding and evaluating the information, you might discover why one scanner is better for your needs. First, consider the reason(s) you're buying a scanner; determine how you'll be using your scanner and for what purpose(s). Then look for a scanner that will most closely satisfy those needs. Don't pay now for extra quality or features that you may not need for awhile (especially if you consider how scanner prices are dropping).

Type of scanner

You'll most likely be selecting either a color flatbed scanner or a personal sheet-fed scanner. (See Chapter 6 for more information on these specific types of scanners.) The choice depends on how you plan to use the scanner. A sheet-fed scanner might be a better choice if you're interested in scanning only individual pages (or stacks of pages) for faxing, OCR and capturing/managing documents. Furthermore, their entry-level price (about $270) is generally less than a comparable flatbed scanner.

The Microtek Scanmaker (X6EL with bonus 35-mm slide and filmstrip adapter) is an example of a flatbed scanner (www.microtekusa.com).

If you need to scan bulky objects, such as pages from a book, color images/photographs, 3-D objects, you need a flatbed scanner. A flatbed scanner also has options for an automatic document feeder (ADF) and a transparency media adapter to scan transparencies (including 35-mm slides). However, since they tend to be expensive options, consider adding an ADF or transparency adapter only if you'll need high-volume scanning or specialized-media capabilities. Although they'll expand the capabilities of your scanner, they can be very expensive options; especially if you'll only get limited use out of them.

Don't buy a three pass scanner

The first generation of consumer level scanners required three passes of the scanhead (the lighted bar that holds the scanning circuitry) to scan an image. The first pass captured red light, the second pass captured blue light and the third pass captured green light. The scanner then combined the colors into the finished scan.

The problem with these scanners was obviously their slow speed. The scanning time was tripled because these scanners scanned the same image three times. Even if the extra time wasn't a concern, a problem combining three separate scans occasionally resulted in *registration* problems. This was when one scan, say the green scan, was not aligned with the other two scans. Three pass scanners suffered other image quality problems as well.

Flatbed scanners today are single pass scanners. These scanners read the red, blue and green light in one scan, hence the name single pass. Single pass scanners are not only faster than three pass scanners, but they eliminate most registration problems because only one scanning pass is required.

Experts and others consider three-pass scanners as "old technology." So be careful: When a scanner, especially a used scanner, is available for an unbelievably low price, check to see if it's a three-pass scanner.

Quick Tips For Selecting A Scanner

Budget and scanner prices

If you have less than $200 in your budge to spend, don't panic. You'll be able to find flatbed scanners for under $200 in today's scanner market. Prices have plummeted in the last year, with many models selling for under $200 (and a few for under $100).

Resolution

Consider only the true optical resolution of a scanner. Scanners will use software to achieve the interpolated resolutions. However, instead of improving the quality of the scan, interpolation more often degrades the quality. The scanner should operate at an optical resolution of 300dpi or above.

Warranty and technical support

Read the warranty carefully before handing over your check or credit card. Check the length of the warranty and its return policy. Most scanners include a one-year warranty but a few have two-year warranties. Be very wary of "extended warranties" and "service plans." The cost of the extended warranty/repair may be close to the cost of a comparable scanner in the future.

Bit-depth

Another item to check when selecting a scanner is its bit-depth. A 24-bit color scanner is likely to be able to handle your scanning jobs. A 30-bit scanner may be better for applications where image quality must be at a high level, such as business proposals or scans of architectural drawings.

Bundled Software

The types of software bundled with a scanner can be invaluable additions to the package. Look for a friendly point-and-scan driver interface with easy-to-read buttons and commands. It should include manual controls (for example, brightness), automatic controls (for example, contrast, density, cropping), color management and more.

TWAIN driver

Any scanner you buy or use should include a TWAIN driver. This will let you scan images directly into an image editor or other application such as a word processor.

Type of scanner

You'll most likely be selecting either a color flatbed scanner or a personal sheet-fed scanner. A sheet-fed scanner might be a better choice if you're interested in scanning only individual pages (or stacks of pages). If you need to scan bulky objects such as pages from a book, color images/photographs, 3-D objects, you need a flatbed scanner. A single-pass flatbed scanner offers the best combination of quality, speed, reliability and ease-of-use.

Dynamic range

Dynamic range measures how wide a range of tones the scanner can scan. It's measured on a scale from 0.0 (perfect white) to 4.0 (perfect black). The dynamic range for most color flatbed scanners is about 2.4. This means a typical flatbed scanner can distinguish between perfect white (0.0) and a deep mid-range gray (2.4). High-end color flatbed scanners are usually capable of a dynamic range between 2.8 and 3.2.

Scanning area

Many shoppers overlook the size of the scan bed when shopping for a scanner. An important price difference among flatbed scanners is the size of the scanning area. Most of your scans will probably be smaller than a sheet of letter-size paper (8.5 by 11 inches). However, there may be situations in which you'll need to scan legal-size papers or large books. If so, you'll need to look for scanner with a larger scanning area.

Easy installation

Most flatbed scanners are SCSI-based, which means you'll need to install a card inside your PC. However, several scanners can connect directly to the parallel port of your PC so you won't need to worry about opening your PC and installing a card.

A SCSI connection may increase the overall system cost of your scanner. Although a connection to the parallel port is simpler, overall performance may be slightly slower.

Budget and scanner prices

If you have less than $200 in your budge to spend, don't panic. You'll be able to find flatbed scanners for under $200 in today's scanner market. Prices have plummeted in the last year, with many models selling for under $200 (and a few for under $100). The bottom line: spend the money to get the best scanner you can afford.

Basic entry-level scanners

The one certainty about scanner prices is that the price will increase as you increase the size, color depth or resolution. Basic entry-level scanners costing $150 or less usually feature a 300 dpi resolution and have a 24-bit color depth. These scanners may also include a minimal amount of bundled software. Many of these entry-level scanners may be from unfamiliar companies but this isn't always the case. For example, Canon (Canon CanoScan 620P), IBM (IBM IdeaScan), Mustek (Plug-n-Scan 1200 III EP), Plustek (OpticPro 9636P) and Tamarack (ArtiScan 9600) are entry level scanners from top manufacturers.

Mid-level scanners

The next level of scanners will feature better resolution (400 to 600 dpi) and higher color capabilities (either 24-bit or 30-bit). These scanners will also include a suitable bundled software including an image editor and OCR software.

Higher level scanners

The next level includes the $600 to $2,000 range of scanners. These scanners feature a minimum resolution of 600 dpi (more likely 1200 dpi) and at least 30-bit (more likely, 36-bit) color depth. They're also bundled with higher quality software such as Adobe Photoshop and OCR software.

Regardless of your budget, the final quality of your graphic image depends greatly on the quality of the scan. Don't buy a low-end scanner thinking you can interpolate to higher resolutions or use an image editor and get a high quality scan. You'll be out some money and disappointed with the poor quality of the scans. In other words, you cannot make an awful scan look good no matter what printer or image editor you use.

Hardware requirements

The hardware requirements for a scanner aren't quite as demanding compared to image editors and most other software. Therefore, you should base hardware requirements on the most demanding part of your work. This is likely to be an image editor or other graphics-intensive application. A 386 PC with 8 Meg of RAM can successfully operate a scanner but you'll find this system to be agonizingly slow (or more likely, impossible) when using an image editor. (See Chapter 10 for information on system requirements for image editors.)

The part of your system where you really need to be careful is with hard drive capacity. Every time you use the scanner, you're also saving an image file on your hard drive. The file size of each saved image can be very large.

For example, scanning this standard color photo (3.5x5-inch) at 600dpi and at 100% required about 19 Meg of hard drive space:

Furthermore, this refers to only one image…multiply this by 12 or 24 or 36 (depending on the number of exposures on the roll of film). Scanning at higher resolutions requires more time on slower machines. Therefore, make certain the hard drive on your system has enough capacity to handle the enormous filesizes. Otherwise, you may have to consider replacing or upgrading your current hard drive. Also, make certain your system meets the requirements mentioned by the scanner manufacturer before you buy.

Scanning area

Many shoppers overlook the size of the scan bed when shopping for a scanner. An important price difference among flatbed scanners is the size of the scanning area. Most of your scans will probably be smaller than a sheet of letter-size paper (8.5 by 11 inches). However, there may be situations in which you'll need to scan legal-size papers or large books. If so, you'll need to look for a scanner with a larger scanning area.

Examples of scanners with larger scan beds include the HP ScanJet 6200C (8.5x14.0), Microtek ScanMaker E3 Plus PC SCSI (8.5 x 13.5), Mustek Plug-n-Scan A3 EP (11.7 x 17.0) and UMAX Astra 1200S (8.5 x 14.0).

Start with the leading scanner manufacturers

The leading scanner manufacturers earned their reputations for top-quality merchandise. Compare your needs with their specifications. Then use the information to compare against other scanners from other manufacturers (see the list idea next). The following table lists several of today's leading scanner manufacturers:

Manufacturer	Website
Agfa	www.agfahome.com
Canon	www.ccsi.canon.com
Epson	www.epson.com
Hewlett Packard	www.hp.com
Info Peripherals	www.infoconnection.com
Microtek	www.mteklab.com
Mustek	www.mustek.com
Nikon	www.nikonusa.com
Pacific Image Electronics	www.scanace.com
Plustek	www.plustek.com
Sharp	www.sharp-usa.com
Tamarack Technologies Inc.	www.tamarack.net

Make certain you understand the important features about the scanner in which you're interested. Also, know beforehand what's important for you. One idea is to create a table or list of specifications and features for which you're searching. List the specifications from most important to least important horizontally across the page. Then list the scanners that you're interested in vertically on the left side of the page. Put an "X" in the area where the products have a particular feature or the value of the feature (dynamic range, for instance). This will let you quickly see which scanners are most likely to meet your needs and price.

Resolution And Its Importance

The most important term you'll need to understand concerning a scanner is its resolution. A scanner uses two types of resolution (*optical resolution* and *interpolated resolution*) and we'll talk about both shortly.

We can describe resolution simply as a measurement of how many pixels a scanner can read in a specific image. An easy way of understanding and measuring scanner resolution is to use a grid. If a board has eight squares along each side, the resolution of that grid is 8 x 8 because there are 8 squares along each side:

Now, imagine if grid has 24 squares along each side, its resolution would be 24 x 24 (see following illustration).

Although the size of the grid is the same, notice how the resolution changes from the 8 x 8 example to 24 x 24 example. This is how the quality of a scanned image increases as you increase the resolution of the scanner. Remember we mentioned at the beginning of this chapter that one of the differences between scanners is the number of pixels they can measure. A 24 x 24 resolution is obviously better than an 8 x 8 resolution. More pixels are measured (each square in the box equals one pixel) in the same amount of area. For the same reason, a 600-dpi scanner will normally produce better scans than a 300-dpi scanner

Optical resolution

The most important resolution measurement for a scanner is its *optical resolution*. Typical optical resolutions are measured in dots per inch (dpi). You'll see scanners with resolutions of "300 x 600 dpi" or "400 x 400 dpi" or "600 x 1200 dpi" and other numbers.

It's safe to assume that a scanner can capture more detail if it has a higher dpi. In other words, say a scanner samples a grid of 600 x 600 pixels for every square inch of the image. It sends a total of 360,000 readings per square inch back to your PC (600 x 600 = 360,000). A higher resolution produces more readings while a lower resolution produces fewer readings. Higher resolution scanners normally cost more but produce much better scans compared to lower resolution scanners.

Interpolated (or enhanced) resolution

Most scanners use software to try to improve upon the optical resolution. This new measurement is called the *interpolated resolution* (also called the *enhanced resolution*). Some manufacturers will say their scanners have interpolated resolutions of 2,400 x 2,400 dpi or better (see sidebar note below).

As with the second number describing optical resolution, don't be fooled by interpolated resolution. It's supposed to sharpen your scan by telling the scanner to, for example, turn a 300 x 300 dpi scan into a 600 x 600 dpi scan. It does this by collecting data from two adjacent pixels. The pixels are then averaged and a new pixel is created to fit between those two pixels.

However, instead of improving the quality of the scan, interpolation more often degrades the quality. At the very best, interpolation won't greatly improve the overall quality of the image. The one thing of which you can be certain concerning interpolation is that it will increase the file size of the scanned image. For example, say you wanted to scan the following photo:

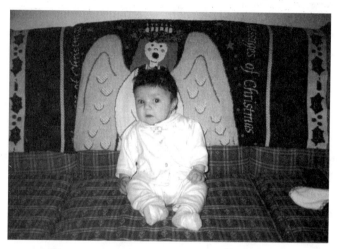

To scan this 4x5.75-inch photo in color at 600 dpi would require over 24 Meg of hard drive space. That's a lot of space for one image. However, since you're probably using a 300 or 600 dpi printer, you wouldn't need a higher resolution scan, anyway. (To reduce the file size, you could either scan in gray scale or use an image editor to remove the colors. This would lower the file size dramatically.) The same file scanned at 1200 dpi required almost 97 Meg, which is much too large for a single image.

The image scanned at 2400 interpolated resolution required a whopping 388 Meg. At this size the image would become unmanageable for most image editors. Even more shocking is the file size if we scanned it at 4800 dpi. At a file size of over 1,552 Meg, it wouldn't even fit on two CD-ROMs.

So, don't pay too much attention to claims of interpolated resolution. Interpolation doesn't really add to the value of the scanner. Even if interpolation were to improve the scanned image, keep in mind that most ink jet or laser printers have either a 300 dpi or 600 dpi resolution. Therefore, these printers cannot use the interpolated information anyway. It's probably overkill to use a 300 dpi laser printer to print a 9600 dpi interpolated scan.

The only exception to use interpolation might be if you plan to scan line art at very high resolutions. For example, a higher interpolated resolution can be good idea when you're enlarging small originals. Using the higher resolution in this case produces an image with far more detail than a 300-dpi scan.

Final notes on resolution

When shopping for a scanner, make certain to consider only its optical resolution. Don't be fooled or tricked by advertisements mentioning interpolated resolution. For most everyday or typical scanning jobs, an optical resolution of 300 or 600 dpi is usually enough.

Remember to base the resolution on how you'll be using the final image. For example, a resolution of 72 dpi is all you need if the image is to be placed on the Internet. Will you be printing the scanned image? If so, most color ink jet printers will get excellent results with scans made at 125-150 dpi. Therefore, scans over 150 dpi probably only mean longer print times and not increased quality. If you'll be using a laser printer or color printer to output your scanned images, a 400-dpi or 600-dpi scanner is probably the right choice. In a few instances, however, a 300-dpi scanner will work just as well.

Another example of when you should use a higher resolution is if you plan to use an image editor to enlarge the original scan. In this case, scanning a high resolution is recommended to maintain the quality of the image when you enlarge it.

Bit-depth

A nother item to check when selecting a scanner is its bit-depth. When a scanner converts an image into digital form, it looks at the image pixel by pixel and records what it sees. However, different scanners record different amounts of information about each pixel. The amount of information a scanner records is measured by its *bit-depth*.

Bits and scanners

The most basic type of scanner is called a 1-bit scanner because it only records black and white. Each bit can express two values because 0 and 1 (on and off) are the only two possible combinations of numbers. However, to see the different levels of black and white, a scanner must be at least 4-bit (maximum of 16 tones). These scanners use 16 combinations of four bits:

0000 0001 0010 0011 0100 0101 0110 0111 1000 1001 1010 1011 1100 1101 1110 1111

An 8-bit scanner can show up to 256 tones. A 16-bit scanner can show up to 65,536 tones. When you have 24 bit color, a total of 16,777,216 colors is available.

24-bit scanners

Why are all these numbers so important? Keep in mind that a scanner with a higher bit depth can record information about a given pixel more accurately. This, in turn, results in a higher quality scan. Most color scanners today are at least 24-bit. They're called 24-bit scanners because they collect 8 bits of information about each of the three primary scanning colors (red, blue and green). A 24-bit scanner can theoretically capture 16.7 million colors — the

maximum most high-end graphics boards will display and the number of colors visible to the human eye. However, the number is often much smaller. Because this is near-photographic quality, these scanners are also called *true color scanners*.

The following two examples are the same image but scanned at different bit-depths. The change in image quality should be apparent between the 8-bit version (256 color) on the top and the 24-bit version on the bottom.

Notice, too, how large the file size becomes. The 8-bit image requires only 1.4 Meg of hard drive space but the superior image quality of the 24-bit image requires 4.3 Meg.

30-bit and 36-bit scanners

Manufacturers have recently started to release 30-bit and even 36-bit scanners. These scanners combine a high dynamic range with a high bit-depth. A 30-bit scanner can produce 11 billion colors and a 36-bit scanner can produce 6.8 trillion colors (at least in theory).

Although that sounds impressive, most 30-bit or 36-bit scanners that are now available can only use the extra bits internally and send just a final 24 bits to the computer. In other words, a major problem right now with a 30-bit or higher scanner is that most software is designed to work only with a 24-bit scan (so you may not be able to take advantage of all those additional colors). This probably won't be a long term problem as the 30-bit or higher scanners become more popular. Software companies will release versions of their software to work with 30-bit and 36-bit scanners.

Nevertheless, some of today's image editors can work with scans from 30-bit and 36-bit scanners. These editors use the huge amounts of extra data to correct for noise in the scanning process and other problems that affect the quality of the scan. In other words, 30-bit or 36-bit scanners tend to produce better color images even in an image editor designed for a 24-bit image.

The reason to look for a scanner with more bits per color is simple. Higher pixel depths will give you better scans. By using higher color depth, your scan will maintain the subtle color changes in shadow areas and similar areas. This, in turn, decreases *posterization*, which is the sudden shifts in color from one pixel to the next where there should be a smooth gradation. Additionally, whites will be whiter and blacks will be blacker.

A scanner with a greater bit depth also lets you see more detail in dark areas (this depends on the quality of other components in the scanner).

Important Note
You should be skeptical of claims mentioning inexpensive 36-bit scanners (currently about $300 to $700). Some vendors may count the calibration bits to make the specifications appear more impressive.

A 24-bit scanner should be enough if you don't expect to scan photos as often as documents or other items. If you'll be scanning photos or artwork regularly, consider a 30-bit or 36-bit scanner.

Bundled Software

A scanner is similar to many peripherals you're already using because it, too, includes utilities and bundled software (programs that are included with the scanner). These programs are designed to help control the scanner and to make it easier to use.

We recommend looking at the software that is bundled with a scanner before making a final purchase decision. The types of software bundled with a scanner can be invaluable additions to the package. If this is your first experience using a scanner, look for a friendly point-and-scan driver interface with easy-to-read buttons and commands. More advanced users will want a package that offers low-level control over a wide range of image attributes. Another important software piece is the OCR (optical character recognition) program that comes bundled with the unit.

Virtually all scanners include software. Check and double-check bundled software that comes with the scanner. The variety of bundled software is large and manufacturers may include several options for software bundles with the same scanner.

A bundle can include several types of software. We'll look at the most frequently included types in this section.

TWAIN driver

Any scanner you buy or use should include a TWAIN driver. The reason for this is that most scanners do not include a "start" button. You instead use software called the TWAIN driver to run the scanner. In other words, the TWAIN driver is the interface between the image editor and the scanner hardware. Most image editors (for example, Adobe PhotoDeluxe, JASC Paint Shop Pro, Ulead PhotoImpact and most others) include a command you can select to start the scanner's software.

Although it sounds techie, TWAIN is simply a program, or more correctly, a software standard that all the scanner manufacturers agree to use. (TWAIN is believed to be an acronym for Technology Without An Interesting Name.) Its main purpose is to allow all graphics software to operate all scanners. Your only choice before TWAIN drivers were available was to use the graphics program that came with the scanner. Now you have your choice of several.

True, that sounds nice but why is it important? The advantage of this is that you can scan images directly into an image editor or other application such as a word processor. You had to perform at least two steps before TWAIN became widely available:

1. You had to save the image you just scanned using software provided by the scanner manufacturer.

2. Reload the file in the image editor.

TWAIN eliminates the first step because the scanned image is sent immediately to the image editor. Most applications even use the same menu command for scanning (the "Acquire..." command in the "File" menu). This makes scanning from different applications even easier.

Use the Acquire... command to load a TWAIN image directly into an image editor or other application (Paint Shop Pro 5 in this example).

Important Note

Although it's usually called the TWAIN driver, a few manufacturers may use a different name. For example, Microtek calls their TWAIN driver ScanWizard, Umax calls their two TWAIN drivers VistaScan and MagiScan and HP has a version called DeskScan.

If an image editor or other application supports TWAIN, it usually lets you call up the TWAIN driver by selecting either the **Scan** command or **Acquire** command. After the scan completes, the TWAIN driver transfers the image into the image editor or other application that you're using. Then you can immediately begin working on the image.

Utilities

Utilities are usually designed for only one task but often offer several features that can enhance the capabilities of a specific scanner. Utilities also let you define the specific part of an image you wish to scan or emphasize. Some utilities can even turn a combination of scanner and printer into a photocopier (even a color photocopier). This is done by redirecting the data from the

133

scanner directly to the printer for output. Then you can print the image immediately without saving the scan as a file. A scanner and a fax modem combination can replace a traditional fax machine by using a fax utility. This utility redirects the scanned data straight to the fax modem driver software.

Drivers

The software that is bundled with a scanner should give you a quick, low-resolution preview of how your scan will look. Fast previews are very important because they'll save you time. Testing corrections on the preview image is faster than working with a final scan.

The most useful scanning software lets you resize, zoom and edit previews quickly and easily. You should also be able to control the brightness as well as the shadows and highlights (called white point, midpoint and black point) of the image. These filters and corrections should reduce the amount of work you'll need to do with an image editor.

Also, make certain the vendor provides an easy way for you to get updated software drivers. A short time ago you would have to wait for a diskette in the mail. Now the easiest and fastest way to get updated drivers (and other information) is to download the drivers from the manufacturer's website on the Internet.

Image editor

Regardless of which scanner you buy, most scans will require some tweaking. This is why scanners often come bundled with an image editor. Unfortunately, the quality and features of the image editors bundled with a scanner vary widely. It's important to have a good image editor available if you're scanning graphics or photographs (see Chapters 10-14). Some scanners include the "full" version of an image editor. Other scanners may include low-priced, limited versions of popular image editors. The limited versions are usually called "LE," "Lite" or something similar.

LE versions won't have most of the important advanced features, but they're usually good enough to get you started. Then, as you become more experienced, you'll probably need a more powerful image editor. Since you'll want to upgrade eventually, consider buying a full version of the image editor when you buy a scanner. You might get a good package price for the scanner and the image editor. Keep in mind too that an upgrade offer might be included with the LE version bundled with the scanner. This upgrade offer may let you buy the full version of the software at a special price.

Make certain you understand what is meant by "LE" and "lite" and "limited" or other names used to describe the bundled image editor. You should know how these versions differ from the full versions and if you can upgrade to the full version at a reduced price.

OCR software

A scanner, of course, can turn your photographs into electronic files. This is obviously the reason you're using a scanner and it's fine so long as the image is a picture, photograph or other type of graphic. You simply use an image editor to tweak the electronic file. However, instead of tweaking a photo of your favorite aunt, say you want to tweak the letter you received from her.

Unfortunately, you cannot edit the text because your PC considers it to be a graphics file and not a text file. However, it is possible to tweak the text itself similar to tweaking a graphics file. To do this, you need to use Optical Character Recognition (OCR) software. Then your PC will treat the scanned image as a text file instead of a graphics file. You can then use a word processor to edit the text.

This type of software, usually simply called OCR, allows you to scan a document with alphanumeric characters (letters, numbers or both). It then converts the text in the scanned image into a file that you can edit using your favorite word processor. It's as if you typed the information in yourself.

You can, for example, use a scanner and OCR software to scan letters, documents, magazine clippings, memos, etc. Then use your favorite word processor to change the text in the image (for example, enlarge or reduce the type, substitute fonts, change the size and even rewrite the text).

Most scanners include free sample OCR software, but if you're interested in scanning text, you should look for a dedicated OCR package. We recommend testing scanners and OCR packages using a sample of documents before buying. You're looking for accuracy greater about 98% or better. If the accuracy is less than 90%, you're probably better off typing in the text. (Before typing in the text, however, make certain the text isn't already available in digital form from another source.)

Two currently popular OCR applications are OmniPage Pro 8.0 (from Caere), Presto! OCR 3.0 (from NewSoft Inc. - www.newsoftinc.com) and TextBridge Pro 98 (from Xerox). These programs are very accurate and work in several languages. They can recognize not only the text on a page, but the format (bold, italic, etc.) in which the text was originally printed. Other OCR software may be easier to use or less expensive, but probably in exchange for less accuracy.

You'll find Presto! OCR3.0 on the companion CD-ROM (see Chapter 15).

Nevertheless, keep in mind that even the best OCR package available today can achieve little better than 99% accuracy. So even with the best OCR software, you'll still have to correct one out of every 100 characters.

Color calibration

Any one who has used a scanner has at least once become frustrated because a scanned image looked different on screen than it did when printed. Then, adding to the frustration was that both looked a lot different from the original. The solution to this problem is *color calibration* (or color matching) software. By installing a color calibration system on your PC, an orange in an original image will appear just as orange on both your monitor and a printout.

Since a book specifically about color is required to talk fully about color matching software, we'll only mention it briefly here. One example of a popular color calibration system is the Kodak Color Management System (CMS). It uses its own color definitions with unique profiles for each scanner, monitor and printer in your computer system to translate and standardize colors. This system is used in many image editors and other software. CMS has become the favorite of graphic artists and others who depend on closely matched colors.

Another reason we don't need to talk much about color calibration systems is that you probably won't need to worry about it. These systems are important only for scanning high-quality images (transparencies, professional-quality prints, etc.) that must meet strict quality standards. In most cases, you're probably more interested in a fast, satisfactory color than a 100% accurate color.

Conclusion On Selecting A Scanner

One general rule applies when shopping for computer hardware and peripherals: The more you know, the smarter you'll buy. Even if you've narrowed your choices to a few scanners, you still may not know which one to buy. To conclude this chapter we'll provide you with some final tips on buying and selecting a scanner.

For example, two additional considerations for selecting a scanner are its dynamic range and scanning speed. We'll talk about these and other important points in this section. Although none are as important as the other items mentioned in this chapter, you should at least be aware of them as you select your scanner.

Dynamic range

Another important criteria for evaluating a scanner is its *dynamic range*. Dynamic range is somewhat similar to bit-depth; it measures how wide a range of tones the scanner can scan. Dynamic range is measured on a scale from 0.0 (perfect white) to 4.0 (perfect black). The single number given for a particular scanner tells how much of that range the unit can distinguish.

The dynamic range for most color flatbed scanners is about 2.4. This means a typical flatbed scanner can distinguish between perfect white (0.0) and a deep mid-range gray (2.4). High-end color flatbed scanners are usually capable of a dynamic range between 2.8 and 3.2. These scanners are designed for more professional work. Drum scanners probably provide the ultimate in dynamic range; they typically feature a dynamic range between 3.0 and 3.8.

Keep in mind that a high dynamic range doesn't guarantee a good scan. Many other factors influence the scan quality. However, the dynamic range suggests the scanner manufacturer is striving to please informed buyers by producing a higher-quality product. If you've narrowed down your choices, select the scanner offering a higher dynamic range.

Scanning speed

Manufacturers, reviewers and dealers have argued the importance of scanner speed for a long time. The importance of a scanner's speed probably depends more on how often you plan to use the scanner. A slow scanner probably won't be a problem if you use it only a few times a day. On the other hand, a fast scanner is more important if you're using it constantly or your job depends on it. The difference in scanning time between the fastest and slowest scanners will barely give you time to get a cup of coffee. You can

typically plan for a lower end scanner to take 40-60 seconds to make a 300 dpi scan. However, a few lower end scanners may take minutes to do the same scan. Also, be careful with lower end scanners claiming a fast scanning speed. You may spend more time with an image editor fixing or tweaking the image. A midrange scanner should not take more than a minute to create a 300 dpi scan.

Many items determine the speed at which a scanner operates. These include whether it's the preview scan or the final scan, the resolution at which the image is scanned and the time required for the scanning software to save an image. Interpolation increases the time required to complete a scan (another reason to avoid interpolation; see Chapter 6).

One main reason for the debate over the importance of scanner speed is that no standard is available to evaluate the time needed for a scanner to scan an image. Therefore, it's difficult to compare scanning speed accurately. When you're shopping for a scanner, you may see a speed expressed in milliseconds per line (or "ms/ln"). Manufacturers usually use this number to specify the raw speed of their scanners' motors. However, that speed rarely compares with real-world performance.

Since no reliable comparison standard is available, the best way to evaluate a scanner's speed is to create your own comparison standard. Try a few sample scans at different dealers. Use the same types of images you're most likely to scan after buying a scanner. If you cannot "test drive" a scanner this way, look for comparisons in magazines or ask the opinions of friends and coworkers. These reviews usually test each scanner by scanning the same image under the same conditions, resulting in a fairly accurate comparison.

Other important considerations

Future plans

Plan for future needs but be careful that you don't overestimate and buy something that's too sophisticated or too expensive for your current needs. Remember that scanner prices are likely to continue falling, so don't spend extra today for something you won't need or use until much later.

Use the Internet

Many on-line resources are available to you that provide information about scanners. Most manufacturers have a website. You'll find a wealth of information by searching their websites. Also, search in magazines for articles on scanners, especially comparison charts, new models, etc.

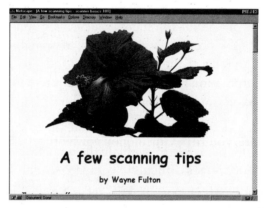

Don't let the simple opening page fool you...this is an excellent website to learn about scanners and scanning (www.scantips.com).

You've probably noticed that the prices for virtually everything in the PC market today are highly competitive. Our advice is to check the virtual stores on the Internet once you've decided on a manufacturer, model, etc., of your scanner. Also, check ads for mailorder companies and then go to retail stores to check their prices. Look in your local newspapers for prices. You'll be surprised how much you can save by doing some good price shopping.

Warranty and technical support

Don't forget to check the service and support policies of the vendors. Go to Internet newsgroups or the vendors' forums on AOL or CompuServe. Computer users are seldom shy to complain about a vendor who doesn't provide good service or competitive prices.

Many manufacturers offer their customers toll-free telephone support. Fortunately, once you're past the initial installation, you should rarely require tech support.

Read the warranty carefully before handing over your check or credit card. Check the length of the warranty and its return policy. Most scanners include a one-year warranty but a few have two-year warranties. Can you return the product for a refund? If so, what about restocking fees if a product is returned. Who pays for shipping if you need to return a scanner you bought over the Internet or from a mail order company? Recognize all the little "gotchas" before you buy. Read the fine print on everything and make certain to get warranty and return policy details in writing.

Be very wary of "extended warranties" and "service plans." We've said it many times...the prices of scanners are likely to keep falling while the features keep improving. Although we cannot consider scanners to be "disposable" items quite yet, the cost to repair one is approaching the price of a new one. Furthermore, you're paying money now with an extended warranty to repair something that may be considered "old" technology in a few years. In other words, the cost of the extended warranty/repair may be close to the cost of a comparable scanner in the future.

There is a best time to buy

Believe it or not, there is a best time to buy a scanner (or any computer or peripheral for that matter). Although sale prices and your payday may influence when you buy a scanner, try to buy on a Monday. Otherwise, buy early in the morning. If you're ordering from a mail order company, try to take delivery early in the week. Then someone in customer support is more likely to be available if you need help. Keep in mind that not all manufacturers or dealers have weekend, evening or 24-hour support.

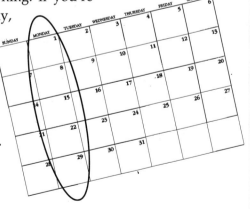

Easy installation

Make certain you understand what is involved in installing the scanner. Most flatbed scanners are SCSI-based, which means you'll need to install a card inside your PC. However, maybe you're one of the many users who are very intimidated by opening their PC and installing a card. If so, perhaps you should consider one of the several scanners that connect directly to the parallel port of your PC. You won't need to worry about opening your PC and installing a card if you use one of these scanners. Keep in mind that a few of the parallel scanners require an EPP (enhanced parallel port). Therefore, if your PC is more than two years old, check the owner's manual or dealer to see if you'll need to install a new parallel port card.

If you plan to use a scanner with your current SCSI card make certain the scanner in which you're interested supports your SCSI card. If you or the dealer are uncertain, check with the manufacturer before buying. Also, some manufacturers bundle a SCSI card with their scanners. If you're planning to use your current SCSI card, see whether the dealer will sell the scanner at a reduced price without the SCSI card. You won't need the SCSI card, so why buy it?

Networks

Some scanners can be made accessible to multiple users over a network. Make certain the scanner is accessible over a network if that's what you need.

If you plan to use the scanner across a network, check its port options. The best hookup for a network scanner server is to use the fastest throughput and that is a SCSI-II connection. Otherwise, a parallel connection is often the easiest for personal desktop use. It can also accommodate occasional group usage by simply detaching the scanner and reattaching it to PCs around the office. A parallel connection is also the best choice if you plan to travel with your scanner.

We'll see more USB (Universal Serial Bus) connections soon. These promise more convenience than parallel connections and are faster than SCSI. Unfortunately, your PC must have USB ports and only newer model PCs do.

In-store demonstrations

If you're shopping at a retail outlet, don't be afraid to ask for a demonstration of the scanner. Also, make certain to use your photos for the demonstration. Otherwise, the store might use photos they already know will look good scanned.

Color rules

You may not want to buy a color scanner if you're planning to scan only black and white images. A black and white or grayscale scanner will work fine in this case. (A good amount of scanning done today is monochrome - faxing, OCR, clipart, line art and document storage.)

You're really limiting yourself by buying a black and white or grayscale scanner. Always remember that color rules. So, be certain that all you'll ever want to do is to scan black and white images. You may discover very quickly that you'll need the versatility of a color scanner (besides, a color scanner can scan black and white images, too).

Furthermore, you're unlikely to find a monochrome flatbed scanner for sale because virtually all flatbed scanners sold today are color. Another reason to consider a color scanner is that your PC now most likely has the horsepower to handle color scans. The combination of a large capacity hard drive, fast processor and 24-bit color means you have a system that can handle color images.

Remember one of our notes: Color rules. You should consider the versatility of a color flatbed scanner not just for your scanning jobs today but also for scanning jobs in the future. The outlook for black-and-white scanners is that they're becoming as obsolete as monochrome inkjet printers and monochrome monitors.

Chapter 8:
Tips On Using A
Scanner

Chapter 8

Tips On Using A Scanner

Installing And Planning

System requirements for scanners
Installation tips
Don't overlook the manual
Connections
Be careful with proprietary interface cards

Getting Quality Scans

Plan ahead
Scanning for quality
Resolution tips
File format tips
Overcoming typical scanning problems
Unneeded backgrounds
Put some distance between your scanner and your printer
Keep your scanner clean
Check the focus
Scanning thick or warped documents or images
Finding the "sweet spot"
Tips on OCR software
When to use interpolated resolution
Scaling tips
Dynamic range

One surprising question I hear quite often is "what is a scanner used for?" A simple answer is that you can use a scanner to turn a photograph or important document into a digital file that you can load into your PC. Then you won't have to retype, redraw or otherwise recreate the object or image.

Keep in mind the paperless office is more a myth than reality. We still receive important documents, receipts and other reports daily. However, now we can scan and archive these important documents or to send to others electronically. A color scanner is needed if you want to add color images to your web site. The traditional target audience for scanners are graphic artists and other professionals. They still need to use a scanner to capture images for layouts (including this book). In short, a scanner is the next must-have peripheral for many typical PC users.

Although you'll probably use a scanner to scan your favorite photos or archive important documents, keep in mind you can also scan many everyday objects. Experiment a little bit with watches, ties, pens and coins. You can scan virtually anything that you can fit on the bed of your scanner. These objects become digital images after you've finished scanning them. What does this mean? It means you can edit, tweak, manipulate and even insert text or apply magical special effects.

For example, we scanned the following photo and loaded the file in an image editor called Paint Shop Pro 5:

Then we used an effect called Clone Brush and removed the woman so it now looks like she never was in the photo:

In this chapter you'll see that you can use a scanner for more than just scanning documents and paper. We'll talk about several interesting, neat and fun things you can do with a scanner.

First, we'll talk about installing a scanner. Then after your scanner is installed, we'll talk about how to get a high-quality scan. Using a scanner is usually very simple and involves only a few steps. However, even experienced users can occasionally become frustrated at the results of their scan. We'll provide some tips in this section on using a scanner to avoid these frustrations. Remembering that your scanner isn't much different from a photocopier may remind you how easy scanning really is.

Installing And Planning

System requirements for scanners

Today's Pentium-class PCs are perfect to use with a scanner. These fast and powerful processors should have no problem running and controlling a scanner. However, some older (pre-486 class) PCs may not work as well with a scanner. So, before buying a scanner, make certain your computer system meets all the requirements listed by the scanner manufacturer.

Today's scanner typically requires a Windows PC with at least a 486 processor. The amount of RAM that is installed on your PC is also important. Keep in mind that using a scanner and an image editor are memory-intensive operations for a PC. Therefore, make certain your PC system has at least 12 Meg of RAM installed (although we recommend at least 24 Meg). A good idea is to base the system requirements on the image editor that you plan to use. By meeting the system requirements for the image editor, your PC should have no trouble running and controlling a scanner.

Installation tips

Today's scanners are mostly *plug and play*. In other words, plug in the SCSI card so your scanner can "talk" to your PC and install the scanner software. Then you're all set to start scanning your favorite images.

Quick Tips For Getting Great Scans

Large originals

Always start with the largest original possible. It will give you the most visual data with which to work.

Start with a clean original

Make certain the original image or photo is good and clean. Better originals will always produce better scans.

Scanning large objects

When scanning large objects, such as pages from a book, place a weight (such as a large phone book) on top of the scanner lid to keep it as flat as possible on the object you're scanning.

Remove borders and other areas

Reduce the scanning area when necessary to remove borders or other areas you don't want to scan. You're only increasing file size by having a scanning area that's too big. Although you can use the Crop tool in an image editor, there's no reason for you to scan this extra area.

Interpolated resolution

Use interpolated resolution to scan line art (logos, ink sketches, etc.). Set the interpolated resolution to the level of your output device. For example, if your output device will be a 1200-dpi imagesetter, try setting the interpolated resolution to 1200 dpi. This will produce smoother lines and eliminate some of the unwanted "jaggies" that usually appear in line art scans.

Is the scanner clean

Keep your scanner clean by using rubbing alcohol on a lint-free cloth and cleaning the scanning bed carefully before you scan images.

Image type

Choose the right image type and set the correct resolution and scaling before you scan. For example, scan at a lower resolution if your planning to e-mail or put the image on a website.

Scaling levels

Set the scaling level using your scanner instead of resizing the images later using your image editor. Scaling in a sense has an inverse relation to resolution. In other words, the lower you set the resolution, the larger you can scale the image, without increasing the file size or appreciably degrading the quality. For example, you're trying to scan a small photo at 600 dpi. To double the image size of the photo without losing any detail (yet keep the resolution at 600 dpi), increase the scaling to 200%. This will create a much larger file. To keep this file smaller, scale it to 200% and halve the resolution to 300 dpi.

However, there is a reason that many users refer to plug and play as *plug and pray* instead. In other words, you can still run into installation problems. Maybe the following tips will help you avoid some of these common problems. We'll start with installation tips for a parallel port scanner.

Parallel port scanner

Scanners using a parallel port interface may be slower compared to scanners using a SCSI card, but they're easier to install. In addition, using a parallel port is a big advantage when it's not possible to install a SCSI card, such as with a laptop or when there are no free IRQ available. Some scanner manufacturers use only a parallel port interface with their lower priced scanners.

Besides the slower speed, another disadvantage of using a parallel port for a scanner is that you must share one parallel port between the printer and the scanner. Furthermore, the parallel port was never designed to be shared (you could install a second parallel port but that means installing another board).

The bottom line is that you may be pushing your luck if you're planning to use a parallel scanner that will be sharing a port with other devices, like a printer, a ZIP drive or a tape backup.

The following are general guidelines and tips on installing a parallel scanner to your PC:

1. Make certain to unlock the shipping lock on the scanner if it has one. Connect the power supply.

2. If you're not using a printer or other parallel port devices, all you have to do is simply plug in your scanner to the parallel port of your PC.

3. Don't panic if you have a printer (or another parallel port device) already connected to your PC. Remove the printer cable from the parallel port and plug the cable from the scanner into the port. Then plug the printer cable into the printer connector (called the *parallel pass-through port*) that you'll find on the scanner or into a central connection box. You can follow this same information for other parallel port devices as well.

4. This step involves installing the scanner software. The scanner should include installation software that you'll find on one or more floppy diskettes (possibly a CD-ROM). This software contains drivers that let your PC communicate with your scanner.

 It's usually a good idea to turn on the scanner first before turning on your PC. Enter the setup program (this procedure varies by PC maker) and then the Device Manager in either Windows 95 or Windows 98. Install the scanner software in Windows. You may need to restart your PC.

5. Make certain to set the parallel port to either ECP or EPP. It's also possible that you'll need to set both. See the Admin\Reskit\Helpfile\Win95rk.hlp help file on the Windows 95 CD-ROM for more information. Type extended in the index. Don't panic if your setup doesn't include the ECP and EPP options. Although you can still use the scanner, it will work slower.

6. Exit setup and restart your PC.

7. Then run the scanner's calibration program.

8. When everything is up and running, do a few test scans. You want to make certain the scanner and its accompanying software is working correctly. If you have problems, shut down your PC. Make certain that you've connected the scanner correctly and that it is getting power. Check all other connections. If you still have problems or questions, don't be afraid to call for technical help from the manufacturer.

Installing a SCSI scanner

A scanner that uses a SCSI interface is a better alternative than one using a proprietary interface card. The main advantage with a SCSI interface is that you can use the same interface with several devices. A proprietary interface card can be used only with one device (the one with which it was intended to be used). You can connect a SCSI interface to any combination of CD-ROM drives, removable hard drives, tape drives, modems and even other scanners.

153

Installing a SCSI scanner requires a bit more work than installing a parallel port scanner.

1. The manufacturer probably shipped the scanner with a sliding lever or screw to lock components in place. Make certain to unlock this lever or screw before using the scanner.

2. Read the manual to determine if you install software or hardware first. Follow the directions to install the software that came with your scanner. Usually you must specify whether you're using a SCSI interface card that's already installed in your PC or a SCSI card that came with the scanner. Most scanners also require you to run a calibration program.

3. You'll need one empty ISA slot (a few scanners may need an empty PCI slot instead) and one free IRQ. You probably won't need to worry about special settings with most cards. However, a few cards have jumpers or switches that you might have to set. Read the owner's manual carefully for both the scanner and the SCSI card for information on installing the card.

 Use the Win95 Device Manager to check your PC to see if the necessary free IRQ is available for a SCSI scanner. Then you'll know whether there may be potential problems before starting. Open the Control Panel by selecting the Start I Settings I Control Panel command. This opens the Control Panel window:

Then double-click the System icon in the Control Panel to open the Systems Properties window. Click the Device Manager tab. Look for the ⸢Properties⸥ button near the bottom of the window and click it.

This opens the Computer Properties window. It lists all the IRQs that your PC currently uses. You're looking for an IRQ between 9 and 12 that is free (in other words, missing from the list). If, for example, IRQ 10 is missing from the list (such as it is in the following picture), then IRQ 10 is free and available for the scanner.

All you need is one free IRQ between 9 and 12. Then you need one empty ISA slot for the SCSI card.

4. Make certain to shut down Windows and turn off your PC. Remove the cover of your PC and insert the scanner card (the SCSI card) into an empty expansion slot on your PC.

5. Connect the SCSI cable between your PC and the scanner. Most SCSI scanners have two identical connectors that let you "daisy chain" more SCSI devices through the scanner. You may not be able to select a connector randomly, so if one doesn't work, try the other.

6. You must "terminate" SCSI devices; otherwise, they won't work. You may have to set a switch or use a special termination plug on the free SCSI connector. Check the manual for more information on terminating the SCSI connection.

155

7. Each SCSI device must have a unique ID number. You'll normally use a rotary switch to set this number. Use the factory default ID if the scanner is your only SCSI device. If you've connected other SCSI devices to your PC, make certain the scanner ID doesn't conflict with them. The SCSI IDs that your PC is using (if any) are listed when you start up your system.

8. The scanner should include test and installation software that you'll find on a CD-ROM (or possibly one or more floppy diskettes). If so, run it to make sure that everything is working properly.

9. When everything is up and running, do a few test scans. Make certain to turn on the scanner before turning on your PC. If you installed a new SCSI card, Windows 95 should detect it and install the correct software. Keep your Windows 95 or Windows 98 CD-ROM and the scanner software handy. You may need them to complete the installation.

You want to make certain the scanner and its accompanying software is working correctly. If you have problems, shut down your PC. Make certain that you've connected the scanner correctly and that it is getting power. Check all other connections. If you still have problems or questions, don't be afraid to call for technical help from the manufacturer.

Don't overlook the manual

The owner's manual is probably the best source to find correct installation information. We say "probably" because, unfortunately, many scanners are manufactured overseas. Therefore, the manuals are not always well written or don't give clear directions. If possible, look at the manual before buying a scanner. Make certain all the instructions are clear and easy to follow.

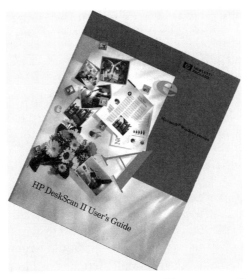

*It's always easy to "forget" the manual but your problems and
questions are often quickly answered by looking through the manual.*

In addition, some manufacturers include accessories to make the installation
easier. For example, a few manufacturers include a videotape that shows how
to install a scanner. Other manufacturers include books that explain color
scanning in more detail. These accessories can add to the price of the scanner,
but they'll help you understand how to install and use your scanner faster.

Connections

We mentioned the SCSI card already but, of course, you'll need something to
connect the card to your scanner. The scanner should have a cable included
for this. The length of the cable when connecting a PC and a scanner should
be less than 12 feet to maintain a quality signal.

This usually isn't a problem if you're using the PC and scanner at home.
However, this could be a problem if you're connecting the scanner and your
PC at work or in an office. A simple solution if the cable length becomes a
problem is to move your scanner and PC closer together. A more expensive
and undesirable option is to consider another type of scanner.

157

Be careful with proprietary interface cards

Some manufacturers include a special type of SCSI card with their scanners that will support only their scanner. This card is called a *proprietary interface card*. Although these cards usually work fine, they can sometimes cause problems. Here are a few problems you might have when using (or trying to use) a proprietary interface card:

❖ A proprietary interface card isn't as versatile as normal SCSI cards.

❖ Since these cards are sometimes older, 8-bit cards, they cannot process data as quickly as a 16-bit card.

❖ Some proprietary interface cards may require additional installation steps, such as setting small switches or jumpers.

❖ They may conflict with other devices already installed in your computer.

The easiest way to prevent the problems of using proprietary interface cards is to avoid buying a scanner that requires one. Consider a scanner that uses a proprietary interface card only if you feel you're getting a great deal or prefer that particular type of interface.

Getting Quality Scans

Despite the recent increase in scanner sales, many users still have problems getting the best quality scans possible. Even users who are "experts" on virtually everything else when using their PCs have less-than-satisfactory results when using scanners.

However, using a scanner doesn't have to be a scary adventure. Scanning is really an easy process: You simply place the object, document, photo or whatever you want to scan on the scanner, load your TWAIN-compliant image editor and select the File/Acquire command. The scanner starts the scanning process and then sends the image to your image editor so you can tweak it or store it as a file.

Although using a scanner is simple and straightforward, you should know a few things before you start scanning. The following suggestions will help you get the best results from your scans.

Plan ahead

Keep the following goals in mind when you plan your scanning project. These questions will grow more important as you become more familiar with your scanner and software.

1. How do you want the final scanned image to look?

2. Where will the final scanned image be used?

3. What image editor do you plan to use?

4. How will the image be reproduced, on what type of printer and what type of paper?

Scanning for quality

We've said that using a scanner is easy and straightforward. However, there's more involved than simply placing the object you want to scan on the scanning bed and clicking a button. You need to consider a few other factors, too. With these in mind, we'll show you how to get high-quality scans from your scanner. We'll also provide a few other tips and suggestions.

Use the correct hardware and connect everything correctly

For example, make certain your PC has enough RAM and that enough space is available on your hard drive to store scanned images. We've said it before so keep it in mind: Scanned images, especially color, require a lot of hard drive space. Therefore, you may need to add RAM, use a larger hard drive or use another storage device.

Make sure your scanner matches your scanning needs

A 36-bit scanner can produce better color and grayscale scans than a 24-bit scanner.

Make certain your video card and monitor support higher resolutions

Use a 24-bit (also called true color) video card that is set to "millions of colors" or "16.7 million colors" for the best quality.

The original image or photo must be good and clean

Remember that better originals will always produce better scans. Types of photos to avoid include those that are out of focus, dirty or poorly exposed (see the following example).

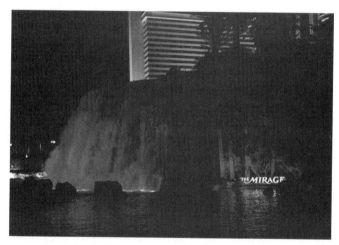

This is an example of what happens when a poorly exposed photo is scanned

This is an example of what happens when a blurry photo is scanned

Even the best scanning software or image editor can only improve image quality to a certain point, no matter how much time you spend retouching.

Also, avoid scanning halftone images or printed images (i.e., pictures from magazines) if possible. Scanning these images usually results in a Moiré (mwa-ray') pattern. This is an undesirable pattern in color printing. Image editors may be able to remove some of the Moiré' effect, but it's best to avoid the problem if possible. In other words, start with a clear original (see below for more information on Moiré patterns).

This image is an example of the Moiré'patterns
that usually result from scanning halftone images

Keep your scanner clean

Use rubbing alcohol on a lint-free cloth to clean the scanning bed carefully
before you scan images. This will help avoid scanning flecks of dust along
with the image. Don't think this can be a problem? Check the following
image:

This is an otherwise acceptable scan except we did not clean the
scan bed before scanning the photo. The result is that a small hair, perhaps
not even noticed on the scan bed, now appears near the bottom of the image.

Choose the right image type and set the correct resolution and scaling before you scan.

Scan line art as line art (even if it isn't black and white). To produce smaller files and save some time, scan black and white photos as grayscale and not color. Also, produce smaller file sizes by scanning a color image as gray scale if you're planning to print it in black and white.

For example, we scanned this black and white photo first in color (2.5 Meg) and grayscale (824K). Since the photograph was black and white anyway, there was no reason to scan it in color.

Use the color correction feature in the scanning software (if included)

This feature will help you obtain colors that are more accurate when scanning color images.

Capture as much detail as possible in the initial scan

Compare the scan against your original image to make certain you've maintained as much detail as possible. Don't be afraid to rescan the image.

Take your time and don't be afraid to experiment

Every combination of PC, software, printer and scanner is different. If something doesn't look right, maybe adjusting the settings and do it over. Have some fun learning how to get the best results from your scanner/PC combination.

Resolution tips

Resolution determines the level of detail recorded by the scanner. It's measured in dots per inch (dpi). In Chapter 6, we talked about the two types of resolution (optical resolution and interpolated resolution). Optical resolution is the more important and accurate resolution number. Interpolated resolution is resolution enhanced through software. Interpolated resolution may be useful for certain tasks (i.e., scanning line art). However, scanning color photos and other images with interpolated resolution usually produces inferior results.

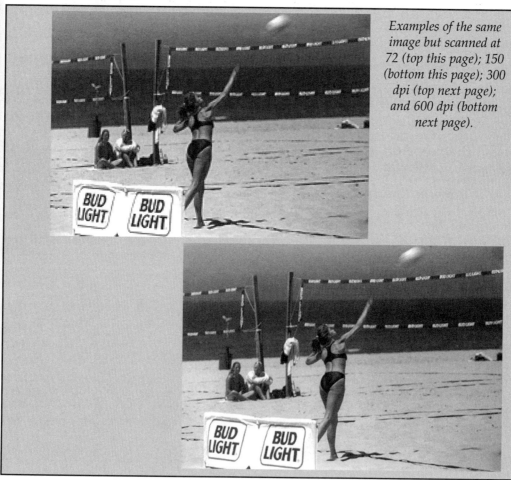

Examples of the same image but scanned at 72 (top this page); 150 (bottom this page); 300 dpi (top next page); and 600 dpi (bottom next page).

It's probably obvious that image quality improves with higher resolutions. Scanners with higher dpi numbers have higher resolutions and usually provide higher quality scans. However, you can reach a point where increasing resolution only increases file size; the image quality won't noticeably improve. Also, it takes longer to print images that were scanned at higher resolutions. For most of your work at home, scans from 300-dpi to 600-dpi are usually good enough.

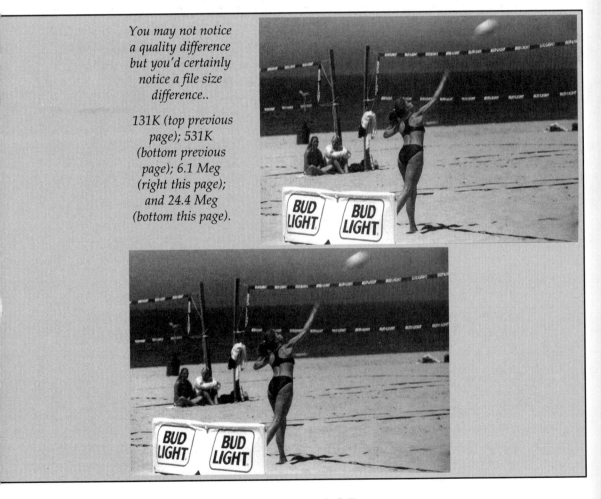

You may not notice a quality difference but you'd certainly notice a file size difference..

131K (top previous page); 531K (bottom previous page); 6.1 Meg (right this page); and 24.4 Meg (bottom this page).

You may think that scanning at a higher resolution is always the best choice. However, this requires more time, memory and storage space. So, before scanning at the highest possible resolution, consider:

1. The type of image you're scanning.

2. What you'll be doing with the scanned image.

Keep in mind that you create an image file on your hard drive each time you scan an image. The size of the file depends on the size and complexity of the photo and the resolution you use when you scan it. For example, if you scan a 5x7-inch photo at 300-dpi, the resulting file size may be 5.5 Meg.

However, scanning the same photo at 600-dpi doesn't double the file size, but quadruples the file size. This is because you're doubling both the horizontal and vertical resolution (from 300x300 dpi to 600x600 dpi).

Another argument for seriously considering resolution is time. Most scanners work much slower at resolutions above 600-dpi.

You'll read it more than once in this book but we'll say it again here: Don't scan an image at a level much higher than that of your final output resolution. You'll just be wasting time and hard drive space making the files unnecessarily large.

When to use 72-dpi or 100-dpi

If you're outputting images to a monitor (such as creating web pages) or e-mailing images to a friend, you won't need to scan images higher than 72-dpi. Monitors can only display images up to 72-dpi. Although you can use a higher resolution image, the only result will be larger file sizes; the image itself will not be any clearer. This not only saves disk space but also saves time when moving the image over the Internet.

When to use 300-dpi

If you intend to print a snapshot-size (4x6-inch or 5x7-inch) photo, then a 300-dpi scan will give you as much detail as you need. This is true even with a high-resolution color printer. In this case, the results from a 300-dpi scan of the image you want digitized are indistinguishable from what you get with a 600-dpi scan.

When to use 600-dpi

Use the maximum resolution of your scanner if you scan a large photo (for example, 8x10 inches) or if you want to enlarge a scan of a smaller original. For example, if you scan a 4x6-inch photo but want to print it at a larger size, scan it at a higher resolution so you don't lose detail when you enlarge it.

A simple way to determine the best resolution for your intended output is to learn the lines per inch (lpi) capability of your output device. Then multiply that number by a factor between 1.5 and 2.0. Don't be confused by the term "lpi." Many names are used for lines per inch (including screen frequency, screen ruling, halftone frequency and probably others). However, they virtually mean the same. It determines the size for the halftone cells (which consist of printed dots) that make up a printed image. The size of the dots are measured in lines per inch. This is important because the relationship between lpi and dpi influences how fine or coarse an image appears on the printed page.

The level of lpi determines the quality of the printing job. The following are some common examples:

❖ Newspapers use low lpi levels (about 85)

❖ Magazines and books (including this one) use lpi levels from 133 to 150

❖ Fine art books may use up to 300 lpi

167

So, for example, if you plan to insert your scanned images in a book or magazine, multiply 133 by either 1.5 or 2.0 to determine the best resolution for a scanned image. This gives us an answer of 199.5 or 266 for this example. Therefore, the optimal resolution setting for your image would then be 200-dpi to 266-dpi (depending on how high the output quality will be).

File Sizes for Typical Scans

This table shows how quickly images scanned at greater resolutions can require more valuable hard drive space. The source photos are typical 3x5-inch photos scanned at 100% and uncompressed.

Source	Color depth	Resolution	File size
4x6-inch b&w	8-bit	300dpi	2.2Meg
4x6-inch color	24-bit	72 dpi	360KB
4x6-inch color	24 bit	300dpi	6.5MB
8x10-inch color	24 bit	600 dpi	84.4MB

Match Resolution with Use

As you increase the resolution of your scan, you're also increasing the file size of the image. The following table lists the best scan resolution for your images.

Use	Scan resolution	Format
On-screen (Web, e-mail)	72 or 100 dpi, 8 bit	JPEG
Print snapshot	200 dpi or 300 dpi, 30 bit	TIFF
Enlarge snapshot or print large photo	Maximum resolution, 30 bit	TIFF

File format tips

One question your scanner software will prompt you to answer is in what graphics format do you want to save the file you're scanning. Here again, knowing your final use is important. Because many file formats are available, you need to select the format that your PC and software can use.

Consideration	Best format to use	Format to use to produce smallest file size	Platform Compatibility (i.e., from PC-Mac)	Format to avoid using
Continuous tones 24-bit color or 8-bit grayscale no text, few lines and edges such as photographs	TIF	JPG	TIF (without LZW)	256 color GIF is limited color, and is a larger file than 24 bit JPG
Solid colors less than 256 colors includes text or lines and sharp edges such as graphics, logos, line art and screen captures	TIF or GIF	GIF	TIF (without LZW)	JPG compression adds artifacts, smears text and lines and edges

As with resolution, you should choose the file type of your image files according to what you want to do with them.

When to use TIF (Tagged Image File Format)

Use TIFF for any image you plan to print or share with Macintosh, UNIX, DOS or Windows users. Also, most desktop publishing programs and word processors work best with TIFF images.

Although TIFF files produce high quality files, the sizes of the files can be quite large compared to the other two formats. Because of the large file size, many image editors and scanner programs include an option for TIF called LZW compression.

Even with LZW compression, TIF files are still usually too large to e-mail. JPEG files are a more efficient size for e-mail purposes.

When to use JPEG (Joint Photographic Experts Group)

Use JPEG (pronounced "Jay Peg") for any file you use in e-mails or on a web site. JPEG files are smaller than TIFs and therefore easier to send over modems, networks or the Internet. Because you view JPEGs on-screen, they don't need the detail required by a file that you want to print. Therefore, JPEG images do not print well compared to TIF files.

The Joint Photographic Experts Group developed the 24-bit JPEG format especially for reproducing photographs. Although popular on the Internet for downloading graphics, JPEG does not support transparency or interlacing. Also, not all Web browsers support JPEG files.

Since JPG uses a lossy compression, some quality is lost when the file is saved. Furthermore, more quality is lost each time the JPG file is compressed and saved again. In other words, every time you edit and save a JPG file, the quality of that image is decreased. (We can, however, read or view a JPG file countless times, such as from a web page, without affecting its quality.) This is why JPG is not suitable for storing a master copy of your data. Instead, save your master image as a TIF file.

A note concerning saving JPG files. When you save a JPG file, you can select the amount of file compression. Many programs will call this option "Quality" but other programs call it "Compression." Typical JPG compression values for normal images are 75-80% Quality or 20-25% Compression (depending on the program). A setting too low for Quality or too high for Compression will affect the quality of the image. This may take some experimenting to find acceptable levels. Save a temporary JPG file with a compression level of 50% and look closely at the image (zoom in 400% or so). Look for areas that are blurred and show some false color. Also, look for areas in smooth background colors that have become "blocky."

When to use GIF (Graphic Interchange Format)

Since all browsers and helper applications recognize GIF, it's one of the most popular graphics formats on the Web. The GIF format uses the LZW compression scheme, which reduces file size without loss of image quality.

CompuServe developed GIF many years ago and it now shows its age. GIF is limited to only 256 colors, which was great for the 8-bit video cards used years ago. Not only does that make it a bad choice for photographic purposes, the file is also large for photographic images.

170

If you're scanning graphics for the web, simple images like a company logo should be reduced to 16 colors if possible and saved as a GIF for smallest size on the web. Fewer colors usually mean smaller GIF file sizes and file size is important to web pages. Select this format when you need to compress an image file to be transferred via modem or a network, or to use it on a web page.

The reason GIF files are so popular on the Internet is that they can be displayed inline as a component within a Web page instead of as a graphic that launches in a new window. For example, a version of the GIF format, GIF89a, lets you assign one color as transparent, so that the background color of your graphic is the same as the color of the browser window.

You can also create an interlaced GIF files so images are sent to the browser in parts. Readers can view the page while the rest of the image is downloading.

Overcoming typical scanning problems

Bad contrast or brightness

The term contrast refers to the difference between light and dark pixels. A sharper contrast is produced when the range between light and dark pixels is higher. The following example shows the contrast in the photo is too low. The contrast must be increased in this photo.

This photo is an example of when you may need to adjust the brightness and contrast settings on your scanner. You can also use an image editor to adjust the levels, which is what we'll do with this photo in Chapter 10.

Askew

This is a frequent problem when using a scanner. It's when the scanned image appears crooked or out of line. The reason is that the photo was placed incorrectly on the scanning bed. This can happen when you lower the cover of the scanner — even this small amount of air moving can cause the photo to move.

The amount that the image is off-center may be subtle but noticeable. For example, the following image is just slightly askew:

*Example of what happens to a scan when the
photo is moved or placed incorrectly on the scan bed.*

Avoiding this problem is simple. Make certain the photo or image is straight by aligning it with the side and bottom/top of the scanner. Then rescan the image. Another possibility if you cannot rescan the image is to use the Rotate command in an image editor. However, using the Rotate command to line up a crooked scan requires a lot of guesswork. So it's probably faster and easier to just rescan the photo.

Pixelization

A problem associated with scanning images at resolutions that are too low is called *pixelization*. By looking closely at an image in a document, newsletter, magazine or even the Internet, you can tell if it's pixelated. An image showing curved or angled lines that appear stair-stepped or jagged is pixelated. The jagged appearance of the lines is why these images are also called the *jaggies*.

The problem of pixelization is increased when you start with an image that was scanned at a low resolution and import that image into a document or web site. Then you "stretch" or enlarge the image in the document or web site. The following is an example of how an image appears when it's scanned at a low resolution and then enlarged in a document.

173

*The image on the top is the original (scanned at 300-dpi).
The image on the bottom is the same photo but intentionally enlarged
here in PageMaker. Notice the pixelation affect in the bottom image.*

If the image doesn't look right when you compare the scanned image to the original image, it might be because the resolution was too low. If so, rescan the photo at a higher resolution. Although scanning at a higher resolution will increase the file size of the image, the resulting scan should look much better.

Another alternative is to use an image editor to adjust the focus. Select the focus or sharpen commands to smooth sharp areas or enhance dull ones.

The rule is to never enlarge or stretch an image in a word processor or desktop publishing program. If you need to enlarge the image, either scale it in the scanning process or using an image editor.

Moiré' patterns

Moiré' patterns are a common problem when scanning images from a magazine or a book. The best solution to this problem is to avoid Moiré' patterns altogether. This is especially true if high-quality scans are crucial to your project.

An example of how a Moiré pattern can affect a scan.

However, since this may not always be possible, use an image editor that can reduce Moiré patterns. An even better idea is to rescan the original image at the highest resolution possible. Then select the Despeckle filter or command in your favorite image editor. Then decrease the number of colors used to fewer colors.

Another possibility is to use the descreening function that the TWAIN driver may have. Although using the descreening function often affects the overall quality of the scan, it won't hurt to try the descreening function before scanning the image. Compare that scan with the scan using the Despeckle filter or command.

175

*Same image as above except we used the
Despeckle filter to remove some of the Moiré pattern.*

Color and brightness

The software included with most scanners lets you adjust color and brightness levels before you scan an image. Since these levels are set before the image is scanned, it's very easy to set the levels incorrectly. The result can be images that are too bright or contain too much of a single color (see the example below).

An example of how setting the brightness level too high can affect a scan.

You may need to experiment with levels on a new scanner until each scan comes out close to what you were expecting. Then you may not need to worry about setting the color and brightness levels again.

Experiment with the levels on your scanner until
each scan comes out close to what you were expecting.

To make small adjustments in the brightness or contrast levels, use an image editor instead of the scanner's software levels. Not only can you determine levels more accurately, it's much easier and faster to use an image editor to set these levels.

Part of the image is distorted or blurred

This problem is usually from a wrinkle, tear or other problem in the document or photo. If the photo is not torn or wrinkled, make certain the document is as flat as possible.

Make certain the image you're scanning fully touches the scanning bed. The document may have moved if you accidentally moved the scanner while it was scanning. Also, make certain the scanner is clean, on an even surface and not tilted.

Scanning thin paper

Scanning thin paper can result in images or text on the "back side" showing through on your scan.

177

To prevent this, place a sheet of black construction paper on top of the paper you're scanning before closing the cover. Then lower the threshold or increase the brightness to compensate for the black paper. The quality of the image may suffer a little but the scan will be much cleaner.

The following illustration shows a scan of an original image and the same image after following these steps (following page).

GEMINI (May 21 - June 21)
Working with your hands is a natural for you, for manual dexterity is a gift of your Sun Sign. But as an air sign you are also intellectually gifted, so a hobby that enables you to express both these talents will satisfy you most. Thus you would probably enjoy making and playing complicated scientific games like chem-chess (chess played with chemistry formulas) and Latin scrabble. Of course, you will probably wind up being a crazy old, eccentric kook, hiding your money in coffee cans and living alone, with a horde of schizophrenic cats and maybe one dog or lizard. Sure it's sad, but that's the price of genius. And it's well worth it.

Scanning thin paper, like newsprint, often presents its own problems but by following the suggestions on this page, you can avoid most of those problems. This is the original image and the tweaked image is on the following page.

> **GEMINI (May 21 - June 21)**
> Working with your hands is a natural for you, for manual dexterity is a gift of your Sun Sign. But as an air sign you are also intellectually gifted, so a hobby that enables you to express both these talents will satisfy you most. Thus you would probably enjoy making and playing complicated scientific games like chem-chess (chess played with chemistry formulas) and Latin scrabble. Of course, you will probably wind up being a crazy old, eccentric kook, hiding your money in coffee cans and living alone, with a horde of schizophrenic cats and maybe one dog or lizard. Sure it's sad, but that's the price of genius. And it's well worth it.

Scanning pages in a book

One problem in scanning large objects, such as pages from a book, is keeping the lid off the scanner as flat as possible on the object you're scanning. A way to avoid this is to place a weight on top of the scanner lid. Then you won't need to have to physically hold down the scanner lid while the scanner is working.

Some users have placed a gallon of water in a plastic jug for a weight on top of the scanner. However, it's not always a good idea to have liquids near a scanner (or anything electrical). A better idea is to use another book...large phone books work well.

Unneeded backgrounds

Sometimes background data, such as a border or text, results from having too large of a scanning area. Try reducing the scanning area or use the cropping tool in an image editor to remove the unneeded area. You're only increasing file size by having a scanning area that's too big.

Although you can use the Crop tool in an image editor, there's no reason for you to scan this extra area. Notice how large we set the scanning in the following example (highlighted by the dark border):

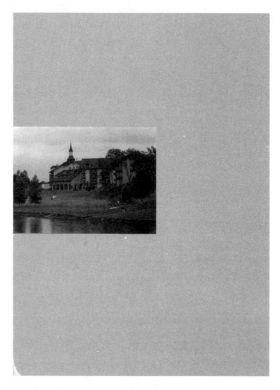

Although exaggerated in this image, sometimes
background data results from having too large of a scanning area.
You're only increasing file size by having a scanning area that's too big. (This
image has been reduced so it can fit on the page...the original size is 8.5x11-inches.)

To scan this image would require several extra (and unnecessary) minutes and take up unnecessary hard drive space. However, by adjusting the scanning area and scanning only the photo, the file size becomes more manageable (from over 26 Meg down to 4.6 Meg) plus the scan time was much faster. Even more time was saved because we didn't need to crop the image.

Put some distance between your scanner and your printer

Don't place your scanner too close to a printer, especially a dot matrix printer. This is particularly true if you plan to use both at the same time. The vibrations resulting from the printer can cause scans to come out blurred or unfocused.

Keep your scanner clean

We've said this before but it's so important we'll repeat it here (and probably many other times): Keep your scanner clean. Clean both the lens and the scanning bed frequently. Some scanners include pre-moistened towelletes for cleaning the lens and glass. Another option is to use a chamois cloth or Tyvek and rubbing alcohol. Do not use any abrasive cleaning cloth or materials to clean the lens and glass bed. Read your owner's manual for specific cleaning instructions.

Also, keep the cover of the scanner closed when you're not using the scanner. This will help protect the glass top. It can be an expensive repair if you need to replace the glass because it's scratched.

Check the focus

Here's a tip if you think your scanner's focus may be offline. Set your scanner to its highest optical resolution and make certain it's in full-color mode. Then scan a sheet of graph paper. Then use an image editor to zoom in on the edges of horizontal and vertical lines. Look for blue and red fringes at the edges of lines. This is a sign that the scanner is improperly calibrated.

Scanning thick or warped documents or images

The edges of the image may be discolored if the document you are scanning is very thick or warped at the edges. Use a sheet of black construction paper and cover the edges of the document to block outside light. A document extending beyond the limits of the scanning bed may also produce discolored edges. In this case, you would need to change the position of the document.

Finding the "sweet spot"

All flatbed scanners have areas within the scanning area that are better than other areas. This is true regardless of the optical resolution and even of the manufacturer and model. Try using this area, called the *sweet spot*, to get the best and most consistent scans. In other words, this is where on the scanning bed you should place the object you're scanning.

The problem is that locating or finding the sweet spot can be difficult. We cannot list or show the known sweet spots of even the bestselling scanners. The sweet spot isn't in the same location on each scanner. This is true with even the same models of scanners. However, we know how you may be able to find your scanner's sweet spot:

1. Make certain to clean the scanner, especially the scan bed, before continuing.

2. Place a clean white sheet of paper on the scanning bed. Make certain it covers the entire scan bed of the scanner.

3. Scan the object using a very low resolution (for example, less than 100-dpi).

4. Use the Equalize command (or its equivalent) in your image editor to show minor differences within the image area. You're looking for dark spots or dark areas on the image. Your scanner's sweet spot will be an area without these dark spots. These minor imperfections accumulate over time due to normal wear, so you'll want to periodically recheck your scanner's sweet spot.

Tips on OCR software

We've talked about OCR (Optical Character Recognition) software in Chapter 6. However, keep the following in mind if you're using OCR software. Most OCR software works well with modern fonts (those designed in the 19th and 20th centuries). However, older printed material or bad reproductions of any font will probably create problems. Typical problems for OCR software include broken letters, ligatures, uneven inking and old-fashioned letterforms.

We recommend trying a test scan before scanning in a large amount of text. Not only can this save time but it also might help reduce the error rate of the OCR software. Remember, the error rate should be low but not zero for most modern fonts.

The error rate can increase as the size and clarity of the text decrease. Try adjusting the brightness and resolution settings on the scanner to lower the error rate. There's no benchmark for this, so you'll have to experiment to find the settings that are best for your scanner and OCR software. Unfortunately, you won't be able to do much with a badly faded photocopy or a 17th- or 18th-century font.

Errors usually result from any problem that breaks the shape of the letter. The following are some examples of how the OCR software may misread letters:

❖ The letter "d" may be read as "cl"

❖ The number"1" may be read as the letter "l"

❖ The letter "h" may be read as "b"

❖ The letter "e" may be read as a "c"

❖ An exclamation point"!" may be read as "l" or "1"

❖ If you're scanning text from a page with tinted or color areas, scan each colored area separately using different threshold and brightness levels.

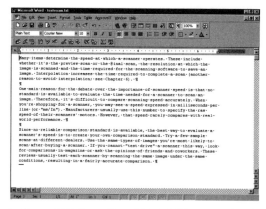

A part of page 139 from Easy Digital Photography that was scanned as text and "read" using OCR software and then loaded into Microsoft Word. See if you notice any problems between this and the real text.

When to use interpolated resolution

We've mentioned that the only time you should use interpolated resolution is when scanning line art. Examples of line art include logos, ink sketches or even mechanical blueprints. Although many people think of line art as only black and white, it can also be a one-color graphic.

Scanning line art

When scanning line art, try setting the interpolated resolution to the level of your output device. For example, if your output device will be a 1200-dpi imagesetter, try setting the interpolated resolution to 1200-dpi.

This will produce smoother lines and eliminate some of the unwanted "jaggies" that usually appear in line art scans.

Enlarging small originals

Another example of when you may want to experiment with interpolated resolution is scanning small photographs. Small school pictures are a good example (or other photos that are about 1x2-inches). We'll assume the maximum optical resolution of your scanner is 600-dpi.

To enlarge the photo to two times the original size without losing detail, interpolate the resolution to 1200-dpi. This way, the image might retain clarity and sharpness even if you double the print size.

Scaling tips

When you hear the term *scaling* with scanners, we're talking about creating larger or smaller images. Scaling images with a scanner means you won't have to resize the images later using your image editor. Scaling in a sense has an inverse relation to resolution. In other words, the lower you set the resolution, the larger you can scale the image, without increasing the file size or appreciably degrading the quality.

For example, you're trying to scan a small photo at 600-dpi. To double the image size of the photo without losing any detail (yet keep the resolution at 600-dpi), increase the scaling to 200%. This will create a much larger file. To keep this file smaller, scale it to 200% and halve the resolution to 300-dpi.

Examples of the same image but scanned at different levels. Notice how the file size increases as the scale of the scan increases.

You can, of course, scan the image at 100% and then enlarge it in your image editor. The image, however, will lose some quality. In this case, it's better to have the scanner do the work instead of the image editor.

Dynamic range

Another important factor in obtaining quality scanned images is the *dynamic range* of a scanner. Dynamic range is the ability of the scanner to register a range of tonal values. This range of values is from near white to near black. A scanner with a good dynamic range can map input shades correctly to the output shades. Then you'll be able to see more detail in an image.

However, a scanner with poor dynamic range cannot detect as wide a range of tonal values. In this case, the scanner will fill in the shadow areas or lose all detail in the highlights in an attempt to map the colors correctly. The resulting image will have much less detail.

A rule to remember concerning dynamic range is that anything above 2.0 is acceptable and anything above 3.0 is impressive. See Chapter 7 for some more information on dynamic range.

Chapter 9:
Don't Know What
To Scan? Try These
Ideas

Chapter 9

Don't Know
What To Scan?
Try These Ideas

Create a visual database
Create a virtual file cabinet
Fun projects
Filling out forms
Put your images on -shirts, mugs and more
Catalog your collection
Magazine/newspaper articles
Is your pet missing?
Archiving important documents
Add a professional touch to your documents or start a family newsletter
Save your signature
Use a photo to help the sale
Use a scanner as a photocopier
Special e-mail delivery
Your photos on the Internet
Make a visual family tree of old photos
Good as new
Removing unwanted subjects or objects from images
Immortalize your child's artwork
Make your web site sizzle
Create holiday cards, calendars and wrapping paper
Organizing your photos
Create a digital photo album
A new kind of slide show
Use a morphing program
Scan 3-D objects
Scanning food
Scanning great background effects
Copy road maps when you need to give directions

So now you've connected and installed everything and you're all set to start scanning. Now you have a new problem-what do you scan? Fortunately, that shouldn't be much of a concern because today's scanners let you scan virtually anything. It simply takes a couple of mouse clicks to scan an object. Maybe not everything will scan perfectly or as expected; for example, the entire image may not be in focus or aligned correctly. However, be optimistic and consider that maybe it will only add to the "artistic value" of the scan.

For example, are you tired of looking at the same wallpaper on your PC? Try scanning part of colorful or plaid design (such as a flannel shirt) and use the resulting scans as new wallpaper. The following image is an example of some bland, old wallpaper.

This is an example of the same "tired" wallpaper that you've seen countless times in Windows 95 or Windows 98.

However, by scanning part of a flannel shirt and then using an image editor to tweak the image, we created this new wallpaper:

Example of new wallpaper created by scanning part of a flannel shirt and then using an image editor to tweak the image.

Don't Know What To Scan? Try These Ideas

Chapter 9

Note About This Section

If you haven't bought a scanner yet, maybe the information in this section will help persuade you to buy one. You'll see that a scanner can be used for more than just scanning documents and paper. We'll talk about several interesting, neat and fun things you can do with a scanner. Of course, we'll also talk about the practical reasons for using a scanner (such as archiving important documents).

Create a visual database

Maybe you or someone you know has been an unfortunate victim of a fire, theft or other damage. If so, you'll understand how valuable pictures can be when it is time to talk to the insurance adjuster. You can create a visual database by combining photos and your PC. This is a great way of keeping a complete record of valuable property such as art, coins or other collections. Owning a picture of a valuable item that is lost can be very useful in settling disagreements about its ownership or condition.

This is an easy project to do. Start by using a 35-mm or digital camera to snap pictures of your collection and valuable possessions. Then scan the photographs (if you were using a 35-mm camera). Use an image editor to enhance or enlarge the photos, if necessary.

Insert the photo in a word processor document or image editor. Add information about the item, such as its condition, purchase date, purchase price, current value, etc.

Don't Know What To Scan? Try These Ideas

Chapter 9

Create a virtual file cabinet

One reason we can say the paperless society is a myth is that we're still buried daily by letters, faxes and other mailings. However, many of us are sometimes hesitant to toss anything because tomorrow we may just need what we throw out today. If you think that a document is too valuable to throw away or want to have another copy, use a scanner and save it electronically.

To make your work easier, several programs are available to manage those electronic documents. These programs (such as Visioneer PaperPort Deluxe or ScanSoft Pagis Pro 2.0) are called document management programs and let you store black and white or color documents, news clipping and more. For more information visit their websites (www.visioneer.com and www.pagis.com).

Don't Know What To Scan? Try These Ideas

Chapter 9

You may also want to turn your scanned text into text you can edit in a word processor. If so, consider an OCR program such as Caere OmniPage Pro (http://www.caere.com/). See Chapter 6 for more information on OCR software.

Fun projects

The weather outside may be lousy and your kid's attitude from being stuck inside is just as lousy. You could switch on the television and let them watch the same old programs. A better idea is to let them get creative with digital photos. Several image editors let your kids put their pictures on magazine covers, Mount Rushmore or in crazy costumes and wigs.

Another idea is using the Olympus P-300 thermal photo printer. It includes a photo-sticker option so kids can snap photos and print them out as mini stickers (see http://www.olympusamerica.com/digital/products/p300/p300.html for more information)

Don't Know What To Scan? Try These Ideas

Chapter 9

Filling out forms

We're all aware that death and taxes are two certainties in life. A third certainty, especially in recent years, might possibly be filling out forms (and filling out forms is almost as exciting). However, to make the work easier, use your scanner and a program like Caere OmniForm 3.0 to scan your forms and make them electronic. These programs then let you and others fill out those forms online. The finished forms can be submitted through an e-mail.

Put your images on T-shirts, mugs and more

A great way to show off your digital images is on a T-shirt. Use a program such as T-ShirtMaker 2.0 from Hanes to create your own t-shirts. This program includes designs, iron-on transfer paper and an editing tool to put your images onto your t-shirts. We've included a demonstration version of the program on the companion CD-ROM. See Chapter 15 for more information on the CD-ROM or visit their website (http://www.hanes2u.com) for more information on T-ShirtMaker 2.0.

You'll find a free preview edition of T-ShirtMaker on the companion CD-ROM.

Don't Know What To Scan? Try These Ideas

Chapter 9

Pix.com (formerly called PictureMall) offers a similar service as Hanes's T-Shirt Maker but specializes in putting digital images on more than only t-shirts. The process is very easy. Simply drag your digitized image onto the Drag-Here box on Pix.com Web page and click the item that you want to affix to your image.

You can select from a T-shirt, mug, baseball cap, calendar, stationery, jewelry, posters and more (even edible cookies). Then enter your credit card number.

In a few days your item will arrive complete with your digital images. Pix.com also offers free software that makes it easy to upload multiple images simultaneously.

Catalog your collection

A related idea is to use a scanner to catalog your collection. A collection doesn't have to be limited to coin or stamp collectors. Perhaps you're a collector of other items: pinup calendars, comic books, recipes or even newspaper clippings, for examples.

Don't Know What To Scan? Try These Ideas

Chapter 9

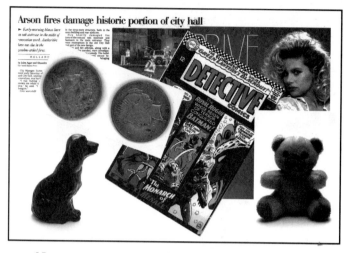

Use your scanner to catalog your collection of pinup calendars, comic books, recipes or even newspaper clippings.

Use a scanner to scan your collection. Then import the scanned file into a database or word processor and catalog every item in your collection. Then you'll be able to find anything in a fraction of the time. If you're using a database, you can sort the items in a particular order (i.e., alphabetical, value, date, etc.). This is also a good idea if the collection is valuable (see above).

Magazine/newspaper articles

Use a scanner to keep copies of newspaper articles and magazine articles. A scanned image of a magazine or newspaper article is usually better quality than a photocopy of the same article. Besides, you can add the article into a letter by importing it into a Word document.

Don't Know What To Scan? Try These Ideas

Chapter 9

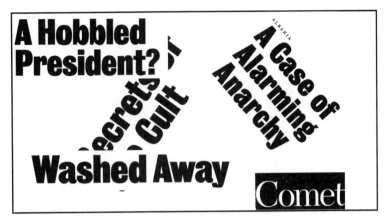

Examples of some recent headlines scanned from a newspaper.

Also, newsprint fades after a short time and magazines can become lost or thrown away. However, if you scan the article you want to keep, you'll always have a copy of it. This is a great way to keep copies of important and unusual news headlines, interesting stories, etc.

Is your pet missing?

You've probably seen "LOST PET" messages on telephone poles, grocery store bulletin boards or other public areas. Did you remember much about the message other than a group of words? Well, if your pet ever decides to run away, you can also use a group of words to describe the lost pet. However, why not scan a photo of your lost pet and use an image editor to add more impact to the message. It's much more effective than simply creating a flyer describing the pet. Potential rescuers are more likely to remember a picture of the missing pet with a description than just a description alone.

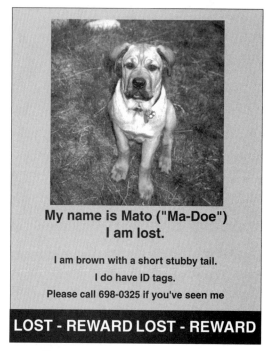

My name is Mato ("Ma-Doe")
I am lost.

I am brown with a short stubby tail.
I do have ID tags.
Please call 698-0325 if you've seen me

LOST - REWARD LOST - REWARD

Archiving important documents

Using a scanner is also an excellent way to archive important documents. These include marriage certificates, savings bonds, deeds, tax forms, sales receipts, birth certificates, important family documents, etc. These documents are easy to misplace but hard to replace. Most electronic files of tax forms, receipts, etc., are considered legal documents by the IRS (check with your tax consultant first).

Don't Know What To Scan? Try These Ideas

Chapter 9

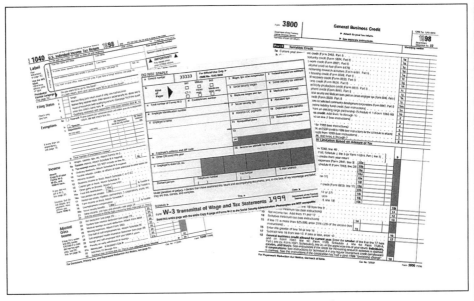

*Use as scanner and scan important documents
such as tax forms, certificates, insurance papers, etc.*

Scan your important documents and store all the images on a floppy diskette or removable storage device such as a Zip drive. Then keep this diskette or cartridge separate from the original documents. You can then print files that are stored on the diskettes or cartridges if necessary.

Add a professional touch to your documents or start a family newsletter

We mentioned that pictures help break up text or add emphasis to a story. So, instead of sending long-winded letters to your friends, add a few scanned photos of your trip, your child's birthday party, wedding or whatever.

A family, especially a large family, usually always has news of some sort to share. If this applies to your family, then start a family newsletter. A family newsletter is great for grandparents and other relatives who you don't see often. The best part is that everyone in the family can add to the newsletter by writing stories about the news in their lives. Use your scanner to scan photos and emphasize the stories and news.

Don't Know What To Scan? Try These Ideas

Chapter 9

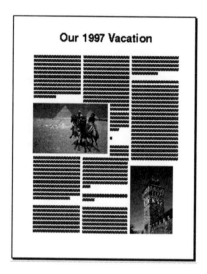

There's no need to panic. You won't need expensive software or hardware to create a family newsletter. Most word processors have basic features that you can use for a simple newsletter. You can also use a program like Microsoft Publisher to create the newsletter.

Save your signature

You're probably one of the millions who are sending and receiving e-mail messages today. Nevertheless, you've probably also noticed that communicating by computer can be very impersonal. How many e-mail messages have you received with a signature? The answer is probably very few, if any. However, you can personally sign your e-mails. Simply scan your signature and save it as a TIF file. Then add it to your e-mail or fax documents to add a more personal touch to e-mail messages.

If you need to encrypt or password protect your signature, consider a program such as ApproveIt for Office from Silanis Technology. These programs are called signature software. For more information (or to download a demo version) visit their websites (http://turboguide.com/data2/cdprod1/doc/software.frame/021/755.pub.Silanis.Technology.Inc.html) and http://www.silanis.com/silanis/

Don't Know What To Scan? Try These Ideas

Chapter 9

ApproveIt from Silanis Technology is an example of how you can personalize your E-mail messages by adding your signature.

Use a photo to help the sale

A picture of what you're selling or promoting can usually do more to generate interest than using plain text to explain the item. Scan a photo of whatever you're selling and add the photo to the text. The item for sale can be as large as a house or as small as articles for a summer garage sale.

Include a scanned photograph can help you sell items.

Don't Know What To Scan? Try These Ideas

Chapter 9

Use a scanner as a photocopier

Use your scanner instead of a photocopier. For example, you're leaving for vacation and want friends to know your itinerary. You could write down the itinerary for everyone but something could be overlooked. A better way is to write down the itinerary once and then scan it. Then you can e-mail the itinerary to those on your list.

Some scanners include OCR (optical character recognition) software. You can use this type of software to create a cookbook of favorite recipes by manipulating scanned text in a word processor or desktop publishing program. See Chapter 6 for more information on OCR software.

Special e-mail delivery

Since an e-mail message is only a collection of words, you probably would not disagree with anyone saying that e-mail massages are not visually exciting. Fortunately you can change that by using an e-postcard utility such as PictureWorks NetCard, Novita LiveLetter and Broderbund Print Shop LiveMail. They let you send photos (with captions, sounds and animations) to anyone with an e-mail account.

The idea for LiveLetter is that all e-mail should act like a Web page. Its messages are created and displayed as HTML documents so your e-mail can include anything that works on a Web page. This includes textured backgrounds, pictures, hotlinks, text formatting and much more.

Both LiveMail and NetCard are only for sending messages. LiveLetter is a full e-mail client complete with multiple folders, sorting and filtering tools, and an address book. Messages you send to other LiveLetter users open automatically in the pseudo-browser interface; everyone else gets an executable attachment, which automatically launches the receiver's default browser.

Don't Know What To Scan? Try These Ideas

Chapter 9

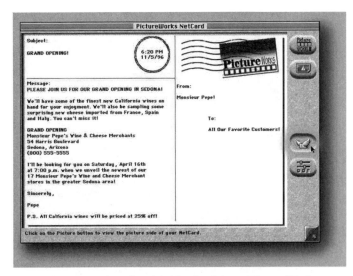

*All you need to do with NetCard from PictureWorks
is to type and address your message, and then click the "send" button.*

The Print Shop LiveMail includes several animations you can use to personalize messages. Once you've created a message from scratch or by using one of over 200 included templates, simply address it and click on Send.

Your photos on the Internet

Maybe you're very proud of the photos you just took of a family reunion but are wondering how to show those pictures to all the family members without making copies for everyone. Instead of ordering copies for everyone, put your photos online for everyone, including the rest of the world, to see. You can do this even if you don't have a web site. Simply rent some space from an online photo service such as Kodak PhotoNet Online (http://kodak.photonet.com/) and Sony ImageStation (http://imagestation.sony.com/). For a low monthly fee, they'll let you store digital photos online for viewing over the Internet.

Don't Know What To Scan? Try These Ideas

Chapter 9

Kodak PhotoNet Online (http://kodak.photonet.com/), top, and Sony ImageStation (http://imagestation.sony.com/), bottom, are two examples of online photoservices.

We'll talk more about online photo services in Chapter 15.

Don't Know What To Scan? Try These Ideas

Chapter 9

Make a visual family tree of old photos

Millions of people are interested in genealogy and use their PCs to create or maintain a family tree. Most genealogy software will let you add a scanned photo to accompany information on each member in your family tree. This is a great way to add "personality" to your genealogy. You may be surprised (and maybe depressed) at who resembles who in your family.

Use a scanner to "archive" old or important photos. Then, in a sense, you have backups of important photos. Photos that are passed around - family photos are a good example – are easily lost or are never returned. Use a scanner to send quality copies to everyone who wants a copy. You'll find the image quality to be better than using a photocopier.

Good as new

Use your scanner to scan your grandparents wedding photos or your childhood pictures into your PC and make them good as new. The image editors we talk about in Part 3 of *Easy Digital Photography* have tools to remove scratches, improve color and provide other "fixes."

Don't Know What To Scan? Try These Ideas

Chapter 9

Removing unwanted subjects or objects from images

You've probably suffered through a bad divorce, breakup or maybe you just want to forget a former best friend. Unfortunately, you probably have good photos in which these people appear. Instead of throwing away all the photos, use a scanner and an image editor to remove the unwanted person from your photo. Add a good quality color printer to your setup, and you'll even be able to print out replacements for the original. We mentioned using the Clone Brush in Chapter 8 to remove people from an image:

Don't Know What To Scan? Try These Ideas

Chapter 9

The same can be done with buildings and other objects, too.

*The top is the original photo but we've "removed" part of
the building in the bottom photo. This is a "work in progress" but will give
you an idea of what can be removed from an image using an image editor.*

Don't Know What To Scan? Try These Ideas

Chapter 9

Immortalize your child's artwork

Turn your child's artwork hanging on the refrigerator door into a screen saver or wallpaper for your PC. You can scan virtually anything. Paintings, crayon scribbles or even projects made with yarn can be scanned and saved. Many image editors have a screen saver feature that will turn your child's artwork into a screen saver or slideshow.

For example, programs such as Creative Wonders Album Maker (http://www.photocreations.com/amaker.html) will let you turn these works of art into screen savers, mouse pads or multimedia scrapbooks that will be around long after your little ones pack up their crayons.

Besides showing off your children's drawings on the refrigerator door, you can show off the same artwork on the Internet. Don't worry if the artwork isn't paper or even completely flat. We'll talk soon about scanning 3-D objects.

Make your web site sizzle

Graphics make the World Wide Web visually interesting. The web sites that not only win awards but also use graphics to get the attention of Internet surfers. This is especially true for Web site home pages. Web sites displaying only text will not get much attention (or at least not the right kind of attention).

To add some "umph" to your web site, scan in photos that relate to the subject of your page. Use the photos to emphasize the information in the text. Add some inviting pictures to attract visitors to a link, add personality to your pages and encourage the surfer to look through your complete site. Web surfers are impatient, so use color graphics to combine important information and maintain their attention. Check the file size of the photos; otherwise, the images may take too long to download.

Don't Know What To Scan? Try These Ideas

Chapter 9

Create holiday cards, calendars and wrapping paper

You may never need to buy greeting cards again. Use your scanner to scan personal items (family photos, objects from a collection or an illustration you drew by hand). Then repeat the pattern over the entire page and print to create a customized card or even gift wrap.

Use a program such as Microsoft Home Publishing 99 or Broderbund Print Shop Signature Greetings to make a greeting card from your digital images. You can even use these programs to create personalized envelopes. Then use an ink-jet printer to print store-quality cards. (You can also send the custom cards over the Internet.)

Using PhotoSuite II from MGI Software
(www.mgisoft.com) to create a greeting card from a scanned image.

Custom greeting cards have one disadvantage: they are short term. If you want something that will last a little longer, use an image editor to create calendars with your photos and images.

Don't Know What To Scan? Try These Ideas

Chapter 9

*Using PhotoSuite II from MGI Software
(www.mgisoft.com) to create a calendar from a scanned image.*

Finally, use an image editor to tile your favorite digital image. Then print the image on a good ink-jet printer and use the printed copy as personalized wrapping paper. Not only is it cheaper, but it can be a lot of fun too to get your creative talents showing.

Organizing your photos

Keep in mind that simply storing digital photos on your hard drive is no better than storing photos in an old shoebox. Instead, use a program such as Photo Org from Canon Software Publishing or ImageStation from Sony to keep track of your photos by date, name and keyword. Since the images are stored in a database, you can look for an image with a search feature or scroll through thumbnails.

Some image editors, such as MGI PhotoSuite II, also let you organize your photos in electronic albums. Then you flip through your favorite memories page by page.

See Chapter 13 for more information on Image Managers.

Don't Know What To Scan? Try These Ideas

Chapter 9

Create a digital photo album

Try creating a digital photo album to memorialize a family reunion, vacation or just to organize your photos. Software is available (such as Creative Wonders Family Album Theatre) that you can use to create a digital photo album.

You can also put your photos into an old-fashioned, albeit digital, photo album. A program such as Album Builder from Sound Vision lets you create digital album pages you can print. You can place, crop, and size your digital images onto any size sheet - even add labels and captions. Then print and insert the sheet into a plastic protector that fits into a three-ring notebook.

A new kind of slide show

Don't bore your friends and neighbors with old-fashioned slide shows. Many image editors, including those we talk about in Chapters 10-14, can create slide shows. So, scan your vacation photos and then use one of these image editors to create slide shows. There's no guarantee that your guests won't still be bored, but it will at least be a new type of slide show for them.

Use a morphing program

Have some good laughs with your scanned photos. Use a morphing program to add some crazy fun to family photos or other images. Blend several photos of your children at different ages and watch them grow. Turn photos of your cat into the neighbor's dog. The results will be entertaining, at the very least.

Don't Know What To Scan? Try These Ideas

Chapter 9

Scan 3-D objects

Use your scanners to scan more than just images on paper. A fun and creative activity is to scan 3-D objects with a scanner. Don't be afraid to experiment; if something doesn't look good or scan just right, all you've lost is a little time. Any 3-D object that you want to scan should be relatively flat but, more importantly, the object must fit on the scanning bed. If you don't want the white background of the scanner cover to appear in the scan, place a colored sheet of construction paper on top of the object for an added effect.

We mentioned neckties above but try other articles of clothing too (for example., a dress pattern, flannel shirt). Try a sheet of fabric softener or a handful of lint from the dryer. Scan other objects such as keys, paper clips, push pins, cotton swabs, cotton balls, sand or dirt (don't spill any inside the scanner and don't scratch the glass).

Examples Of 3-D Objects

Examples next page (clockwise), pushpin, pinecone, plastic fork/spoon, dish scrubber, ponge and scissors.

Examples this page: water pistol (above) and navel orange (right).

See the companion CD-ROM for more examples.

Don't Know What To Scan? Try These Ideas

Chapter 9

Note On Scanning 3-D Objects

Feel free to experiment but don't damage your scanner. Also, remember to clean the scanning bed carefully when you're finished scanning. You'll find that flatbed scanners are very versatile except for maybe one scanning job. Under no circumstances do you want to scan liquids — it's simply too dangerous.

Other items you can try include buttons, pencils, pens, screws, bolts and countless other items.

Notice the shadow that appears on some 3-D objects in one direction after they're scanned.

This shadowing effect can make the image look better than the same scanned image without shadows. This effect can add some perspective or depth to the 3-D objects.

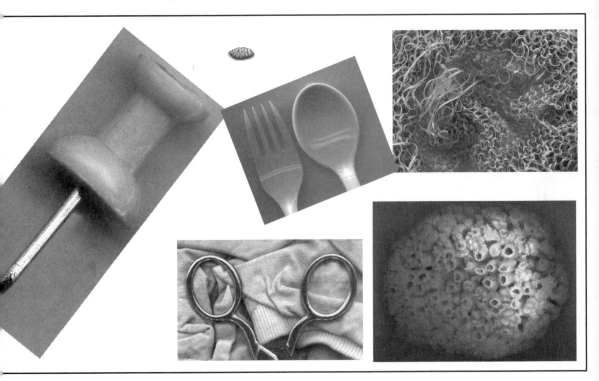

Don't Know What To Scan? Try These Ideas

Chapter 9

Scanning food

Some food can be fun to scan. For example, try scanning M&Ms, jelly beans or sugar. The resulting scan of many foods can look surprisingly good. As we mentioned above, the scanner creates a soft, natural shadow that is similar to the effect of studio lighting.

Note On Scanning Food

We'll repeat it here...feel free to experiment but don't damage your scanner. Also, remember to clean the scanning bed carefully when you're finished scanning food.

Under no circumstances do you want to scan liquids – it's simply too dangerous.

Examples Of Food

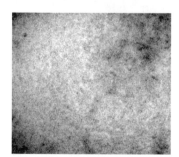

Examples this page (clockwise): rice, breath mints, fortune cookie and sugar.

See the companion CD-ROM for more examples.

Don't Know What To Scan? Try These Ideas

Chapter 9

The following page shows some examples of how sugar and rice appear after they're scanned.

Scanning great background effects

Use a textured background to add depth and interest to multimedia presentations, web sites or even wallpaper for your PC. You may never run out of background ideas to scan. As we've said, don't limit yourself to paper and photos. Place leaves, coins, cloth, keys, certain foods (no liquid!) or even tinfoil on the bed of your scanner. Then save the scanned file for use in later projects.

Money and coins can make interesting effects for projects or computer wallpaper.

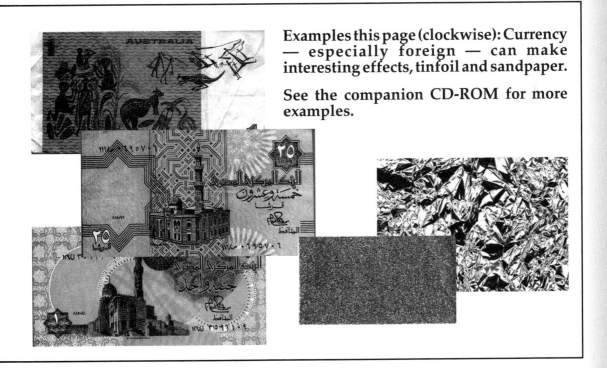

Examples this page (clockwise): Currency — especially foreign — can make interesting effects, tinfoil and sandpaper.

See the companion CD-ROM for more examples.

Scan money and coins or even tinfoil and sandpaper for some great background effects.

You can find many items around your house that can make an interesting backdrop or computer wallpaper. Check your closets, drawers and especially "junkboxes." Whatever you use as a background effect, be careful not to scratch the glass of the scanning bed (for example, with the sandpaper).

Copy road maps when you need to give directions

If you've ever had out-of-town or out-of-state friends or relatives visiting you've probably sent them a list of directions. Now you can use your scanner to scan a map and indicate the best route to reach you right on the map.

This is a much more effective way of showing directions than a list of "Right turn at the fourth light. Continue until you see the golf course and then take the first right until the stop sign..." Instead of sending them just a list of directions, scan a map and add that image to the directions (see example next page)

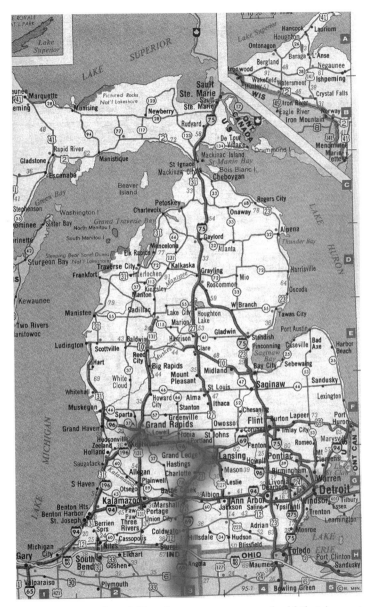

Instead of sending a list of directions, scan a map and add that image to the directions or use one of the paint tools in an image editor to highlight a specific route.

Part 3

Image Editors

Chapter 10: Image Editors Are The Digital Darkrooms

Chapter 10

Image Editors Are The Digital Darkrooms

Introducing Image Editors

What is an image editor?
Hardware requirements
Evolution of image editors
Using an image editor doesn't need to be difficult

Features You'll Need In An Image Editor

Zooming in and out
Undo command
Restore command
Reversing orientation: Flip, mirror, skew
Cropping an image
Special effects
Filters
Brightness and contrast
Adjusting Highlights/Midtones/Shadows...
Clone tool for touching up problem areas

Image Correction Tips

The image you just snapped with your digital camera or scanned with your scanner is only a starting point. The next step is using an image editor to manipulate (or what we like to call *tweak*) the image. You might even tweak the image to the point where you can't recognize that it's related to the original.

You can even tweak the image to the point (right)
where you can't recognize that it's related to the original (left).

At this point you may be asking, "Why would I want to manipulate a photo?" If you're asking that question, you may be surprised to learn that your photolab has been manipulating your pictures for years. A good photolab is usually able to "fix" pictures that were taken at the wrong f/stop or shutter speed.

In fact, photographs have been manipulated as far back as the mid-1800s. These changes included adding or removing subjects, adjusting contrast or cropping the photograph. These tweaks required very special darkroom equipment and a lot of expertise (not to mention large amounts of time and patience). However, now anyone with a computer, the right type of software and a few minutes of time can tweak an image. The right type of software is called an *image editor*.

Introducing Image Editors

Image editors have joined digital cameras and scanners in the "hot" category of the consumer market for the same main reason: Today's powerful PCs generate the necessary horsepower and speed. In case you're not familiar with image editors, we'll talk about what they are and what they're capable of doing in this section.

What is an image editor?

We'll start by explaining what we mean by the term *image editor*. An image editor is a software program that includes commands, features and functions that let you improve or enhance a less than perfect photograph. You can also use an image editor to change or modify a part of a photo.

Many image editors are available from many sources. Many scanners and digital cameras include an image editor but these editors are usually limited or special edition versions of other, more capable programs. We recommend getting the full working version of an image editor that has all the features and power. Don't panic; you won't have to get a loan to buy one of these programs. Most of the image editors we're talking about here cost under $100 yet include the features and capabilities you'll need to perform your magic on an image.

Copyright Issues

You can, of course, do any amount of editing to your own photos. However, if you're planning to edit images taken by others, (particularly, but not exclusively, professional photographers) first make certain you're not breaking any copyright laws.

Even images that you can buy usually have strict guidelines on how you can use them. Our advice is that if you're in doubt about an image, don't use it. Copyright issues also apply to images that you do not edit so it's generally illegal to publish (including on the Web) images without the permission of the image creator.

Hardware requirements

You've undoubtedly heard the term "bigger is better" when it comes to computer hardware and software. Image editors are a good example. The following table shows our hardware recommendations to use a typical image editor:

System	Minimum ("bare" minimum)	Recommended
Processor	486/66	Pentium-class (or higher)
Hard drive	300 Meg free on your hard drive	1.2 Gigabyte or better hard drive
	These images are normally very large—it's not unusual for 4 x 5-inch color photos to be about 20 Meg each in size.	
RAM	8 Meg	32 Meg
	Try to have 3 times as much RAM as the largest image on which you're working, plus enough for your software and operating system.	
Video card	SVGA Video card (2 Meg of video RAM)	
Monitor	14-inch	15-inch but a 17-inch is better
CD-ROM drive	8x speed	12x or higher

Keep in mind that if you're limited to using the minimum hardware requirements, the image editor will probably run dreadfully slow on your PC. Never consider anything less than the minimum requirements; you'll only be frustrated.

227

Another system component that you might want to consider is a removable storage device such as the Zip drive or the Jaz drive (both from Iomega). The Zip uses discs similar to floppy diskettes but these discs can store 100 Meg of data. The Jaz drive uses a removable 1-Gigabyte cartridge.

Consider a removable storage device such as the Zip drive or the Jaz drive (both from Iomega - www.iomega.com) when your storing images.

Also, many of the image editors we talk about are for Windows 95 or Windows 98. If you're using Windows 3.x, check with the publisher or dealer. A Windows 3.x version is probably available as well.

Evolution of image editors

Photo editing software and image editors have evolved from "paint" programs such as Paintbrush and PC Paint Plus. Many of today's experienced users probably started with at least one of these programs (maybe even the "Paint" program that is included with Windows). Obviously, software has evolved quite a bit from the original paint programs. In fact, about the only similarities are that today's image editors can still work with the BMP and PCX files used by the old paint programs and they include many of the paint functions.

Paint programs are still used today;
Paint has been part of Windows 3.x and Windows 95/Windows 98.

The first image editors were very expensive (costing several hundred dollars for one program) and designed primarily for professional editors and graphic artists. So if you were new to image editing or wanted to experiment with image editors, software like Photoshop was an expensive overkill. Fortunately, many publishers have released image editors designed specifically for the home market. Although these editors are much less expensive, they included many of the same features as the powerful editors. Again, most of the image editors that we use in this book cost about or under $100.

Although the programs we're talking about do have paint features like their ancestors, they're image editors because they let you actually edit an image. Remember we said at the beginning of this chapter that you could change the original image in so many ways that it can become unrecognizable. For example, does the following image on the left look anything like the image on the right? Well, it is the same image, only it's undergone several changes courtesy of an image editor.

Features You'll Need In An Image Editor

An image editor should have certain basic features and functions because even the most basic image editor will let you do many things to an image. These are the same tasks that are done in a darkroom (but it would take a lot more time in a darkroom). Regardless of price and other features, you should look for certain features in an image editor. We'll talk about those features in this section.

Zooming in and out

You can zoom into and out from an image by using the Zoom tool. How you select and use the Zoom tool depends on the image editor, although the effect is the same. It works like a magnifying glass so you can get a close-up look at your work. Notice in the following illustrations how much easier it would be to work on small details after zooming in on a specific part of the image.

Being able to zoom in on part of the image lets you tweak
small details that may be missing in a larger size of the image.

The image only appears to be larger on the screen; the Zoom tool has no affect on the file size of your image or the size of the printout.

Undo command

Since everyone makes mistakes, it's always a good idea to use an image editor that has an Undo command. Select this command if you want to reverse ("undo") a mistake. In other words, this command reverses the last edit to the current image. Some image editors have several levels of undo so you can correct the most recent mistake and a mistake you may have made before that one, and so on.

Say for example, that you used the Paint tool to paint part of an image. However, you decided that maybe the Pen tool would look better instead. In that case, select the **Edit | Undo** command to reverse the action of the Paint tool and restore the image to its appearance before you used the Paint tool.

Restore command

Since you may not be able to use the Undo command in some situations or if Undo cannot fix a mistake, image editors include a Restore command (also called "Revert" or something similar). Use this command to abandon all changes you've made to a file since you saved it last. Most image editors will prompt you to confirm that you want to restore or revert to the original file.

Reversing orientation: Flip, mirror, skew

An image editor should include commands that let you reverse the orientation of an image or a selected part of an image along the vertical and horizontal axes. These commands are usually called Flip, Mirror and Rotate (or something similar).

A Flip command reverses the image or selection vertically. In other words, what was the top becomes the bottom and the bottom becomes the top.

Quick Tips For Selecting An Image Editor

Templates

Most software will include examples and templates that provide an easy way to get started.

Layers and Masks

These were features previously found only in powerful, expensive image editors. Today the ability of working with layers and masks are an important features for all image editors.

Undo command

Since everyone makes mistakes, it's always a good idea to use an image editor that has an Undo command. Select this command if you want to reverse ("undo") a mistake.

Special effects

One of the reasons many people use an image editor is to apply special effects to an image. Some special effects are unique to a specific image editor. However, most image editors should have Emboss, Negative and Motion Blur special effects.

Restore command

Since you may not be able to use the Undo command in some situations or if Undo cannot fix a mistake, image editors include a Restore command (also called "Revert" or something similar). Use this command to abandon all changes you've made to a file since you saved it last. Most image editors will prompt you to confirm that you want to restore or revert to the original file.

Capabilities

Make certain the features of the image editor match your requirements. Don't spend money on features you'll never use.

Zooming in and out

Make certain the image editor has a zoom tool that lets you zoom in on and out from an image.

Windows 98 or 95

Some image editors may be available only for Widows 98 so make certain it matches your operating system.

Easy-to-use

The software should be intuituve and easy-to-use. The manual or help files should be all that is needed to learn how to use the program.

Reversing orientation: Flip, mirror, skew

An image editor should include commands that let you reverse the orientation of an image or a selected part of an image along the vertical and horizontal axes. These commands are usually called Flip, Mirror, Skew and Rotate (or something similar).

Cropping an image

One of the easiest-to-use features yet one of the powerful features is cropping. Using an image editor to crop an image is similar to taking scissors to a photograph: you cut off one or more of the outside edges to remove unwanted parts of the original graphic.

Original image is on the top but it has been flipped in the illustration on the bottom.

The Mirror command reverses the image or selection horizontally. Then what was the left side becomes the right side and the right side becomes the left side.

Original image is on the top but it has been mirrored in the bottom illustration.

Note that the Mirror command reverses everything in the image. This includes billboards, street signs, clocks, and anything with words and letters so be careful when applying this command. For example, note how the player's numbers have changed after the Mirror command was applied.

One more item concerning applying the Mirror command. Remember that right-handed people will appear left-handed, watches and rings will appear on the opposite hand and drivers will be on the right side instead of the left side in their cars. Therefore, because the Mirror command reverses everything in an image, you need to be careful when using it.

An image editor should also have another useful option called the Rotate command. This lets you rotate the image clockwise or counter clockwise in precise degrees that you specify.

Our original image has been rotated in these illustrations
(90 degrees clockwise, left, and 90 degrees counterclockwise, right).

A related feature is called skewing. This feature slants a selection vertically or horizontally.

Original image is on the left; it has been skewed on the right.

In other words, you can slant a selection left, right, up or down. You move one side of the image or selected part of the image parallel to the opposite side.

Cropping an image

One of the easiest-to-use features yet one of the powerful features is cropping. Using an image editor to crop an image is similar to taking scissors to a photograph: you cut off one or more of the outside edges to remove unwanted parts of the original graphic. In the example below, we cropped the picture to remove part of the sky and the moon.

Cropping is an easy-to-use yet powerful feature in an image editor.

By cropping this image, we were able to emphasize the pitcher more than the other players. However, you have to be careful when cropping. You don't want to be overeager and crop important details or throw off the image's visual balance. Although this is especially true with people or animals, it also applies to other objects as well. For example, notice the difference in the following two images. Although the bottom of the photo was cropped effectively, too much was cropped from the top. This resulted in part of the top of the house being removed:

*Examples of not being careful with the crop tool
and cropping too much from our original image.*

Special effects

One of the reasons many people use an image editor is to apply special effects to an image. For example, silhouetting an image can produce impressive results. The best part is that you won't need to spend much time or money on an image editor to get these results. You'll find it's easy (and quite likely, fun) to make both subtle and dramatic changes to your photos and images.

Some special effects are unique to a specific image editor. However, most image editors should have Emboss, Negative and Motion Blur special effects.

An example of the Emboss special effect

An example of the Negative (Inverse) special effect.

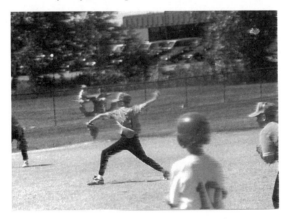

An example of the Wind special effect.

Filters

A feature related to special effects is called filters. Filters use a combination of mathematical algorithms to produce unique effects on the image or part of an image. Again, some filters are unique to a specific image editor. However, most image editors should have a Find Contour, Add Noise, Blur and Sharpen filters.

241

An example of the Find Edge filter.

An example of the Add Noise filter.

Brightness and contrast

One feature that an image editor must have is the ability to adjust the levels of brightness and contrast in an image. Brightness refers to the overall lightness of an image or a selected area of an image. Contrast, on the other hand, is the difference between the lightest and darkest part of an image or selected area of an image.

Examples of a Brightness and Contrast dialog box (this one is from Paint Shop Pro 5)

Scanned images are often too dark. So using an image editor to increase the brightness level will help compensate for the scanning process. You may also want to look at the original image if the scanned image is too dark or too light. It's possible the original is underexposed or overexposed.

If the contrast of an image is too low, the image will look dull and flat. Taking pictures on a sunny day with harsh shadows can often result in high contrast. An example of a low contrast image is one taken on a cloudy day with diffuse light. Increasing the contrast will lighten the light areas and make the darker areas darker.

Adjusting Highlights/Midtones/Shadows

Another feature that you should look for in an image editor is called Highlights/Midtones/Shadows in most image editors. Other names you might see include Tone Adjustment or Tonal Adjustment, etc. Regardless of its name, this command is used to control the highlights, midtones and shadows of an image.

The Brightness and Contrast controls only shift the entire image up or down in brightness or contrast. The Highlights/Midtones/Shadows command gives you greater control over brightness in an image than the Brightness/Contrast command.

Example of a Tone Adjustment dialog box (this is from Paint Shop Pro 5)

Clone tool for touching up problem areas

As its name suggests, an image editor must be able to edit an image. To let you edit an image, two features (usually called "tools") that an image editor should have are called Airbrush and Clone (or something similar). We recommend using an image editor that has these tools because they'll make your work much easier and faster. You can use them for anything from removing blemishes and fixing a small tear to removing people and objects from your photos.

The following image is from an old post card. Notice all the marks, small tears and other problems in the "sky" of the image.

An image editor can be used to remove small tears and other problems in your images.

Using an image editor, we can remove these problem areas in just a few seconds.

Although these tools are powerful, we're not talking about completely recreating a photo. The following photo, for example would require an extensive amount of work to fix. In a case like this, it would be better to use a different photograph or image.

However, the clone tool may not be able to help some images and photos.

245

Masks

A powerful feature in many image editors is the *mask*. It lets you apply different special effects such as feathering the edge of a photograph so it blends smoothly into the background color. By using a mask, you can combine two pictures or graphic images and mathematically-add or subtract pixels to create a unique combination.

A mask is a template and let areas in one graphic to appear through areas in another. A mask is similar to a stencil (a sheet of paper with cutouts in it) since it has an area that is closed (black) and an open area (white). The theory is that what is white will accept color and black will reject color. In other words, a stencil allows paint to be applied to an image through open areas or cutouts in the stencil. These open areas are represented by the color "white" when the stencil is made. Areas of the stencil that hold back paint from getting through are represented by black areas on the stencil.

Layers

Layers in an image editor let you edit specific areas of your image without affecting any other data. When you create a new image in your image editor, the image consists of a background. This is similar to the canvas under a painting. You can add one or more layers to the image, depending on the capabilities of the image editor. You can draw, edit, paste, use masks and move elements on a layer without affecting other layers in the image.

Some image editors, notably Adobe Photoshop, use an adjustment layer. It's a special type of layer that lets you apply tonal and color correction effects to all the layers. An adjustment layer lets you experiment with combinations of graphics, text, special effects and more. Each layer remains independent of the other layers in the image until you combine the layers.

Image Correction Tips

Y ou cannot start just anywhere when working with an image editor. How and where you begin to manipulate an image is often important. The following lists some general steps when correcting an image. We say "possible" because every job is a little different, but this is a good general guideline.

1. Before you start working, make a backup copy of the image. This is a good idea regardless of the amount of tweaking you're planning to do.

2. If you have enough space on your hard drive, save the file under a different name as you make changes. This is especially true if you make several large changes. Remember, since many image editors will only let you Undo an action once, you cannot "undo" any earlier changes. By saving files under different filenames, you can return to an earlier version without repeating (or remembering) your work. Just remember to keep track of available hard drive space. Save the file using consecutive numbers, such as "IMAGE01," then "IMAGE02" then "IMAGE03", etc.

3. Don't try to reverse image corrections by performing the opposite correction. For example, don't reverse an action that increases highlights by increasing shadows. Instead, use the Undo command if you can or use the Restore command to start again from the most recently saved version of the image.

4. The first step to tweak an image should be to correct tonal range and color balance. We recommend starting here for the simple reason that if the tonal range and color balance of the image cannot be improved, you'll probably have to rescan or use another image.

5. The next step should be sharpen or blur the image to soften or enhance detail.

6. Make any necessary changes to the content of the image. These changes include repairing torn areas, cropping to improve the composition, etc.

By using the image editors that are available today, you can greatly improve most photographs, regardless of how poorly exposed, out of focus or badly composed they are. We'll use the tools and features of several image editors in the next few chapters to further explain using an image editor. You'll find that most image editors will have similar tools and functions.

Chapter 11:
Working With Filters
And Plug-ins

Chapter 11

Working With Filters And Plug-ins

Corrective Filters

Sharpen
Noise factors
Motion Blur...

Destructive Filters

Emboss
Find contour
Twirls and spirals
Using the Effects commands to create new images

External plug-ins

A *filter* in an image editor is an effect that you an apply to an image. Some filters imitate conventional photographic filters, but you can use many others to tweak images in unusual ways. A pointillism filter, for example, can make a digitized photograph look like a pointillistic painting. You can slightly increase the focus, introduce random pixels, add depth to an image or completely rip it apart and reassemble it into a hurky pile of goo. Any number of special effects are made available through filters.

You need to also realize that "special" refers to the effect itself and not because you're the only one who can use it. In other words, anyone can use the same filters in their image editor that you can use in yours. Therefore, if you rely on filters to edit your images for you, your audience will quickly recognize your work as poor or, at least , unremarkable art.

In this chapter we'll talk about the different types of filters that you'll use in an image editor. We won't show how an image is changed by every filter available but instead explain exactly how the most important filters work and offer some concrete ways to use them

You'll also learn how to apply several filter sin tandem and how to use filters to edit images and selection outlines. My goat is not so much to reach you what filers are available – you can learn this by tugging on the File menu – but how and when to use filters.

Most filters in an image editor are accessed through the menu system. Although there is no true classification of filters, we'll use two terms to explain filters.

Let's look at some examples of corrective filters first.

Corrective Filters

Corrective filters include the filters you're most likely to use on most often in your work. They include changing the focus of an image, enhancing color transitions and averaging the colors of neighboring pixels. You'll use these filters to tweak scanned images and to prepare an image for printing or screen display. A corrective filter is generally used in way so that the effects are subtle enough that the viewer won't notice that a filter was used.

An image editor normally has corrective filters that are direct opposites of another filter. For example, the blur filter is the opposite of the sharpen filter. Note this may not cancel out the effect of the other filter but the two opposite filters produce contrasting effects.

Sharpen

One problem that has occurred with scanners is that the scanned image often appears "soft" or out-of-focus. This is true regardless of which type of scanner was used. Even images scanned on high-end drum scanners sometimes have this problem.

To "fix" this problem we need to use a feature called sharpening (or what the professionals usually call unsharp masking). Regardless of its name, sharpening is a standard technique that emphasizes the differences between adjoining areas of significantly different hue or tone.

In a sense, Sharpen is the opposite of Blur. This filter can be useful if the image was blurry before you scanned it or became blurry as a result of scanning.

For example, select Enhance/Sharpen Filters/Sharpen Lightly to produce less of an effect:

Selecting Enhance/Sharpen Filters/Sharpen Heavily produces a much stronger effect:

Use the Unsharp Mask filter to adjust the contrast of edge detail. This will help the image to appear sharper. You'll usually use the Unsharp filter to correct the focus on blurry images. In other words, use Unsharp Mask to fix the focus of an image that has become blurry from interpolation or scanning. It produces a lighter and darker line on each side of an edge, which helps emphasize the edges.

Noise factors

The pixels with randomly distributed color levels in an image is called noise. When you want to add or remove noise from an image you'll need to use the noise filters in your image editor. This will help make a selection blend into the surrounding pixels.

You can use the Noise filters to remove problem areas from an image, such as dust and scratches, and to create unusual textures, such as those used as backgrounds behind title text. The Add Noise filter can also be useful in reducing banding in feathered selections and graduated fills and in giving a more realistic look to heavily retouched areas.

Add Noise

Use the Add Noise filter to add random colors on the image. Applying the Add Noise filter to a current image creates a grainy, high-speed film effect.

Most image editors let you apply this effect to either a selected area of the image or the entire image. You just select the area you want to change or make certain that no area is selected to change the entire image.

The top image is an example of using the Add Noise filter to the entire image. The bottom image is the result of applying the filter to a part of the image.

You may have two options for Add noise. These are normally called Uniform and Gaussain or Random.

Using Add Noise as a new image

You can use an image editor for more than tweaking photos and images. For example, apply the Add Noise filter to a new image with a solid white background to create a speckled, grainy pattern. Then use the pattern as an element in another image or in a document in another application.

1. Create a new 16 million color image. We're using 24-bit color and a size of 900 x 585 and 300 pixels.

2. Set the background color to white.

3. Select the Add Noise... command in your image editor.

4. Set the "Intensity" level if it's available.

4. Click [OK] or press Enter.

The following is an example of an Add Noise pattern:

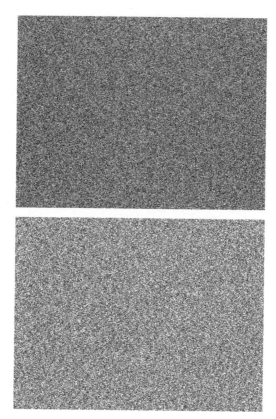

Two examples of using the Add Noise filter to create new patterns...
These are good too for new desktop images on your Windows screen.

Despeckle

Use Despeckle to remove "noise" from your images. You can also use Despeckle when trying to remove Moire patterns from your images.

*Example of how the Despeckle command can
remove the Moire patterns from a scanned halftone.*

Motion Blur

As its name suggests, the Motion Blur filter produces an illusion of motion
across the image. The effect of this filter is similar to taking a picture with a
fixed exposure time.

Example of using the Motion Blur effect (Left direction, Speed set at 32)

Destructive Filters

The second type of filters you'll find in an image editor are called *destructive filters*. These filters are well-named because they'll produce very dramatic effects. The effects can be so dramatic that the change can overwhelm your artwork if used improperly. This can make the filter more important than the image itself.

Nevertheless, this is why many new users first try a destructive filter on their images. It can be fun to experiment with destructive filters but always remember that destructive filers, by definition, can destroy the original clarity and composition of your images.

Emboss

The Emboss filter makes a selection appear raised, or "stamped" by suppressing the color within the selection and tracing its edges with black. Your images then seem as if they're stamped onto porous paper or fossilized stone. Use the Emboss filter to create a raised pattern from a piece of flat two-dimensional art. This filter simulates light falling at an angle on an image. The Emboss filter works well with text, too.

Most image editors let you apply this effect to either a selected area of the image or the entire image. You just select the area you want to change or make certain that no area is selected to change the entire image.

Example of using the Emboss effect in Paint Shop Pro.

Also some image editors, notably PhotoStudio from Arcsoft, let you not only set the "Intensity" level of the effect but also to determine of the background depth and to determine the type of the effect with the "Color" option.

Example of using the Emboss effect in PhotoStudio but with the direction set from the right, intensity set at 10 and color set at gray.

Find contour

This filter changes a continuous tone image into a contour drawing on a black background. For the best effect, try applying the Find contour filter to an image or selected area of an image that has many shapes and colors.

259

Select the Enhance/Special Filters/Find Contour... command. This opens the Find Contour dialog box. You can set different options in this dialog box. The "Threshold:" setting (1 to 254) determines which edges will be traced.

You can also determine which color to adjust with the "Channel" option. The default setting is the RGB button, but you can also select only "R" (red), "G" (green) or "B" (blue). The following is an example of applying the Find Contour command to an image:

An example of using the Trace Contour command
(also called Find Contour in some image editors).

Twirls and spirals

You can be silly and apply special effects such as the "Pinch" and "Punch" effects (called Cone and Cylinder in other image editors). Let's look at the Pinch effect first. Use this effect to pull the image in at its center. It works great on human faces or areas of the human body. It also works good on text characters.

Most image editors let you apply this effect to either a selected area of the image or the entire image. You just select the area you want to change or make certain that no area is selected to change the entire image.

Also you should be able to set the "Intensity" level of the effect. As its name suggests, this is how much of an effect you want to apply to the image. This is usually set by moving a slider box left or right to set the level. The higher (to the right) you move the slider box, the greater the intensity of the effect. Look in the preview window, if your image editor includes one, for an idea of how the effect will change your image.

The Pinch effect in Paint Shop Pro pulls the image in at its center.

The Punch effect (also called Fisheye in some image editors) is similar to Pinch except it causes the image to bulge from its center.

Other destructive filters let you make the image look like it is being pulled down by a whirlpool.

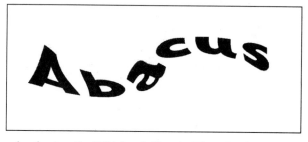

Example of using the Whirlpool filter in PhotoStudio 2 by Arcsoft

Another example of a twirling spiral destructive filter is a spiral command. Use it to twist the image around its center.

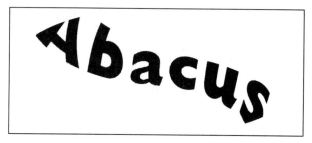

Example of using the Spiral filter in PhotoStudio 2 by Arcsoft.

Again, you should have the opportunity of setting an intensity level with these filters.

Many image editors will have filters called Sphere, Cylinder and Ribbon (or something similar). These effects are slightly different. The Sphere effect is similar to the Fisheye effect. The difference is the image bulges from its center in the shape of a sphere instead of a fisheye. There are no options with the Sphere effect; the effect is applied to the image when you select the command. You can, however, apply the effect to the whole image or a selected part of the image.

Select the Cylinder effect if you want your image to appear as if it's wrapped around a cylinder.

The Ribbon effect stretches the image into a thick, wavy ribbon. You can apply the effect to a selected area of the image or the entire image.

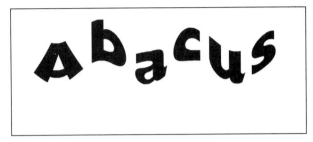

Example of the Ribbon command (Frequency set at 25; Amplitude set at 25%).

Using the Effects commands to create new images

Creating a woven pattern

Another example is to create woven textures or spaghetti textures. Follow these steps to create a woven texture:

1. Select the File | New... command to create a new document and select the size in the dialog box. We're using 24-bit color and a size of 900 x 585 and 300 pixels.

2 Select the Special Filters/Add Noise... command.

3. Enter a number between 1 and 100 for the "Intensity" level.

4. Click (OK) or press (Enter).

5 Select the Effects/Motion Blur command.

6. Click the lower-right pointing arrow and set the "Speed" to "32" using the sliding bar.

7. Other options include using the Brightness/Contrast to adjust the levels if necessary. You can also add a wave to the texture by applying the Whirlpool command filter to it.

Example of a woven pattern you can create in an image editor.

Adding a wave to the texture by applying a destructive filter ("Punch" from Paint Shop Pro in this example).

Spaghetti-like texture

Follow these steps to create a spaghetti-like texture:

1. Create a new 16 million color image. We're using 24-bit color and a size of 800 x 600 and a resolution of 300.

2. Set the background color to white.

3. Select the Add Noise... command in your image editor.

4. Set the "Intensity" level if it's available.

4. Click (OK) or press (Enter).

5 Select the Gaussian Blur command in your image editor.

6. Set the desired amount of blur and click (OK) or press (Enter).

7. Select the Find Contour... command in your image editor.

8. Set the desired amount of the contour and click (OK) or press (Enter).

9. You can also apply the Sharpen filter to the image.

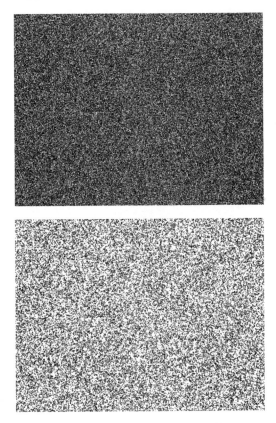

Two examples of applying other filters
to the Add Noise example from page 260.

External Plug-ins

An image editor should already include several filters. However, other filters called *plug-ins* are available. Plug-in let you add more effects to your image editor. You can find many plug-ins on the Internet for popular image editors like Paint Shop Pro. Many of these plug-ins are free but others are shareware or commercial programs.

The Easy Digital Photography companion CD-ROM includes several Paint Shop Pro and Photoshop plug-ins that you can use. See Chapter 15 for more information. Otherwise, the following pages talk about a sampling of the Internet sites where you'll find other plug-ins. We recommend doing a search for "plug-ins" using your favorite Internet search engine.

Simple Filters
http://www.btinternet.com/~cateran/simple/

A set of easy to use filters for Photoshop and Paint Shop Pro. These filters have no adjustable settings, this limits their usefulness, but it also makes them much quicker and easier to use. Each filter is shown with an image which uses a 'mouseover', move the mouse over the image to see what it does, click the image to download a zip file

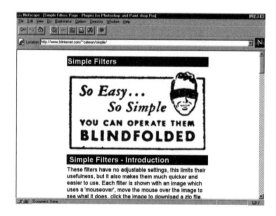

Ulead Web.Plugins for Photoshop
(http://www.ulead.com/webutilities/wp4ps/framwp.htm)

These plug-ins from Ulead add tileable backgrounds and drop shadows, 3-D buttons and text banners, frames and image map tags and special effects.

The Andromeda Series
(http://www.andromeda.com/)

A series of powerful imaging filters for Photoshop, Paint Shop Pro and other image editors.

The i/us Filter Factory CD
(http://pluginhead.i-us.com/ffcd.htm)

This CD-ROM includes over 300 Paint Shop Pro compatible plug-in filters.

Auto F/X
http://www.autofx.com/

An example of plug-ins from Auto F/X is called AutoEye 1.0. Use it to reclaim color and detail that is lost in the transition from film or prints to digital.

DC Special Plug-in Filters
http://www.teleport.com/~pegasys/plgn.html

A site that includes filters for making buttons from familiar rectangle buttons to round buttons.

268

AFH Beveller Filters
http://www.afh.com/web/pshop/free.html

These two filters are probably the best of the button maker filters around. In just two filters you have a large number of options to create the bevel exactly the way you want. I have just put up an example of each filter, the bevel can be customized greatly.

Chapter 12:
Working With Text
And Effects

Chapter 12

Working With
Text And Effects

Once you've decided to include some text with your image, you first need to decide first whether to use a TrueType or Type 1 font (also called a Postscript font). Although you'll find good fonts in either format in Windows 95 and Windows 98, Type 1 fonts have several advantages. Commercial printers prefer Type 1 fonts. Also, you have a bigger selection of Type 1 fonts from which to choose. Finally, Type 1 fonts have the typographic refinements of ligatures, old style numerals and small caps. These refinements are an important part of what makes digital type avoid looking like digital type.

Note On "Font"

The term font is often used incorrectly as another word for typeface. However, a font is actually more than just the typeface; it's a combination of typeface, size, pitch, spacing and more. Palatino is a typeface that defines the shape of each character. However, you can select from many fonts within Palatino - different sizes, italic, bold, fpr example. Therefore, a font is the design for a set of characters.

You should learn all you can about typefaces regardless of whether you decide on Type 1 fonts or TrueType fonts. Then you'll use type like a pro in your image editor.

Font characteristics

The image editor you use should have a dialog box that lets you select font, styles, size and other information about the text you want to include with your image. The following illustration explains the most common font characteristics (taken from Paint Shop Pro 5):

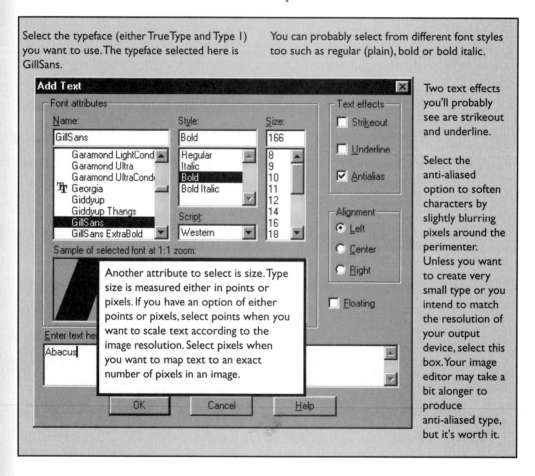

Select the typeface (either TrueType and Type 1) you want to use. The typeface selected here is GillSans.

You can probably select from different font styles too such as regular (plain), bold or bold italic.

Two text effects you'll probably see are strikeout and underline.

Select the anti-aliased option to soften characters by slightly blurring pixels around the perimeter. Unless you want to create very small type or you intend to match the resolution of your output device, select this box. Your image editor may take a bit alonger to produce anti-aliased type, but it's worth it.

Another attribute to select is size. Type size is measured either in points or pixels. If you have an option of either points or pixels, select points when you want to scale text according to the image resolution. Select pixels when you want to map text to an exact number of pixels in an image.

274

Other characteristics

Leading

Line spacing or leading is the vertical distance between the baseline of one line of type and the baseline of the next line of type within a single paragraph. Leading is measured in the unit you selected from the pop-up menu.

Spacing

Each character in a font carries with it a predetermined amount of side bearing that separates it from its immediate neighbors. Although you cannot change the amount of side bearing, you can insert and delete the overall amount of space between characters by entering a value into the Spacing option box. Enter a positive value to insert space or enter a negative value to delete space.

Outline and Shadow

The outline option is basically for amateurs so you should avoid using it. The shadow option produces equally unattractive results. To create better shadowed type, try one of the examples we talk about in this chapter.

Remarkable Text Effects And Other Stuff

You can use an image editor to create remarkable effects using text, textures or by simply starting with a plain background. In this section we'll show how to create these effects.

Although we're using Paint Shop Pro 5 in these examples, we'll try to keep the information generic enough that you can use other image editors as well. If you do not own Paint Shop Pro, visit the JASC Software web site (www.jasc.com) and download a fully functioning trial version.

This section is not meant to be a guide to using Paint Shop Pro and many examples assume you have a working knowledge of Paint Shop Pro 5.

Also, the steps in these examples are meant only as a guide so feel free to experiment. For example, try using different colors, settings or levels. You may be surprised at how your new images and text appear by just making a few minor adjustments.

Make certain to save your work often in case you make a mistake or something doesn't quite look right.

Quick and dirty 3-D text

This is a simple yet effective way to get a 3-D effect with your text. This example works best using a wide font and light colored text. We're using GillSans Extra Bold and a color of R199, G200 and B243.

1. Create a new 16 million color image

2. Set background color to white and the foreground color to the text color you want to use (keep in mind that a light color works best, again we're using R199, G200 and B243).

3. Type and place your text but don't deselect it yet.

4. You must first save the save the selected text. To do this, select the Selections | Save To Disk... command (a PSP5 command).

5. Enter a name in the Save Selection Area dialog box.

6. Press Ctrl + D to deselect the text.

7. Switch the foreground and background colors so white is now foreground.

8. Apply the hot wax coating by selecting the Image | Other | Hot Wax Coating command.

9. Load the selection saved in Step #5 with the Selections | Load From Disk... command.

276

10. Apply a drop shadow by selecting the Image | Effects | Drop Shadow... command. You may want to experiment with the settings — especially the Offset values — to get the desired effect.

Abacus

*This is an example of simple 3-D text easily created in
Paint Shop Pro 5 (see the file called 3dtext1.tif on the companion CD- ROM).*

Glowing text

This glowing text effect works best on a dark background.

1. Create a new 16 million color image.

2. Select a solid dark color for the background. It's best not to use a pattern. We're using solid black in this example.

3. Set the foreground color to the color you want the to use for the "glow." We're using yellow in this example (R255,B255,G0) but another light, bright color would also work.

4. Type and place your text but don't deselect it yet.

5. You must first save the selected text. To do this, select the Selections | Save To Disk... command (a PSP5 command).

6. Enter a name in the Save Selection Area dialog box.

7. Feather the text with the Selections | Modify | Feather... command. Try setting the number of pixels to 5 or less but this depends on your text and personal preferences.

8. Select the Paint Bucket and set its options to Solid Color and a Tolerance of 200. Fill the selected text several times until you get the desired size of the glow.

9. Deselect the text

277

10. Load the selection saved in Step #3 with the Selection | Load From Disk command.

11. Fill the selection with a desired color. We're using red (R255, G0, B0) in this example.

This is an example of glowing text easily created in Paint
Shop Pro 5 (see the file called 3dglowtext1.tif on the companion CD-ROM).

Filling text with background images

Filling text with background image can be a lot of fun. However, be careful when filling text with a background image: It can be very effective when done correctly but it can be very bad when done poorly.

One important suggestion is to use wide fonts for the text. This way the background will show through better. Don't be afraid to experiment with different textures and patterns .

A simple, quick way to create a text background is to place the text on a background graphic containing the pattern you want. Then cut the text out of the background.

1. Open a background graphic that is at least 16 million colors and large enough to include your text. You don't necessarily need to use a background graphic but you'll find it's more fun to use a graphic or a texture.

2. Click on the text tool and move the crosshairs to the center of the graphic and click to open the text tool.

3. Select a font and font size. Make certain to click off the "Floating" option. Then click the (OK) button.

4. You should see your selection in the center of the graphic. If not, use the Mover tool and right click on the selection. Hold down the right mouse

278

button and drag your selection to another spot on the background graphic.

5. Select the Selections | Invert command and press the ⌐Del⌐ key.

6. Select the background color for the "new" background.

7. Select the Selections | Invert command again to select only the text.

8. Add a drop shadow or bevel the text if you want.

This is an example of filling text with a background image
(see the file called cutouttext1.tif on the companion CD-ROM).

Imitation plastic text

1. Create a new 16 million color image.

2. Set the foreground color to white.

3. Set the background color to white.

4. Enter your text — don't panic it should be white.

5. Select the Image | Effects | Cutout command.

6. Make certain to Uncheck fill interior, set the Shadow color to black; use an Opacity of 100, set Blur to 10, set Vertical to -5 and Horizontal to -5. Click the ⌐OK⌐ button

7. Select the Image | Other | Emboss command.

8. Select the Colors | Colorize... command

9. Enter values of Hue: 242 and Saturation: 255

10. Click Image | Effects | Add Drop Shadow....

11. Set the Color to black, Opacity to 100; Blur 10; Vertical 5; Horizontal 5 (the numbers for Vertical and Horizontal depend on your text and personal preferences).

12. Click the OK button to close the dialog box

Abacus

*This is an example of giving text a "plastic" appearance
(see the file called fakeplastictext.tif on the companion CD-ROM).*

Metallic text

This is another example of creating a different text effect without using special plug-in filters. Although it works well with all colors, start with a dark color and then change to a very light version of that color before applying the hot wax coating.

1. Create a new 16 million color image.

2. Set the background color you want to use

3. Set foreground color to R165, G124, B3 and background color to white.

4. Create and place your text (it's best to use a wide fat text). Don't deselect the text yet.

5. Select the Selections | Modify | Feather… command.

6. Set feather to "0" and click the OK button.

7. Make certain the text is still selected and press the Del key.

8. Switch the foreground color to R253, G228 and B153.

9. Make certain the text is still selected and select Image | Other | Hot Wax Coating.

10. Add a drop shadow if you want.

11. Press Ctrl + D to deselect the text.

This is an example of filling text with a background image
(see the file called metaltext.tif on the companion CD-ROM).

Beveled text

Another method of applying a 3-D effect to text is called beveling. It helps make text "pop out" from the page.

Although Eye Candy from Alien Skin Software (see the companion CD-ROM) does an outstanding job on beveling text, you don't necessarily need to use plug-in filters. This example uses the Cutout filter in Paint Shop Pro 5.

You'll apply the Cutout filter twice to the text to create the beveled effect. The first time uses white and the second uses black. This way the top and left portions of the text will be highlighted in white and the bottom right part will be shadowed in black.

1. Create a new 16 million color image. Make certain the background colors and foreground colors don't conflict with the text colors or colors you'll be using in the bevel effect. This example uses blue for the background and white for the text.

2. Create and place your text but don't deselect it yet.

3. Select the Image | Effects | Cutout... command. Make certain the "Fill interior with color" option is unchecked.

4. Set the shadow color to black, opacity to 100 and blur to 12

5. Set the horizontal offset to -3 and vertical offset to -3.

6. Click the OK button but do not deselect the text yet.

281

7. Select the Image | Effects | Cutout… command again. Make certain the "Fill interior with color" option is unchecked.

8. This time set shadow color to white, opacity to 80 and blur to 12

9. Set the offset to 3 and 3.

10. Click OK to close the dialog box.

11. Experiment with the opacity and offset for different effects.

12. Press Ctrl + D to deselect the text.

Different Effects Using An Image Editor

Besides using an image editor to create different text effects, you can also create new effects and images. In this section we'll show how to create burnt wood, lightning, stars and more.

As with the previous section, we're using Paint Shop Pro 5 in these examples. If you do not own Paint Shop Pro, visit the JASC Software web site (www.jasc.com) and download a fully functioning trial version. The steps in these examples are meant only as a guide so feel free to experiment. For example, try using different colors, settings or levels. You may be surprised at how your new images and text appear by just making a few minor adjustments.

Make certain to save your work often in case you make a mistake or something doesn't quite look right.

Burnt wood effect

1. Open the "WOODTEXT.TIF" file from the companion CD-ROM.

2. Change the foreground color to black (R255,G255,B255).

3. Select the Airbrush Tool and use these settings: Size=100, Shape=Round, Opacity=50, Texture=None, Density=13.

282

4. Carefully spray around the edges of the wood with the black color. Add heavier areas to add a "charred" effect.

5. Change the foreground color to R116, G60, B10

6. Keep the same Airbrush settings and click in random spots. Try to make the color slightly darker toward the middle of the burnt area and lighter the further away from the burnt area.

7. Repeat the above step 7 but change the color settings to Hue=40, Sat=240, Lum=81.

This is an example of burnt wood using Paint Shop Pro 5. The top image is the original (WOODTEXT.TIF from the companion CD-ROM). The bottom image shows the effect of applying the burnt wood texture.

Creating spheres

1. Create a new 16 million color image.

2. Select your foreground color (color for the sphere).

3. Select the background color.

283

4. Click the Selection Tool and select Circle.

5. Drag the mouse to create a circle. Make it as large as you want.

6. Click the Flood Fill Tool and click in the selected circle.

7. Set the fill with Tolerance=10 and Fill Style=Sunburst Gradient

8. Click the (Options) button and set Verticle=75% and Horizontal=25%

9. Use the Airbrush Tool and a complimentary darker color to enhance the sphere slightly if necessary. Airbrush the lower right 75% of the sphere. Start with a lower opacity setting.

10. Add more spheres with different colors, opacity settings, sizes, etc.

Example of creating spheres in Paint Shop Pro 5 (see SPHERES.TIF on the companion CD-ROM).

Lightning shots

Before starting this small project, you may want to get some pictures of real lightning shots to use as a guide (such as that on the right).

1. Create a new 16 million color image.

2. Set background to black.

3. Set foreground to a purplish color (R200, G0, B250).

4. Select the Airbrush tool and use the settings of Size=50, Shape=Round, Opacity=30 and Texture=None.

5. Draw one main line but add a few purple jagged lines that branch off from it.

6. Change the foreground color to blue (R0, G0, B250).

7. Select the airbrush tool again and change the size of the airbrush to 10.

8. Draw more jagged lines over the purple lines.

9. Change the foreground color to a lighter blue (R0, G186, B255).

10. Draw more jagged lines over the purple lines.

11. Create light blue squiggly lines over the other squiggly lines.

12. Select the Image | Deformations | Wind command

13. Set the level of wind between 13-18 (the wind strength and direction is your choice - whatever looks better in your "lightning").

14. Change the foreground color to white (R255 G255 B255)

15. Change the size of the airbrush to 10 and opacity to 25.

16. Use the airbrush tool to create the lightning bolts. Draw jagged lines that branch off the main lines. Follow the other colors but experiment with new "branches."

17. These last two steps are optional. Select the Airbrush tool and use the settings of Size=50, Shape=Round, Opacity=10 and Texture=None.

18. Go over existing bolts to widen the main bolts and to highlight certain areas.

Example of creating lightning in Paint Shop Pro 5 (see LIGHTNING.TIF on the companion CD-ROM).

Create a star

Feel free to experiment with this project. For example, add more lines from the center or create several smaller stars with only a horizontal and a vertical line. Then use the Airbrush set at Size=3-5 and Opacity=30-50. Another possibility is to apply the Airbrush rings around your star first and then use the Retouch Tool afterwards to smudge out from the center of your star to create a more radiant effect.

Also, don't by afraid to use the zoom tool to get real close.

1. Create a new 16 million color image.

2. Set foreground to white (R255, G255, B255).

3. Set background to black.

4. Click on the Line Tool and set the Width to 1

5. Press down (but don't release) the Shift key

6. Create a long vertical line.

7. Press and hold Shift and create a horizontal line through the middle of the vertical line. This line should be a little shorter than the first.

8. Move your mouse pointer to where the two lines intersect.

9. Press and hold down \bar{s} and create a line at 45° to the upper left and make that shorter than your first vertical line and your second horizontal lines.

10. Repeat the last step until you're drawn four lines at 45° angles. (So it looks like an "x" in the star)

11. Select the Retouch Tool and Smudge for the mode.

12. Press and hold the left mouse button and drag ("smudge") the line from the middle of the star and out to the ends. This will soften the lines that you created. Repeat this a few times to get the desired effect.

13. Use the Airbrush tool to help blend in the area where the lines intersect. (Make certain the foreground color is white.) Start with settings of Size=50, Shape=Round, Opacity=10 and Paper texture=None.

14. Move the mouse pointer to where all the lines intersect. Press and hold the mouse button for a few seconds until the intersection is blended.

15. Change the opacity to 30.

16. Once again, move the mouse pointer to where all the lines intersect and press and hold the mouse button for a second or so.

17. Change the Size to 150 and the opacity to 50.

18. Again, move the mouse pointer to where all the lines intersect and press and hold the mouse button for a second or so.

19. You may also want to experiment with different colors too. For example, select R200, G0 and B250 (a purplish color) for the foreground color. Move the mouse pointer to where all the lines intersect and press the mouse button once or twice.

*Example of creating a star in Paint Shop
Pro 5 (see STAR.TIF on the companion CD-ROM).*

Make certain to check out the companion CD-ROM for other examples of working with text and effects. See Chapter 15 for more information on the companion CD-ROM.

Part 4

More Info

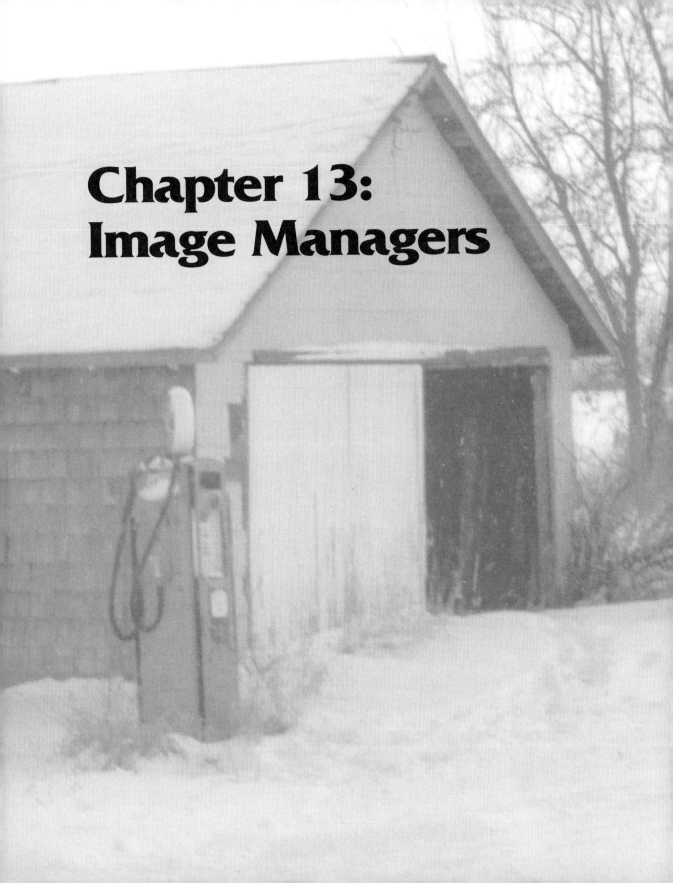

Chapter 13:
Image Managers

Chapter 13

Image Managers

Arriba Express 1.1
ixla Explorer 1.2
PhotoRecall Deluxe 2.0
imageAXS 3.02
Photo Org 1.0
ArcSoft PhotoBase 2.0
ThumbsPlus

You may soon find that you're having so much fun using your digital camera or scanner that images are cluttering up your hard drive. All these images also make finding a specific image difficult.

The solution to this problem is called an image manager (also called an image-cataloging program, asset manager and others). Regardless of the name, this program is a database that lets you organize, annotate and search for images. They also should store thumbnails and other information about your files. The image manager scans folders and drives on your system and generates catalogs of thumbnails and information about each image. Then display an image by clicking its thumbnail or drag and drop the thumbnail to move the image to a new folder.

We're not intending this chapter to be a complete summary of all image managers that are available. Because this is only a sampling of the image managers that are available, we cannot mention all the details and features of the image managers that we do discuss. However, we hope to whet your appetite for more information. You'll find the developer's web site and other information listed if you need more information..

Finally, we're not intending this to be a critical review, but a source of information. Prices, features, availability and other information may change, so please contact the manufacturer for specific information.

Arriba Express 1.1

Arriba Express is media management for anyone who creates, uses and manages several forms of digital media. This includes images, audio, video, web files, animation and text. Its intuitive, "drag-and-drop" Windows environment makes it perfect for media professionals, enthusiasts and "power users."

Use Arriba Express to capture, discover, experience, organize any media object. Arriba Express is easy to use, fast and cost effective. Now you can effectively find, see, hear and experience media in a new way. Arriba Express provides the power and speed to satisfy all media users. Its sophisticated media management capabilities, powerful search and display, and native support of popular media creation and publishing tools makes it a top choice.

We've included a 15 day trial version of Arriba Express on the *Easy Digital Photography* companion CD-ROM. See Chapter 15 for more information on how to download Arriba Express from the companion CD-ROM.

For More Information	
Digital Arts & Sciences Corporation	http://www.dascorp.com/
3200 College Ave, Suite 6	
Berkeley, CA 94705	
Telephone: (510) 652-8950	
Fax: (510) 652-8789	

ixla Explorer 1.2

ixla Explorer is the ultimate tool for looking after your images. ixla Explorer automatically creates high quality thumbnails of the images stored on your computer. Simply click on a folder to view thumbnails in large, medium or small sizes. Then double-click the desired image to view it immediately full size. You won't need to start an image editor first.

ixla Explorer supports flash memory cards, PC Cards, ZIP disks and TWAIN scanners. It also supports all popular image, photo and clipart file formats including Flashpix. It includes direct support for 120 digital cameras. Simply drag-and-drop photos directly from your camera. You won't need to use a TWAIN driver.

For More Information

IXLA USA Inc.
17 Jansen Street
Danbury, CT 06810
Telephone: (203) 730-8805
Fax: (203) 730-8802

http://www.ixla.com/

PhotoRecall Deluxe 2.0

PhotoRecall Deluxe 2.0 supports over 25 file formats. It consists of several parts. One part is called the PhotoRecall Library. It's for your digital photo and clipart albums. You can load images from your digital camera, scanner, hard drive(s) or the Internet. Then store them for easy retrieval. Use read-only privileges to protect valuable photo albums.

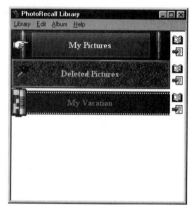

The PhotoRecall Library is for your digital photo and clipart albums.

Use keywords to search the Internet. Download pictures directly into albums. Scan your PC's local or network drives. Then quickly organize image files. Catalog photo CDs, or find pictures stored in other albums.

Don't panic if you don't have HTML experience. PhotoRecall's web authoring wizard lets you choose from several page layouts and styles. It will even automatically upload the files to your ISP.

Image editing includes the capability of adjusting brightness/contrast, adjusting colors and removing "red eye" easily. You can even add special effects or apply color filters to set a special mood in your images.

Use the PhotoRecall Darkroom to adjust brightness, contrast, colors and more.

You can even attach sound files to your images. Use the Portable Player to create independent, self-running albums. Then send E-mail messages to your friends and family.

We've included a 30 day trial version of PhotoRecall on the companion CD-ROM. See Chapter 15 for more information on how to download PhotoRecall.

For More Information	
G&A Imaging Ltd. 975 St-Joseph Blvd. Hull, Quebec Canada J8Z 1W8 Telephone: (819) 772-7600 Fax: (819) 772-7640	http://www.www.photorecall.com/

imageAXS 3.02

ImageAXS is a sophisticated solution for electronic cataloging. Use it to catalog, retrieve and display still images, video and audio files.

Since it's more of a media database than album software, ImageAXS has powerful search and index capabilities. They include keywords, definable fields, a long text field and twelve file information fields.

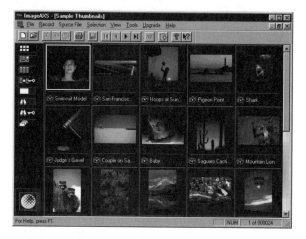

The program handles 60 file formats that are stored in "collections" consisting of thumbnails and pointers to source files. Create as many ImageAXS collections as you need. Each can contain unlimited records from different file formats and creator applications. You can store the original files on your hard drive, removable media, CD-ROMs or network drives.

ImageAXS automatically creates a thumbnail preview of the image. Double-click to view the full image without launching another application. ImageAXS supports TWAIN devices so you're able to acquire images from digital cameras and scanners. Drag and drop images from your hard drive, Zip disks, PhotoCD, etc.

We've included a 30 day trial version of ImageAXS on the *Easy Digital Photography* companion CD-ROM. See Chapter 15 for more information on how to download PhotoRecall from the companion CD-ROM.

For More Information	
Digital Arts & Sciences 3200 College Ave Berkeley, CA 94705 Telephone: (510) 652-8950 Fax: (510) 652-8789	http://www.dascorp.com/

Photo Org 1.0

Photo Org is an easy-to-use photo management package designed for everyone. It lets you organize, customize and share your images from digital cameras, photo CDs, scanners and the Internet. It supports 16 file formats.

Photo Org uses toolbars instead of menus. Your files are organized in "rolls of film" or photo albums that you can name and protect with passwords. Use Photo Org to create albums and greeting cards and then annotate them with formatted text. The Photo Editor window lets you crop, zoom, rotate and remove red-eye.

Use Photo Org to import images from your digital camera, scanner, the Internet or photo CD. Then organize photo into "rolls of film" or photo albums.

Canon Software Publishing has an exclusive Photo Org Web page where you can post your personalized photo album for free.

For More Information
Canon Software Publishing www.software.canon.com
Costa Mesa, CA Telephone: 800-652-2666;

ArcSoft PhotoBase 2.0

PhotoBase v2.0 is an easy-to-use multimedia management application with several presentation options. Use PhotoBase to create albums of image, sound, video and document files for easy storage, retrieval and management. Share images and other files as multimedia slide shows, web presentations, video postcards and more.

Three customizable description fields display information about selected items. A toolbar provides easy access to key functions, such as acquiring photos from TWAIN devices. Its image editor supports common tasks (crop, rotate, sharpen and color adjustments). Record and attach sound files (WAV) to images when you want to add notation or narration.

For More Information
ArcSoft Inc. www.arcsoft.com
46601 Fremont Blvd.
Fremont, CA 94538
Telephone: 800-762-8657

ThumbsPlus

ThumbsPlus is a graphic file viewer, locator and organizer. It helps you find and maintain graphics, clipart, fonts and animations. It displays a small image (thumbnail) of each file. Use ThumbsPlus to browse, view, edit, crop, launch external editors and copy images to the clipboard. You can use drag-and-drop to organize graphics files by moving them to appropriate directories. ThumbsPlus will also create a slide show from graphics you select and install bitmap files as Windows wallpaper.

Print either individual graphics files or the thumbnails themselves as a catalog. ThumbsPlus can convert images to several formats. This can be done either individually or in batch mode. You can also perform image editing in batch mode.

For More Information
Cerious Software Inc. www.cerious.com
1515 Mockingbird Ln. Suite 1000
Charlotte NC 28209
Telephone: (704)-529-0200

Chapter 14: Other Ways Of Working With Digital Images

Chapter 14

Other Ways Of Working With Digital Images

So far we've talked a lot about using digital cameras and scanners. However, since scanners and digital cameras have only recently become more popular, most of us don't yet own one. If you don't have a scanner or digital camera, don't feel the digital world is passing by you. For example, you can continue to use your 35-mm camera to snap pictures as you always have. Then, if you're lucky, maybe you can borrow a scanner from a friend or you can hire someone to digitize your photos.

That's all well and fine if you own or can borrow a 35-mm camera. However, what if you need to digitize some photos but you don't own either a digital camera, scanner or a 35-mm camera? Again, don't panic—you're not out of luck. Remember, the Internet is always ready, every day, 24 hours a day. And even if you can't log onto the Internet, there's still no need to panic. In this chapter we'll talk about alternatives you have for working with digital images.

Seattle FilmWorks And Pictures On Disk

One option is for Seattle FilmWorks to scan your photos from your processed film. You'll not only receive the scanned images on a floppy disk, but you'll also have the photos and negatives.

The images on the floppy disk are called *Pictures On Disk*. You can then use one of the image editors we've talked about or use the images in countless other ways. You can even create your Personal Home Page on the Internet using Seattle FilmWorks's free FilmWorksNet.

Seattle FilmWorks also includes a free copy of PhotoWorks software with your first Pictures On Disk order. PhotoWorks is specially designed to let you get the most out of your Pictures On Disk images. We'll talk more about PhotoWorks later.

PhotoMail

If you're impatient, you can download your Pictures On Disk files over the Internet. Seattle FilmWorks uses a service called *PhotoMail*. This service will deliver your images to you within minutes after they are scanned. You'll receive an e-mail message telling you that your images are ready for downloading within seconds after Seattle FilmWorks has completed the scanning.

Only a few minutes are needed to download PhotoMail files. The time depends on your modem speed, file size and the quality of the connection between your computer and their server.

It's very unlikely anyone will get access to your pictures. You must provide a personal Seattle FilmWorks customer number and a password before a file can be downloaded, both of which are in the e-mail notice you receive. However, you can let someone else download your images if you want to share your pictures. Simply give them the customer number and roll number(s) of the roll(s) you wish to share. Seattle FilmWorks will keep your images on file for 14 days. The file is deleted three days after you have downloaded it. You must save the image file you download because you do not get a disk with PhotoMail.

Resolution and image formats

You're probably wondering whether the resolution is good if the images are stored on a floppy diskette. The resolution of Seattle FilmWorks images is 640 x 480 pixels. Seattle FilmWorks uses a format with a, not surprisingly, ".SFW" extension. It was developed to provide fast display time and the most efficient compression for storing images on a floppy disk. The PhotoWorks software lets you convert .SFW files to 50 other formats so they can be used with other applications, such as image editors, word processors and many others. You can also convert more familiar formats like .GIF and .BMP to the .SFW format using the PhotoWorks "Plus" software.

PhotoWorks

PhotoWorks was specifically created for Pictures On Disk images. However, you can also use it with other image files. You can use PhotoWorks to:

❖ Tweak your images

❖ Make albums

❖ Export images to other programs

❖ Process your PhotoMail images downloaded from the Internet

❖ Upload your Personal Home Pages to the FilmWorksNet

Although PhotoWorks is a Windows 95 program, SFW also includes a program called *Win32S*. This special program, included with your PhotoWorks on floppy disks, allows Windows 3.1 to run 32-bit programs. It's installed automatically only if you have Windows 3.1.

PhotoWorks is not a power hungry program, although, as with most anything, the bigger the better. The system minimum is a 386 with 4 Meg of RAM; a minimum 486DX with 8 Meg of RAM is recommended.

PhotoWorks Plus is an enhanced utility program for Pictures On Disk. It can work with over 50 graphics file formats and includes features such as color correction, screen capture, a built-in screen saver, warp, emboss, blur, sharpen, and more. You can use effects one at a time or combine different effects. This upgrade costs $14.95 through SFW.

PhotoWorks's Albums

PhotoWorks gives you powerful album management tools for organizing photos on your PC. Each album is a collection of photos and other graphics files that you have selected. It's easy to create new albums and move photos between albums. You can change the sequence of images within an album, add and delete images and set slide-show viewing preferences.

PhotoWorks's Slide Show

The PhotoWorks Slide Show viewer uses albums that you've created to present a slide show of your images. You can sequence the photos however you choose, even add special effects and set the display time for each photo.

PhotoWorks's Photo Enhancer

The PhotoWorks Enhancer lets you tweak your photos. This includes rotating, resizing and cropping your photos. You can also use it to adjust the exposure, contrast and color balance. The PhotoWorks Enhancer lets you preview any tweaks before the changes are made.

PhotoWorks's Screen Saver

PhotoWorks Plus includes a Windows screen saver interface that lets you choose any PhotoWorks album as your Windows screen saver. The screen saver uses the Slide Show settings associated with the album to control the display time and transition effects.

For More Information
Seattle Filmworks 1260 16th Avenue West Seattle, WA 98119 Telephone: (206) 281-1390 Fax: (206) 284-5357 http://www.filmworks.com/

PhotoNet

Another way to view, store, share and tweak your photos on the Internet is through PhotoNet. All you need to do is take your film to your nearest PhotoNet retailer. Be sure to indicate on the envelope that you want digital copies made. You'll receive your photos and negatives back like normal. However, digital copies of your photos are also available on-line.

How it works

PhotoNet will send you an e-mail message when your order is ready. When you pick up your pictures and negatives, you'll be given the film ID. This ID number is what you'll use to access your photos on-line. You'll also be given the Online PhotoCenter home page address. You'll be prompted at the Online PhotoCenter for your name and access code. After these are verified, you'll have access to the on-line images for your roll of film.

A proof sheet soon appears that displays thumbnails of all the photos from that roll of film. If you want to see a full-size version of a photo, simply click on its corresponding thumbnail. Your photos remain on-line for 30 days. PhotoNet will notify you before this time expires. You can buy an optional time extension if you want the images to remain on-line longer.

You can share your photos with family and friends while the photos remain on-line. Simply send the film ID or e-mail the images to your family and friends for free.

Download all or any of the images to your PC. Then you can use your photos to create exciting web pages, print low-resolution photos or edit them with an image editor. Downloading images is free.

Also, while your images remain on-line, you can order reprints and enlargements of your photos. They can be mailed to you or to someone else.

All photos are stored in a high-quality JPEG format. The photos you see on the Internet use a lower resolution to facilitate faster download times. The high-resolution image is used to generate reprints and enlargements by your PhotoNet Dealer.

The quality of the prints you order on-line is comparable to the quality of standard reprints developed in the store. The high-resolution image captured by PhotoNet retailers ensures that you receive a photographic print with all the detail and color you're used to from standard processing.

For More Information	
Picture Vision	http://www.photonet.com/
250-A Exchange Place	
Herndon, VA 20170	
Telephone: (703) 733-0500 or (888) FUN-PICS	

PhotoDisc

Maybe you've had the horrifying experience of frantically finishing a project only to discover you're missing a picture. Another time you may need an animal photo to add a certain "feel" to your newsletter. Other times you may need photos of cities, airports or other places where you've never visited. Where can you look for such a photo?

In these cases you may want to try PhotoDisc, Inc. The best way to describe PhotoDisc is to say it's a stock photo agency on the Internet. It's arguably the best collection of Web-ready photos you can find. In other words, PhotoDisc lets you search for and download images from the Internet.

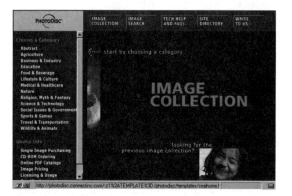

You should find the right one among the 50,000 available images. (This was the number as we went to press; PhotoDisc expects to have 100,000 images on-line by January, 1998.) These images are available in low, medium and high resolutions (complete with Photoshop clipping paths). Furthermore, they're available 24 hours a day, every day. The photos are sold royalty-free, so you pay only a one time charge, which depends on the image resolution and the purpose for which you'll be using the image. Prices for images range from $9.95 to $189.95.

In 1991, PhotoDisc became the first to offer a royalty-free CD-ROM with a selection of random photos for businesses to use. Then, in 1996, PhotoDisc became the first royalty-free dealer to take its product onto the Internet. Conventional stock photo agencies, on the other hand, mainly negotiate individual per-use license agreements with customers. The cost is based on how the customer uses the photo.

Simply look through the photo files and select the one(s) you want to buy. As we've said, the catalog has thousands of images available. Several types of images are available and are ready for you to download. Considering that you can select from over 50,000 photos, you're sure to find anything you need. Once you've selected the image(s), you do a little secure transaction and download the images. Then you can use them almost any way you want. In most cases, you pay only once and use them as often as you wish.

Purchasing and downloading images

The Photodisc website includes step-by-step directions on buying PhotoDisc images. About 15 to 20 minutes are required for a typical single image search and purchase cycle.

The steps mainly involve entering search criteria according to keywords. Then you review the images matching your search criteria. Select a license and resolution. Continue until you've selected all the images you want and click the $\boxed{\text{\$\$\$\$ PURCHASE}}$ button. Then click on "Download Image." When you see "Document Done" in the bottom left hand corner of the screen in Netscape, select the **File/Save As...** command. Then point to where you want the image saved.

Return to the Download page to retrieve other images you have bought for downloading.

The Photodisc Series

Photodisc has their images in categories called *Series*. Each Series includes hundreds of high-resolution 24-bit images for less than the cost of a single traditional stock photograph. The following are some examples:

PhotoDisc's Signature Series

This series features portfolios of several world renowned stock and commercial photographers. Categories include "Wild West," "Action Sports," "Details of Nature," "Panoramic Landscapes," "Everyday People" and more. Each disc includes at least 100 high-end images in three file sizes with embedded clipping paths for easy outlining.

Fine Arts

This series includes photos ranging from complete paintings, architectural elements, wallpaper and antique maps. Examples of categories in this series include "European Paintings," "Antique Maps and Heraldic Images," "American Fine Art and Illustration" and "Religious Illustrations."

ClipPix

The award-winning photos in ClipPix are optimized for on-screen use and desktop printing. They give you a powerful edge for business communications, such as training presentations, financial reports, customer presentations and more.

Background series

PhotoDisc's new images in the Background Series represent different images from metal sculptures to hand paintings. They range from quirky to sophisticated. These are available individually on the Web or in eight thematic collections of 100 on CD-ROM.

Animation Series

The PhotoDisc Disc Animation Series is a collection of royalty-free animated GIFs and Shockwave files. The premiere title in the series is Metamoraphically Speaking. It features objects like traffic, a squawking goose laying an egg and a construction sign with a blinking light.

The Animation Series includes 8 CD-ROM titles with 120 photos in each title. Pricing starts at $149, with individual animations priced between $29.95 and $49.95.

For More Information	
PhotoDisc, Inc. 2013 Fourth Avenue Seattle, WA 98121-2460 Telephone: (800) 979 4413	www.photodisc.com

Kodak PhotoNet

Use Kodak PhotoNet online to e-mail your favorite shots or share an entire roll at once. Your friends and family can even order reprints. Order reprints online and have photographic quality prints mailed wherever. Create personalized gift items from your photos such as mugs, T-shirts, mouse pads and more. Download your photos to your computer and use them in documents, auction sites, screensavers, web pages and more.

To use PhotoNet from Kodak, drop off your film at any of 40,000 participating retailers. Make certain to request Kodak PhotoNet online at the counter or check the box on the film envelope.

You'll receive a claim card when you pick up your prints and negatives. This card includes an Access Code and a secure Owner's Key so you can see your photos online. Then to view your photos, go to the Kodak PhotoNet online website and create your free account or log in (if you already have an account).

Click on the "Pick Up Photos" link and enter the Access Code and Owner's Key. Your photos will be added to your account. They'll be available online 30 days from when they were scanned, but you can store them longer.

You can also upload photos snapped with your digital camera and order high quality prints on photographic paper. Create a free account and purchase a "roll" of spaces on the site. Then upload your photos.

For More Information	
Eastman Kodak Company 343 State Street Rochester, NY 14650 Telephone: (888) 368-6600	www.kodak.com

Sony ImageStation

A similar service to the Kodak PhotoNet online is the Sony ImageStation. Use the postage-paid film mailer to send traditional 35-mm film for processing. Sony will digitize and upload your images. You'll receive an e-mail message telling you how to view and share your photographs on ImageStation. If you're using a digital camera, upload your images directly from your PC.

After you've set up an account, just log into the ImageStation website and go to the Dock area to "pick up" your 35-mm processed film. Or, if you're using a digital camera (instead of a traditional 35-mm camera), you can upload digital photos directly from your computer.

You can also personalize your online photo albums in the Dock.

The ImageStation Gallery lets you showcase your online images. Thumbnails are used so you can view images of an entire album. Personalize images with descriptive titles and share them with friends and family by sending e-mail messages or your own digitally created ImageStation postcards.

Order prints, t-shirts, and other fun keepsakes in the Shop by selecting one of your online images, and then select an item from the Shop directory.

Visit the Sony website (http://imagestation.sony.com/) for more information.

Digitizing Services

Many print shops, photo shops, on-line services and some software manufacturers can digitize your photos. Kinko's, for example, will scan a 4 x 6 inch photo and even do basic editing for about $10 or $1 per minute. You'll get the scanned image back on a diskette or on a removable storage device. (See their website for more details: http://www.kinkos.com/products/listing/.)

America Online can digitize prints, slides and negatives for 99 cents each. The prints are then downloaded to you. You can also have AOL create an on-line photo album for only $24.95 per year. You can then store up to 100 images in this album. An option with the album is to create a Picture Circle. This will let your friends and family view the album on-line. This will cost 9.95 additional per year. The AOL keyword for this service is "pictureplace."

Photo shops will digitize photos and put them onto a Kodak Photo CD (see below). Check with the photo shops. You may save money by using prints from recently developed negatives instead of the printed images ("positives"). You'll probably be charged per image placed on the CD-ROM (and probably for the CD-ROM itself). Typical prices are about $10 for the CD-ROM and from about 99 cents to more than $2 per image. As you can see, prices vary widely, so we recommend comparing prices at as many photo shops as you can.

Keep in mind the prices we mention here may have changed since we went to press.

Chapter 15:
Contents Of The
Companion
CD-ROM

Chapter 15
Contents Of The CD-ROM

Using The Companion CD-ROM

Loading the MENU in Windows 95
Installing Adobe's Acrobat Reader

A Note About Shareware Software

Programs On The Companion CD-ROM

Image editors
Image managers
Filters and plug-ins
Other programs/utilities

The companion CD-ROM to *Easy Digital Photography* contains several programs for image enhancing, editing, cataloging and much more. These include 30-day 'trialware', software demonstrations and a variety of the best graphic shareware products in the industry. Many of this programs featured on the CD-ROM are fully functioning *shareware evaluation versions* of the best programs available today. Shareware benefits both the user and the author. By avoiding distribution, packaging, and advertising costs, prices of shareware remains low. Keep in mind, however, that shareware programs are copyrighted programs. Therefore, the authors ask for payment if you use their program(s). To ensure that the program authors continue writing programs and offering them as shareware, we urge you to support the shareware concept by registering the programs that you plan to use permanently.

Using The Companion CD-ROM

You must load the MENU.EXE program located in the root directory before you can use the companion CD-ROM. When the program is loaded, you will have various buttons to select your utilities. Insert the CD-ROM into your CD-ROM drive. We're assuming that the letter assigned to your CD-ROM drive is "D:". If this is not the case, simply substitute your CD-ROM drive letter instead of "D:"

Loading the MENU in Windows 95

Select the Start menu and then the **Run...** command. This opens the Run dialog box. Then type the following in the Run dialog box:

```
d:\menu.exe
```

and press Enter.

The Run dialog box should appear. Then press the Enter key or click the OK button. The main MENU program will start. This MENU program is used to install the various programs. Simply click on the program name and follow the onscreen prompts.

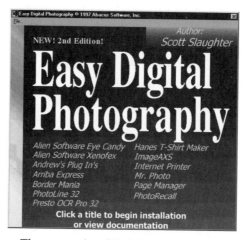

The companion CD-ROM main menu.

Installing Adobe's Acrobat Reader

Adobe's Acrobat Reader is a utility allowing you to view PDF files. We have included the Abacus Catalog (CATALOG.PDF) on the companion CD-ROM. If you already have Acrobat Reader, skip the next steps. Follow these steps to install Acrobat Reader on your hard drive (requires approximately 2 Meg on space on your hard drive). Insert the CD-ROM in your drive and load Windows. Select the **File/Run...** command from the Windows Program Manager. Then type D:\ACROREAD.EXE and press the Enter key.

322

Simply follow the instructions and prompts which appear on your screen. Double click the Acrobat Reader icon to load it.

A Note About Shareware Software

Many of the programs included on the CD-ROM are fully functioning "shareware evaluation versions" of the best programs available today. Because shareware is copyrighted, the authors ask for payment if you use their program(s). You may try out the program for a limited time (typically 10 to 30 days) and then decide whether you want to keep it. If you continue to use it, you're requested to send the author a nominal fee. Shareware benefits both the user and the author as it allows prices to remain low by avoiding distribution, packaging, and advertising costs. The shareware concept allows small software companies and program authors to introduce the application programs they have developed to a wider audience. The programs can be freely distributed and tested for a specific time period before you have to register them. Registration involves paying registration fees, which make you a licensed user of the program. Check the documentation or the program itself for the amount of registration fee and the address where you send the registration form.

One final note: You'll find program instructions and notes on registration for the shareware programs in special text files located in the program directory of each program. These programs are usually called READ.ME, README.TXT or README.DOC. As a rule, the TXT, WRI or DOC extensions are used for text files, which you can view and print with Windows 95 editors.

Programs On The Companion CD-ROM

The following pages give an overview of the programs, utilities, plug-ins and other information you'll find on the companion CD-ROM. Please read the file called COMPANIONCD.PDF on the root directory of the companion CD-ROM. It lists and describes all the programs that are on the CD-ROM and installation instructions.

Image editors

PhotoLine 32 from Computerinsel GmbH

Image managers

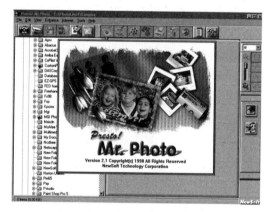

Mr. Photo from NewSoft Inc.

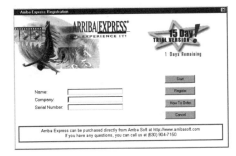

Arriba Express from Arriba Soft

PhotoRecall from G&A Imaging

ImageAXS from Digital Arts & Sciences

Chapter 15

Filters and plug-ins

Eye Candy plug-in from Alien Software

Xenofex plug-in from Alien Software

Plug-ins courtesy of Andrew

Other programs/utilities

Nadio Internet Printer

Hanes T-ShirtMaker

Presto OCR from New Soft Inc

Index

Nadio

Print color photos
Anywhere
Anytime Instantly
Over the Internet

Imagine that you can print your color photos directly to your friends' and family's printers. Just choose "Print" from any Windows 95/98 program to print to a remote printer, anywhere in the world -- instantly.

With Nadio InternetPrint, your color photos won't get lost or torn in the mail. You can cut down on express delivery or long-distance fax charges for important documents. And unlike e-mail, there are no file format problems and no file attachment to save, view, and print.

Nadio InternetPrint Lite Benefits:
- ✓ Everyone can print color photos to family and friends
- ✓ Graphic designers, artists, illustrators can print color creative proofs to clients' printers, without worrying about file formats or e-mail file size limitations
- ✓ Business users can print documents to the office when on the road or working at home
- ✓ Lawyers, government officials, insurance and health care agents can print contracts or licenses, without worrying about changes to the original document

FREE Nadio InternetPrint Lite 1.0
http://www.nadio.com/abacus

a Presto! solution for every
scanner, camera & printer!

PageManager 98 Gold:

the best solution to scan, manage, and share documents and forms. Includes three titles to make your scanner more productive:

- Presto! PageManager 98 files and retrieves documents/photos; supports 100+ applications; and features *Presto! Wrapper* to share multiple photos with a viewer
- Presto! ImageFolio has powerful image editing tools for illustrations, paintings, stationery, signs & more
- Presto! Forms lets you scan any form, fill in text and check-marks, and print it out or fax it

Presto! OCR Pro 3.0:

fast and accurate OCR to make you more productive. With OCR Pro and you scanner, you never have to re-type another document!

- "Human Eye" precision
- Scan&Read for one-step OCR
- Retains font type, style, & size
- Keeps original page layout
- "True-word processor" tables, columns, spreadsheets
- Batch scanning over networks
- Reads English, French, German
- Exports direct to MS Office97, WordPro, and WordPerfect
- Upgrade from any other OCR

Mr. Photo Gold 2.0:

the easiest way to create, edit and share photo masterpieces. Includes four creativity software to get the most out of your digital camera:

- Presto! Mr. Photo previews and organizes photos; shares photos by slide show, e-mail, or Internet; prints photos, catalogs, stickers
- Presto! PhotoDesigner offers step-by-step editing and creativity
- Presto! PhotoAlbum creates keepsake photo albums with frames, clipart, and voice-overs
- Presto! PhotoComposer lets you put your photo into any scene

NewSoft

FREE trial software!
www.newsoftinc.com/abacus
or call 1-800-436-4365 to order!

Using The Companion CD-ROM

You must load the MENU.EXE program located in the CD-ROM's root directory to use the companion CD-ROM. Insert the CD-ROM into your CD-ROM drive. We're assuming that the letter assigned to your CD-ROM drive is "D:". If this is not the case, simply substitute your CD-ROM drive letter instead of "D:"

Loading the MENU in Windows 95

Select the Start menu and then the **Run...** command. This opens the Run dialog box. Then type the following in the Run dialog box:

```
d:\menu.exe
```

and press Enter.

The Run dialog box should appear. Then press the Enter key or click the OK button. The main MENU program will start. This MENU program is used to install the various programs.

The companion CD-ROM main menu

Read The Companion CD-ROM.PDF file

Look for the file named COMPANION CD-ROM.PDF on the root directory of the companion CD-ROM. It describes all the programs, files, utilities and more that are on the companion CD-ROM.

About The Companion CD-ROM

Easy Digital Photography's companion CD-ROM contains several programs for image enhancing, editing, cataloging and more. These include several fully functional programs you can try for a limited time (sometimes called *trialware*). Some programs are *shareware* programs that you can try before you buy. Some programs, such as the plug-ins from Alien Skin Software, are limited versions of the full program. However, check out Eye Candy and Xenofex — each also includes two filters that you can apply to your images. The companion CD-ROM also includes several free plug-ins you can apply to your images. Make certain to contact the author(s) of the plug-ins to let them know how you're using the plug-ins — they'll appreciate your comments.

We've also included several high-quality scanned images in the IMAGES folder. You can use these images in your work or to experiment with your image editors.

The CD-ROM includes several filters from Andrew, Border Mania and Alien Skin Software (Xenofen and Eye Candy) you can use on your images

The companion CD-ROM includes image managers such as Arriba Express, ImageAXS, Mr Photo, PhotoRecall, Presto! Page Manager 98

Turn the page for more information on the companion CD-ROM or read the COMPANION CD-ROM.PDF file on the root of the companion CD-ROM for complete information on the programs, files, utilities and more that you'll find.

The companion CD-ROM also includes OCR software (OCR Pro! from New Soft) and an image editor (PhotoLine 32) that you can use immediately.